Television Production Workbook

TENTH EDITION

Herbert Zettl

San Francisco State University

Television Production Workbook, Tenth Edition Herbert Zettl

Publisher: Michael Rosenberg

Managing Editor, Development: Karen Judd

Assistant Editor: Christine Halsey

Senior Editorial Assistant: Megan Garvey

Technology Project Manager: Jessica Badiner

Marketing Manager: Erin Mitchell

Marketing Assistant: Mary Anne Payumo

Marketing Communications Manager: Shemika Britt

Content Project Manager: Georgia Young

Creative Director: Rob Hugel

Art Director: Maria Epes

Print Buyer: Susan Carroll

Permissions Editor: Mollika Basu

Production Service: Ideas to Images

Cover and Text Designer: Gary Palmatier,

Ideas to Images

Photo Researcher: Cheri Throop

Copy Editor: Elizabeth von Radics

Illustrator and Compositor: Ideas to Images

© 2009, 2006 Wadsworth, a part of Cengage Learning

ALL RIGHTS RESERVED. No part of this work covered by the copyright herein may be reproduced, transmitted, stored or used in any form or by any means graphic, electronic, or mechanical, including but not limited to photocopying, recording, scanning, digitizing, taping, Web distribution, information networks, or information storage and retrieval systems, except as permitted under Section 107 or 108 of the 1976 United States Copyright Act, without the prior written permission of the publisher.

For product information and technology assistance, contact us at Cengage Learning Academic Resource Center, 800-423-5263

For permission to use material from this text or product, submit all requests online at www.cengage.com/permissions

Further permissions questions can be emailed to permissionrequest@cengage.com

ExamView® and ExamView Pro® are registered trademarks of FSCreations, Inc. Windows is a registered trademark of the Microsoft Corporation used herein under license. Macintosh and Power Macintosh are registered trademarks of Apple Computer, Inc., used herein under license.

© 2009 Cengage Learning. All rights reserved.

Cengage Learning WebTutor™ is a trademark of Cengage Learning.

ISBN-13: 978-0-495-56589-5 ISBN-10: 0-495-56589-X

Wadsworth Cengage Learning

10 Davis Drive Belmont, CA 94002-3098 USA

Cengage Learning products are represented in Canada by Nelson Education, Ltd.

For your course and learning solutions, visit **academic.cengage.com**Purchase any of our products at your local college store or at our preferred online store **www.ichapters.com**

To all the students using this workbook, with the best wishes for success

Photo Credits

Edward Aiona: 8, 9, 66 (Ex. 15), 74, 78, 80, 81 (Ex. 2c & 2d), 82 (Ex. 3), 119, 120, 140 (nos. 42–44), 141 (nos. 45–47), 142 (nos. 48–50), 144, 146 (Ex. 3a & 3b), 147, 154, 156, 167–170, 197 (Ex. 1a & 1b), 198–200, 202, 247 (Ex. 6a–6c)

Broadcast and Electronic Communication Arts Department at San Francisco State University: 204–205 (Ex. 1)

Chimera: 110 (no. 66)

Lowel-Light Mfg., Inc.: 106 (no. 26), 110 (nos. 61–63, 65, 67 & 68)

Larry Mannheimer: 248

MCI: 97

Mole-Richardson Co.: 106 (nos. 24, 25, 27, 29 & 30)

Chris Rozales: 65 (Ex. 9)

Selco Products Company: 96

Thomson/Grass Valley: 138, 140 (Ex. 8, top), 141 (Ex. 9, top), 142 (Ex. 10, top)

John Veltri: 241, 242, 247 (Ex. 6d)

Zettl's VideoLab 3.0 DVD-ROM: 246

Herbert Zettl: all other photos

Contents

Chapter 1	The Television Production Process	1
	Review of Key Terms 1 Review of Effect-to-cause Model 4 Review of Production Personnel 6 Review of Technical Systems 8 Review Quiz 12 Problem-solving Applications 13	
Chapter 2	The Producer in Preproduction	15
	Review of Key Terms 15 Review of Preproduction Planning: Generating Ideas 17 Review of Evaluating Ideas 21 Review of Program Proposal 22 Review of Coordination 24 Review of Unions and Legal Matters 25 Review of Ratings 27 Review Quiz 28 Problem-solving Applications 29	
Chapter 3	The Script	31
	Review of Key Terms 31 Review of Basic Script Formats 33 Review of Story Structure, Conflict, and Dramaturgy 36 Review Quiz 38 Problem-solving Applications 39	,
Chapter 4	Analog and Digital Television	41
	Review of Key Terms 41 Review of Analog and Digital Television 45 Review of Basic Image Creation and the Colors of the Video Display Review Quiz 47 Problem-solving Applications 48	46

Chapter 5	The Television Camera	49
	Review of Key Terms 49 Review of Basic Camera Elements and Functions 52 Review of Electronic Operational Features 54 Review of Resolution, Contrast, and Color 55 Review Quiz 56 Problem-solving Applications 57	
Chapter 6	Lenses	59
	Review of Key Terms 59 Review of Optical Characteristics of Lenses 62 Review of How Lenses See 64 Review Quiz 67 Problem-solving Applications 68	
Chapter 7	Camera Operation and Picture Composition	69
	Review of Key Terms 69 Review of Camera Movement and Camera Supports 74 Review of How to Work a Camera 76 Review of Framing Effective Shots 78 Review Quiz 83 Problem-solving Applications 84	
Chapter 8	Audio: Sound Pickup	85
	Review of Key Terms 85 Review of How Microphones Hear 88 Review of How Microphones Are Used 90 Review Quiz 91 Problem-solving Applications 92	
Chapter 9	Audio: Sound Control	93
	Review of Key Terms 93 Review of Studio and Field Audio Production Equipment 96 Review of Audio Control 98 Review Quiz 100 Problem-solving Applications 101	
Chapter 10	Lighting	103
	Review of Key Terms 103 Review of Studio Lighting Instruments and Controls 106 Review of Field Lighting Instruments and Controls 109	

	Problem-solving Applications 114	
Chapter 11	Techniques of Television Lighting	115
	Review of Key Terms 115 Review of Lighting Techniques 118 Review Quiz 125	
	Problem-solving Applications 126	
Chapter 12	Video-recording and Storage Systems	127
	Review of Key Terms 127 Review of Tape-based and Tapeless Video Recording 130 Review of How Video Recording Is Done 132 Review Quiz 133 Problem-solving Applications 134	
Chapter 13	Switching, or Instantaneous Editing	135
	Review of Key Terms 135 Review of Basic Switcher Layout and Operation 138 Review of Electronic Effects and Switcher Functions 143 Review Quiz 149 Problem-solving Applications 150	
Chapter 14	Design	151
	Review of Key Terms 151 Review of Television Graphics 154 Review of Scenery and Scenic Design 158 Review Quiz 162 Problem-solving Applications 163	
Chapter 15	Television Talent	165
	Review of Key Terms 165 Review of Performing Techniques 167 Review of Acting Techniques 173 Review of Makeup and Clothing 174 Review Quiz 175 Problem-solving Applications 176	

Review of Light Intensity, Lamps, and Color Media

Review Quiz 113

112

Chapter 16	The Director in Production: Preparation	179
	Review of Key Terms 179 Review of Process Message and Production Method 181 Review of Script Marking 183 Review of Interpreting Storyboards 188 Review of Support Staff 189 Review of Time Line 190 Review Quiz 193 Problem-solving Applications 194	
Chapter 17	The Director in Production: Directing	195
	Review of Key Terms 195 Review of Director's Terminology 197 Review of Rehearsal Techniques 203 Review of Multicamera Directing 204 Review of Timing 206 Review of Single-camera Directing 207 Review Quiz 208 Problem-solving Applications 209	
Chapter 18	Field Production and Big Remotes	211
	Review of Key Terms 211 Review of Field Production 214 Review of Big Remotes 215 Review of Facilities Requests 221 Review of Signal Transport Systems 222 Review Quiz 223 Problem-solving Applications 224	
Chapter 19	Postproduction Editing: How It Works	225
	Review of Key Terms 225 Review of Nonlinear Editing 230 Review of Linear Editing 231 Review Quiz 234 Problem-solving Applications 235	
Chapter 20	Editing Functions and Principles	237
	Review of Key Terms 237 Review of Continuity Editing Principles 240 Review of Complexity Editing 248 Review Quiz 250 Problem-solving Applications 251	

viii

Preface

The basic purpose of the *Television Production Workbook* has not changed for this tenth edition: to help students learn the tools and the techniques of television production and to help instructors monitor and assess this learning process. I have used the *Workbook* quite successfully as an initial diagnostic tool. This is one of the few standardized instruments to determine just who knows what about television production at the beginning of the semester. The initial resistance to some of the *Workbook* exercises usually dissipates quickly when even the more experienced students discover that they still have a considerable amount of brushing up to do and realize that your course will give them a chance to overcome their deficiencies.

The chapters in this edition of the *Workbook* correspond to those of the *Television Production Handbook*, Tenth Edition, without necessarily being tied to them. Students should be encouraged to solve the assigned *Workbook* problems at least initially without the use of the *Handbook*. This way the results will reflect a more accurate picture of each student's knowledge of television production; it will also provide him or her with a more realistic guide for further study. When used in conjunction with *Zettl's VideoLab 3.0* DVD-ROM, the *Workbook* can serve as a handy extension of the disc's quizzes and skills testing. Eventually, students must translate the written exercises into actual studio and field production experiences. I hope that the *Workbook* will make such a translation as painless and effective as possible.

The *Workbook* is laid out for ease of use and optimal student learning. Here are some of its main features:

- Each chapter begins with a review of key terms that tests the understanding of that chapter's basic terminology.
- The middle section of each chapter offers a variety of objective questions, including illustrations to analyze. The aim is to help students recognize and apply various production principles discussed in the *Handbook*.
- A true/false Review Quiz tests whether students know the basic terminology and production principles.
- The Problem-solving Applications are primarily intended for in-class discussion, although you may choose to select a few problems and have students write up possible solutions to hand in before the class discussion. You are encouraged to add other such production problems that are specific to your own requirements and production environment. Whatever problems you choose, they should give students the opportunity to put their knowledge into a realistic context and seek creative solutions to a variety of common production problems.

All objective questions can be answered by filling in numbered bubbles. This design is intended to minimize ambiguity in answering and maximize speed and accuracy in evaluating. Because each bubble in a chapter is assigned a specific number, the design lends itself readily to computer scoring. A number of problems require multiple answers,

which means that students should fill in two or more bubbles. Whenever such multiple answers are not obvious, the instructions indicate "Fill in two bubbles" or "Multiple answers are possible."

You will find that the problems differ considerably in degree of difficulty. Some are designed simply for quick recall; others require a more careful evaluation of the possible solutions to the problems. I usually inform students of these differences and encourage them not to get careless, especially when they find the answers to be quite obvious.

If you use the *Workbook* in conjunction with *Zettl's VideoLab 3.0* DVD-ROM, you will find that the production quizzes and the interactive exercises on the disc are a convenient extension of the *Workbook* problems. Both are intended to help students move from the description of the tools and the techniques in the text to their actual application in a variety of realistic contexts.

ACKNOWLEDGMENTS

Again, my thanks to the people at Wadsworth Cengage Learning, who insist on a work-book that is as efficient to use as it is effective for student learning.

I am also most grateful to my colleague, Dr. Paul Rose, University of Utah, for scrutinizing and answering all the problems in the *Workbook* to make sure that they are answerable and free of ambiguities. I am especially indebted to my former colleagues and students who helped me with formulating the various problems and doubled as on-camera talent.

Once again, I was privileged to have Wadsworth Cengage Learning call on the expertise of its "A-team" to produce this Tenth Edition of the *Television Production Workbook*: Michael Rosenberg, publisher; Karen Judd, managing development editor; Ed Dodd, development editor; Christine Halsey, assistant editor; Megan Garvey, assistant editor; Erin Mitchell, marketing manager; Maria Epes, executive art director; Georgia Young, content project manager; Cheri Throop, photo researcher; and Mollika Basu, permissions editor.

Gary Palmatier of Ideas to Images, art director and project manager; Elizabeth von Radics, copy editor; and Ed Aiona, photographer, are the principals who actually produce the *Workbook* out of the many loose pages, notes, and sketches I handed them. The highest praise I can give them is to say that they are all true professionals and incredibly dedicated people who are fun to work with.

Finally, I owe a big thank-you to my wife, Erika, who as a longtime classroom teacher, administrator, and educational consultant taught me how to clarify and objectify the answers without impinging on the students' creativity.

1

The Television **Production Process**

REVIEW OF KEY TERMS

Match each term with its appropriate definition by filling in the corresponding bubble.

- 1. medium requirements
- 2. EFP
- 3. nonlinear editing
- 4. preproduction
- 5. effect-to-cause model
- 6. television system
- 7. technical production personnel
- 8. production
- 9. linear editing
- 10. ENG
- 11. process message
- 12. postproduction
- A. A relatively uncomplicated field production shot for postproduction
- A O O O O
 1 2 3 4
 O O O O
 5 6 7 8
 O O O O
 9 10 11 12
- **B.** Television production that covers daily events and is usually transmitted live or after immediate postproduction
- **C.** Moving from idea to the program objective, then backing up to the specific medium requirements to produce this objective

D. Analog or digital editing that uses tape-based systems

D \(\cdot \

P A G E T O T A L

8. production 4. preproduction 9. linear editing 5. effect-to-cause model 0000 E. People who primarily operate television equipment 1 2 3 4 0000 5 6 7 8 0000 9 10 11 12 0000 F. The basic equipment necessary to produce video and audio signals and 1 2 3 4 reconvert them into pictures and sound 0000 5 6 7 8 0000 9 10 11 12 G 0000 G. All activities during the recording or televising of an event 1 2 3 4 0000 5 6 7 8 0000 9 10 11 12 0000 H. The information that the viewer actually receives 1 2 3 4 0000 5 6 7 8 0000 9 10 11 12 0000 Preparation of all production details 1 2 3 4 0000 5 6 7 8 0000 9 10 11 12 0000 J. Allows random access to, and flexible sequencing of, recorded video and 1 2 3 4 audio material 0000 5 6 7 8 0000 9 10 11 12 PAGE

10. ENG

11. process message

12. postproduction

6. television system

personnel

7. technical production

1. medium requirements

3. nonlinear editing

2. EFP

K. Video and audio editing phase

- K 0 0 0 0 1 2 3 4 0000 5 6 7 8 0000 9 10 11 12
- L. The people, content, and production elements needed to generate the desired viewer effect
- 0000 1 2 3 4 0000 5 6 7 8 O O O O O 9 10 11 12

	¢		,
	٩		
	٤		
	ē	į	,
	¢	ľ	
-			
			,
	č	į	
¢			į
4	2		
1	ţ		
		5	
		5	
-	i		
	٤		
:	;	5	
9		Ē	
à	Ė		
•	•	•	4
(ξ		
		-	

REVIEW OF EFFECT-TO-CAUSE MODEL

Select the correct answers and fill in the bubbles with the corresponding numbers.

1. Identify each part of the effect-to-cause diagram below and fill in the bubbles with the corresponding numbers.

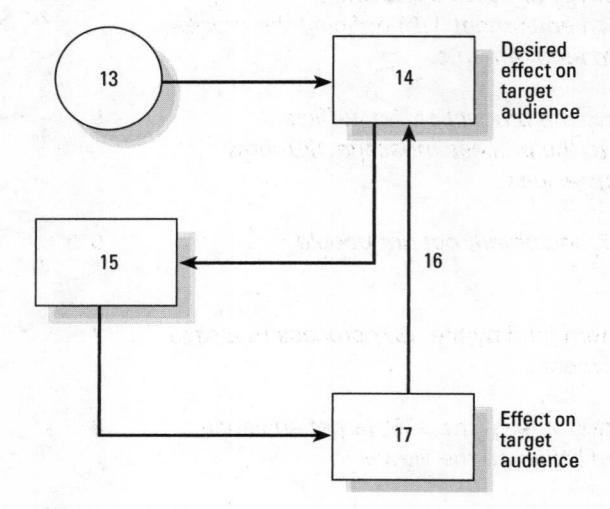

- a. feedback
- b. actual process message
- c. initial idea
- d. program content, people, and production elements
- e. defined process message

- 1a O O O O O O 13 14 15 16 17
- 1c 0 0 0 0 0 13 14 15 16 17
- 1d O O O O O O 13 14 15 16 17
- 1e O O O O O O 13 14 15 16 17

PAGE

- 2. The effect-to-cause model is especially helpful in (18) preproduction (19) production (20) postproduction.
- 0 0 0
- 3. In the effect-to-cause model, we move from (21) idea to medium requirements to production (22) idea to production to process message (23) idea to process message to medium requirements.
- O O O O 21 22 23
- **4.** The most important initial step in the effect-to-cause approach is (24) determining the available production equipment (25) defining the process message (26) determining the medium requirements.
- 4 0 0 0
- **5.** Feedback helps determine (27) whether the production was efficient (28) how close the actual effect came to the process message (29) how close the actual effect came to the original idea.
- 5 O O O O 27 28 29

- **6.** The medium requirements include (30) equipment but not people (31) equipment and people.
- 6 O O
- 7. Medium requirements are basically determined by the (32) process message (33) chief engineer (34) available equipment.
- O O O O 32 33 34
- **8.** A defined process message must contain at least the (35) target audience (36) medium requirements (37) desired effect on the viewer.
- O O O 35 36 37
- **9.** The angle will define the (38) basic production approach (39) process message (40) position of the camera.
- 9 0 0 0
- **10.** The effect-to-cause model is especially useful in the production of (41) *dramas* (42) *documentaries* (43) *breaking news stories*.
- 10 0 0 0

© 2009 Wadsworth Cengage Learning

P A G E T O T A L

s	EC	T	10	N	
T	0	T	A	L	

REVIEW OF PRODUCTION PERSONNEL

1. Match each job title with the most appropriate function by filling in the corresponding bubble.

(44) LD

(48) video-record operator

(51) floor manager

(45) PA

(49) director

(52) VJ

(46) TD

(50) producer

(53) AD

(47) DP

a. In charge of all production activities on the production day

b. In EFP, works the camera; in cinema, is in charge of the lighting and film exposure

c. In charge of lighting

49 50 51 52 53 1c \(\circ\) \(

d. Supports the director in directing activities

O O O O O O 49 50 51 52 53

1d O O O O O O 44 45 46 47 48

49 50 51 52 53

e. In charge of video recording

1e O O O O O O O 44 45 46 47 48

f. In charge of all preproduction activities

0 0 0 0 0 49 50 51 52 53

g. Relays the director's messages to talent

1g 0 0 0 0 0 0 0 44 45 46 47 48

h. Shoots and edits own news footage

0 0 0 0 0 49 50 51 52 53

i. In charge of a crew; usually does the switching

1i O O O O O O 44 45 46 47 48

0 0 0 0 0 49 50 51 52 53

PAGE

Name

i. Assists producer and director in all production phases

- 00000 44 45 46 47 48 00000 49 50 51 52 53
- 2. Match each title of news personnel with its appropriate definition by filling in the corresponding bubble.
 - (54) anchor
- (57) news producer
- (60) videographer/

- (55) sportscaster
- (58) assignment editor
- shooter

- (56) news director
- (59) reporter
- (61) writer
- a. Prepares on-the-air copy for the anchorpersons

0000 54 55 56 57 0000 58 59 60 61

b. Responsible for all the news operations

0000 54 55 56 57 0000

c. Sends reporters and videographers to specific events

2c 0000 54 55 56 57

58 59 60 61

d. Principal presenter of newscast, normally from a studio set

- 0000 58 59 60 61
- e. Operates camcorder and, in the absence of a reporter, decides what part of the event to cover
- 2d 0000 54 55 56 57 0000

58 59 60 61

- f. Gathers the news stories and often reports on-camera from the field
- 0000 54 55 56 57

0000 58 59 60 61

g. Responsible for individual news stories for on-the-air use

2f 0000 54 55 56 57 0000 58 59 60 61

- 0000 54 55 56 57 0000
- 2h 0000
 - 54 55 56 57 0000 58 59 60 61

58 59 60 61

P A G E T O T A L

SECTION TOTAL

h. On-camera talent, giving sports content

REVIEW OF TECHNICAL SYSTEMS

- 1. Identify each of the major elements of the basic television system by filling in the corresponding bubble.
 - a. TV camera
- d. TV receiver sound
- f. video signal

- b. TV receiver image
- e. microphone
- g. audio signal

c. VTR

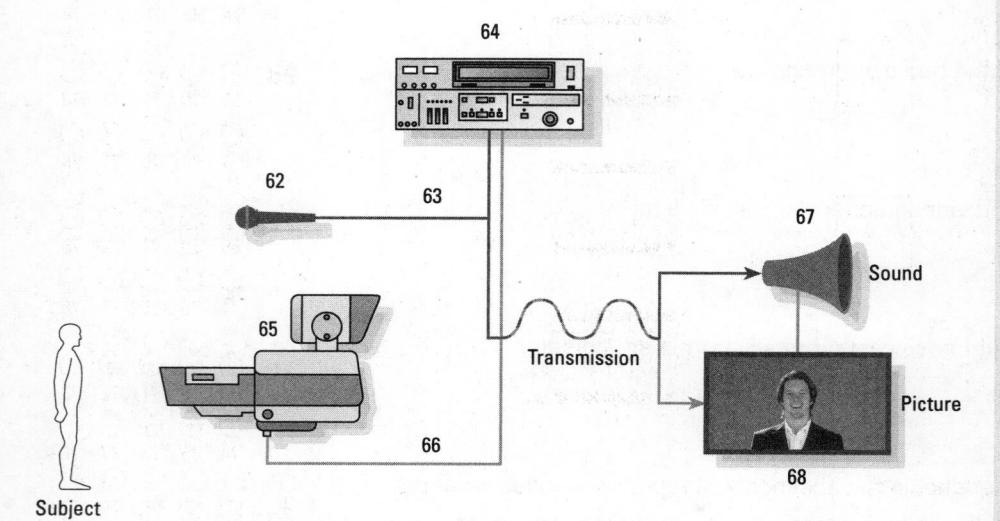

1a	62 66	63 67	O 64 O 68	65
1b	62 66	63 67	0	65
1c	62 66	63 67	64	65
1d	0	63 67	0	65
1e	O 62 O 66	63 67	64	65
lf	0	63 67	0	65
lg	62	0	0	0

B A C F	
PAGE	
TOTAL	

O O O 66 67 68

- 2. Identify each major component of the expanded television system by filling in the corresponding bubble.
 - a. audio monitor speaker
 - b. video recorder
 - c. CCUs 1 and 2
 - d. audio console
 - e. home TV receiver

- f. video switcher
- g. transmitter
- h. line monitor
- i. cameras 1 and 2
- j. preview monitors

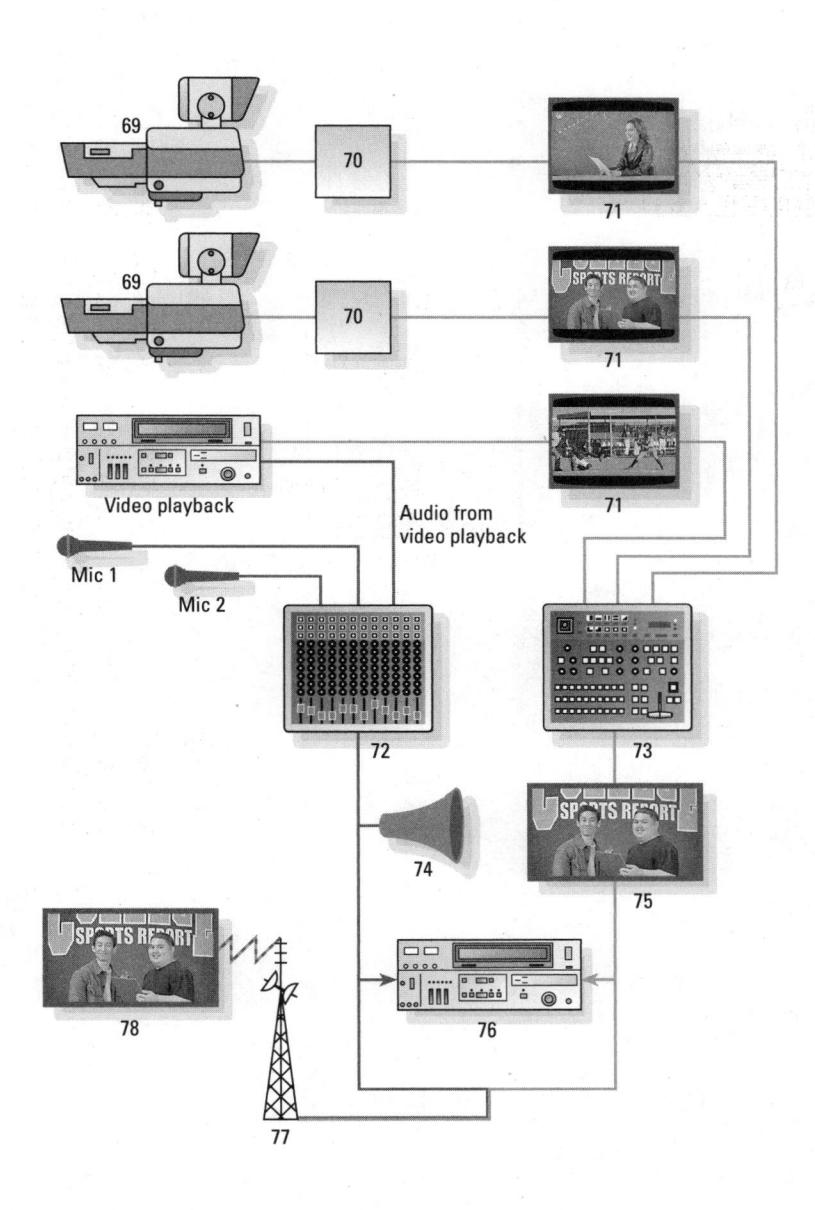

2a	69	O 70	O 71	O 72	73
			76		
2b	69 74	70 75	○71○76	O 72 O 77	73 78
2c	0 69 0 74	7075	○ 71 ○ 76	O 72 O 77	73 0 78
2d	0 69 0 74	70 75	○ 71 ○ 76	O 72 O 77	73 0 78
2e	0 69 0 74	70 75	O 71 O 76	O 72 O 77	73 0 78
2f	O 69 O 74	70 0 75	O 71 O 76	O 72 O 77	73 0 78
2g	O 69 O 74	70 0 75	○ 71 ○ 76	O 72 O 77	73 0 78
2h	69 0 74	○ 70 ○ 75	O 71 O 76	O 72 O 77	○ 73 ○ 78
2i	O 69 O 74	70	O 71 O 76	72	73
2j		70	○ 71 ○ 76	72	73

3. Match each system element with its appropriate function by filling in the corresponding bubble. (79) cameras (84) microphones (85) switcher (80) preview monitors (81) TV receiver (86) audio console (87) CCUs (82) audio monitor speaker (83) line monitor (88) VR 3a 00000 a. To control the audio quality of the various audio inputs 79 80 81 82 83 00000 84 85 86 87 88 3b 00000 b. To convert what we see into electrical signals 79 80 81 82 83 00000 84 85 86 87 88 3c 00000 c. To translate the broadcast signals into pictures and sound 79 80 81 82 83 00000 3d O O O O O O 79 80 81 82 83 d. To convert what we hear into electrical signals 00000 84 85 86 87 88 e. To record video and audio signals on recording media 3e 00000 79 80 81 82 83 00000 84 85 86 87 88 3f 00000 f. To control the picture quality of the television cameras 79 80 81 82 83 00000 84 85 86 87 88 PAGE

g. To reproduce the line-out sound

3g ○ ○ ○ ○ ○ ○ ○ 79 80 81 82 83 00000 84 85 86 87 88

h. To display the line-out pictures

3h 00000 79 80 81 82 83 00000

84 85 86 87 88

84 85 86 87 88

i. To display the pictures supplied by the various video sources

00000 79 80 81 82 83 00000

j. To select video inputs

O O O O O O 79 80 81 82 83 00000

© 2009 Wadsworth Cengage Learning

REVIEW QUIZ

Mark the following statements as true or false by filling in the bubbles in the \boldsymbol{T} (for true) or \boldsymbol{F} (for false) column.

			T	F
1.	The switcher allows for instantaneous editing.	1	89	90
2.	In the television studio, we use spotlights and floodlights.	2	91	92
3.	Digital memory devices (flash cards) can be used to record video segments.	3	93	94
4.	The primary function of the C.G. is to enhance picture quality.	4	95	96
5.	A microphone converts sound into electrical signals.	5	97	98
6.	Linear editing involves copying shots onto another videotape in a specific order.	6	99	100
7.	At least two VTRs are needed for nonlinear postproduction editing.	7	O 101	102
8.	With nonlinear editing you edit directly from the source tapes to the edit master tape.	8	103	104
9.	All audio consoles can select the signals from multiple incoming audio sources and control sound volume.	9	105	106
10.	A digital camcorder cannot use videotape as its recording media.	10	O 107	108

SECTION	
TOTAL	

PROBLEM-SOLVING APPLICATIONS

Think through each production problem and consider the various options. Then pick the most effective solution and justify your choice.

- 1. List in any order the major components (equipment) of the expanded television system that will allow you to produce and select optimal pictures from three studio cameras, produce optimal sound from four microphones, and video-record and simultaneously transmit the signals to a television receiver. Now order these components and connect them with lines that show the basic signal flow from cameras, microphones, and the various video and audio selections to the video recorder and the home television receiver.
- 2. List the components of a linear videotape-editing system that permits a dissolve; then draw a diagram that shows the basic signal flow for these components.
- **3.** What system elements are incorporated into a single camcorder? What are some of the advantages and the disadvantages of the camcorder system compared with those of the expanded television system?
- 4. What exactly distinguishes ENG from EFP?
- **5.** Apply the effect-to-cause model to a variety of goal-directed programs. Pay particular attention to a precise process message.
- **6.** How does a clearly stated process message help with the medium requirements?
- 7. List two alternative tapeless recording options and describe the advantages and the disadvantages of each.

THE THE STATE OF T

2

The Producer in Preproduction

REVIEW OF KEY TERMS

Match each term with its appropriate definition by filling in the corresponding bubble.

- 1. target audience
- 4. demographics
- 7. share

2. program proposal

3. time line

- 5. production schedule
- 8. rating
- 6. psychographics
- 9. treatment
- **A.** Audience factors concerned with such data as age, gender, marital status, and income

B. Viewers identified to receive a specific message

- **C.** The calendar dates for preproduction, production, and postproduction activities
- **D.** Percentage of television households tuned to a specific station in relation to the total number of television households
- D 0 0 0 0 0 0 1 2 3 4 5 0 0 0 0
- **E.** Percentage of television households tuned to a specific station in relation to all HUT

P A G E T O T A L

- 1. target audience
- 2. program proposal
- 3. time line
- 4. demographics
- 5. production schedule
- 6. psychographics
- 7. share
- 8. rating
- 9. treatment
- F. Written document that outlines the process message and the major aspects of a television presentation
- G. A breakdown of time blocks for various activities on the actual production day

H. Narrative description of a television program

- $\bigcirc \bigcirc \bigcirc \bigcirc \bigcirc \bigcirc \bigcirc \bigcirc \bigcirc \bigcirc$ 6 7 8 9
- Audience factors concerned with such data as consumer buying habits, values, and lifestyles

PAGE	
SECTION	

REVIEW OF PREPRODUCTION PLANNING: GENERATING IDEAS

- 1. Expand three of the following four clusters according to the key word. Develop a precise process message for each. Choose the key word for the fourth cluster and develop its process message accordingly.
 - a. cluster 1

Process message: __

b. cluster 2					
	Peace				
	(Peace)			
Process message:					
	140				
			and the second		

c. cluster 3

Alternative energy sources

Process message: _

d. cluster 4 (on a subject of your choice)		
	•	
Process message:		

REVIEW OF EVALUATING IDEAS

Select the correct answers and fill in the bubbles with the corresponding numbers.

1. In the preproduction flowchart below, match the unmarked steps with the corresponding numbers.

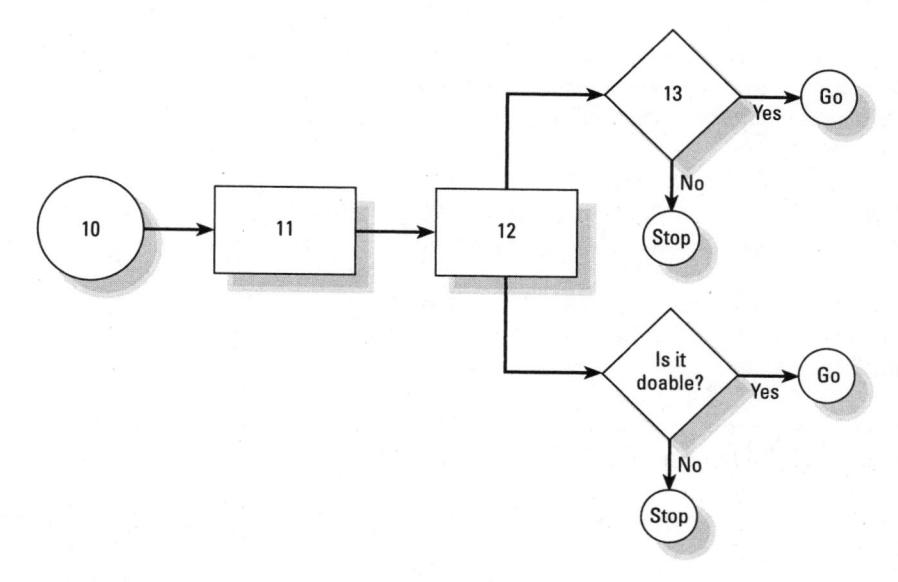

- a. angle
- b. idea
- c. worth doing?
- d. process message

- 1a O O O O O 10 11 12 13
- **1b** $\bigcirc \bigcirc \bigcirc \bigcirc \bigcirc$ \bigcirc \bigcirc \bigcirc \bigcirc \bigcirc 10 11 12 13
- 1c O O O O
- 1d O O O O O 10 11 12 13

© 2009 Wadsworth Cengage Learning

SECTION

	REVIEW OF PROGRAM PROPOSAL				
Sel	ect the correct answers and fill in the bubbles with the corresponding numbers.				
1.	The standard program proposal usually contains a (14) description of the target audience (15) list of studio or remote equipment (16) program objective. (Multiple answers are possible.)	1	O 14	O 15	O 16
2.	A show treatment usually contains a (17) brief narrative description of what we see and hear (18) script sample with major visualization cues (19) one-page sample of the dialogue and the video and audio cues.	2	O 17	18	19
3.	A well-stated process message should (20) include the specific objective of the show (21) state the steps of moving from idea to finished show (22) describe the process of moving from idea to detailed script.	3	20	21	22
4.	A good description of the target audience should include (23) only demographic indicators (24) only psychographic indicators (25) both demographic and psychographic indicators.	4	O 23	24	O 25
5.	When preparing a budget for an outside client, you can skip the cost for (26) the writer (27) the equipment (28) neither the writer nor the equipment.	5	O 26	O 27	28
6.	In a large production, the daily activities are supervised by the (29) producer (30) executive producer (31) PA.	6	O 29	30	31
7.	Preproduction is necessary for (32) every production except ENG (33) studio productions only (34) EFP only.	7	32	33	34
8.	In the production schedule on the facing page, identify potential problems for each EFP shoot. From the list below, select the items that best describe the problems and fill in the corresponding bubbles. Most shoots have more than one problem. (Multiple answers are possible.)	*			
	(35) different talent; break in continuity				
	(36) different director and crew; potential break in style and continuity				
	(37) need for remote truck questionable relative to the production scope				
	(38) shooting time too late; will cause lighting and continuity problems in postproduction				
	(39) should be done in conjunction with similar previous activity or opening				
	(40) facilities request very late				
	(41) facilities request too late				
	(42) too little time allotted				
	(43) too much time allotted				
		Р	A G E		

3	Ξ
	<u>_</u>
-1	ñ
	۳
	_
- 3	Ф
- 0	
- 8	=
- 6	ä
- 6	\simeq
- 13	-
- 3	യ
- 0	_
	_
-	=
- 3	ч
- 11	$\overline{}$
	=
- 2	≤
- 3	S
-	ö
- 74	—
-	~
	<
-	_
C	S
- 0	_
- 0	_
c	V
- 3	
6	()
,	_

Show/Scene/ Subject	Date/Time	Location	Facilities	Talent/ Personnel
Leisure City SHOOT I OPENING	Aug. 8 8:30 am 4:30 pm	In Front of completed model home— Simple opening remarks, 1:00 min.	Normal EFP as per Eac, rea. Aug. 8	Talent: LYNNE Director: B.R. Crew A scheduled
Leisure City SHOOT 2	Aug. 9 12:30 pm 1:00 pm	Homes under construction. Show homes being constructed.	Special remote Truck, See equipment Eac. req. Aug. 8	Talent: LYNNE Director: B.R. Crew A scheduled
Leisure City SHOOT 3	Aug. 10 8:30 am 9:00 am	Interior of model home. Shows how Typical home looks and works inside.	Normal EFP as per Eac. req. Aug. 7	Tolent: LYNNE Director: B.R. Crew A scheduled
Leisure City SHOOT 4	Aug. 11 7:30 pm 10:30 pm	Homes under construction.	Normal EFP as per Eac, req. Aug.11	Tolent: SUSAN Director: JOHN HEWITT Crew B scheduled
Leisure City SHOOT 5	Aug. 12 8:00 pm 8:30 pm	In Front of completed model home— Simple closing remarks, 1:30 min.	Special remote Truck, See equipment Eac, req. Aug, 8	Talent: SUSAN Director: B.R. Crew A scheduled

- a. shoot 1
- **b.** shoot 2
- c. shoot 3
- d. shoot 4
- e. shoot 5

8a	35	36	37 0 42	38	39
8b	0	36	O 37 O 42	38	39
8c	35	36	O 37 O 42	38	39
8d	35	36	O 37 O 42	38	
8e	35	36	37 0 42	38	
P A	G T A	E [

SECTION TOTAL

REVIEW OF COORDINATION Select the correct answers and fill in the bubbles with the corresponding numbers. 1. The person principally responsible for all preproduction communication is the (44) director (45) executive producer (46) producer. 2. When coordinating an EFP on water conservation, you don't have to include in your preproduction memos the (47) technical personnel (48) sales department (49) PA. 0 3. In a typical television station, facilities requests are necessary (50) only if you are planning a new production (51) for every production except ENG (52) for the preproduction conference. 4. When sending your memos via e-mail, you must insist on a written response from (53) every person on your mailing list (54) technical personnel only (55) production people only.

REVIEW OF UNIONS AND LEGAL MATTERS

Select the correct answers and fill in the bubbles with the corresponding numbers.

- 1. The theater department of the local high school would like to play its video production of Arthur Miller's *Death of a Salesman* on a local TV station. The student actors (56) will (57) will not need AFTRA clearance.
- **2.** A potential sponsor would like a treatment of the proposed play of your humanities series. Sending the script instead is (58) *acceptable* (59) *not acceptable*.
- **3.** For each of the trade unions listed, mark whether it is a (60) *technical* or a (61) *nontechnical* union by filling in the appropriate bubble.
 - a. DGA
 - **b.** IBEW
 - c. SEG
 - d. SAG
 - e. WGA
 - f. AFTRA
 - g. IATSE
 - h. AFM
 - i. NABET

- 1 O O 56 57
- 2 0 0
- 3a O C
- 3b O O
- 3c O O
- 3d O O
- 3e O O
- 3f O O
- **3g** ○ 61
- 3h O O
- 3i O O 61

P A G E T O T A L

Determine whether each of the production cases below (62) <i>requires</i> or (63) <i>does not require</i> copyright clearance and fill in the appropriate bubble.	
a. using a recent CD recording of Bach's <i>Toccata and Fugue in F Major</i> as the theme for a show on architecture	4a \bigcirc
b. having your pianist friend play and record her own composition for use as a theme on your weekly music series	4b \bigcirc
c. taking close-ups of paintings in your news coverage of the local outdoor art festival	4c \bigcirc
d. using a record album cover as the background for your opening and closing titles on a music series	4d O O 63
e. using a recently published art book to make a digital scan of a church floor plan for your show on Baroque art	4e \bigcirc
f. using a sixteenth-century book to make a digital scan of a church floor plan for your Renaissance show	4f O O 63
g. using three different scenes of published plays as the basis for your series about acting for the video camera	4g ○ ○ 63
h. using a Beatles song as the theme for a historical documentary	4h O O 63
	PAGETOTAL
	SECTION
REVIEW OF RATINGS

Select the correct answers and fill in the bubbles with the corresponding numbers.

- 1. Share figures are usually (64) higher (65) lower than rating figures.
- 1 O O 64 65
- 2. A rating of 13 indicates that (66) 13 of 2,000 (67) 800 of 6,000 (68) 13 of 1,300 (69) total television households (70) of all households using television are tuned to your station. (Fill in two bubbles.)
- 2 O O O 68 O O
- 3. A share of 22 means that (71) 175 of 2,200 (72) 22 of 2,200 (73) 175 of 800 (74) total television households (75) of all households using television are tuned to your station. (Fill in two bubbles.)
- O O O 71 72 73 O O 74 75
- **4.** All rating services use (76) *audience samples* (77) *total populations* as a basis for their figures.
- 4 0 0

5. HUT is a factor in figuring (78) shares (79) ratings.

5 O O

© 2009 Wadsworth Cengage Learning

SECTION TOTAL

REVIEW QUIZ

Mark the following statements as true or false by filling in the bubbles in the T (for true) and F (for false) column 1. The two major criteria for evaluating program ideas are Is it doable? and How much does it cost? 2. Two of the important items of an effective program proposal are a treatment and a description of the target audience. 3. It is the writer who establishes the initial production process. 4. Once you have generated a worthwhile message, the producer can leave the day-to-day production details to the PA. 5. CDs sold in record stores are in the public domain, so you can use them for television productions without securing copyright clearance. 6. Budgets must include expenses for preproduction, production, and all postproduction activities as well as personnel. 7. A time line and a production schedule are the same thing. 8. Because production is primarily a creative activity, any type of production system would prove counterproductive. 9. Demographic descriptors help define the target audience. 10. A show treatment is necessary only for television documentaries. 11. The producer works only with nontechnical personnel. 12. Broadcast unions include technical personnel only. 13. The line producer is responsible primarily for budgets. 14 0 14. Whereas the budget is essential for a program proposal, a description of the target audience is not. 15. The facilities request for a specific production should contain equipment and technical facilities.

	0.40 17	
SECTION	V	
TOTA		

PROBLEM-SOLVING APPLICATIONS

- 1. The art director asks you, the producer, whether her floor plan will allow optimal camera traffic. Are you the right person to answer this question? If so, why? If not, who would be the appropriate person to answer this question?
- 2. Your new comedy series is shot multicamera-style in the studio. You intend to video-record the dress rehearsal and the uninterrupted live-recorded show for later on-air scheduling. The production manager suggests that you prepare a budget that includes a generous amount of money for postproduction editing. Do you agree with the production manager? If so, why? If not, why not?
- 3. Write an effective program proposal for one or more of the following ideas. The proposal should include these points: (1) program title, (2) target audience, (3) process message (objective), (4) show treatment, (5) ideal program time and broadcast or other distribution channel, and (6) tentative budget.
 - a. a series of shows about the effects of television on children
 - b. a weekly fashion show
 - c. a 10-week series about how to preserve water
 - d. a three-show series about your favorite sport
 - **e.** a five-show series for seventh- and eighth-graders about the dangers of drugs
 - f. a 10-part series about human dignity and happiness
 - g. a 10-part mini-documentary series about road rage and safe driving
 - a 10-part series about the life and the work of a classical composer or a contemporary rock composer
 - i. a 10-part series about the life and the work of your favorite sports figure
- 4. The local high-school video club has produced a music video, using magazine pictures that are synchronized with the latest recording of a rock band. The students plead with you to persuade the local cable company to put it on the air. What concerns, if any, do you have about airing this video recording? What can you do to accommodate the group's request?

3

The Script

REVIEW OF KEY TERMS

Match each term with its appropriate definition by filling in the corresponding bubble.

- 1. classical dramaturgy
- 2. event order
- 3. fact sheet
- 4. two-column A/V script
- 5. partial two-column A/V script
- single-column drama script
- 7. show format
- 8. goal-directed information
- A. Lists the items that have to be shown on-camera and their main features
- **B.** Used to describe a show for which the dialogue is indicated but not completely written out
- 3 O O O O O O O O

C. Program content intended to be learned by viewers

0 0 0 0 0

D. Traditional composition of a play

- **E.** Traditional script with audio information in the right column and video information in the left

P A G E T O T A L

- 1. classical dramaturgy
- 2. event order
- 3. fact sheet
- 4. two-column A/V script
- 5. partial two-column A/V script
- 6. single-column drama script
- 7. show format
- 8. goal-directed information
- F. Traditional format for dramatic television and motion pictures scripts
- G. The lineup of event details
- H. A list of routine show segments

F	0	2		
	5	0	0	0

G	0	\bigcirc 2	O 3	0
			0	

Н	0	0	3	0
		0		

P	A	G T A	E	

SECTION

REVIEW OF BASIC SCRIPT FORMATS

Select the correct answers and fill in the bubbles with the corresponding numbers.

- 1. Each of the following three figures (a through c) shows a script segment that contains some format errors. For each figure identify the specific format errors: (9) unnecessary camera instructions (10) video or audio instructions in wrong column (11) incomplete dialogue (12) unnecessary talent instructions (13) nonessential and confusing information. (Multiple answers are possible.)
 - a. fully scripted serial drama (excerpt only)

1a O O O O O O 9 10 11 12 13

GARY'S OFFICE: DAY

GARY is working intensely at his computer and ignores two telephone calls, when KIM bursts cheerfully into his office.

CUT TO CAMERA 3 WHEN KIM ENTERS

Let's go for coffee.

GARY (not looking up)

Don't have time.

KIM

Oh, shucks, make time.

GARY

You seem to be in a good mood today.

KIM

I'm always in a good mood...

GARY

[Says something about having to finish the report]

KIM

[Tries to persuade GARY to pay more attention to her]

CUE GARY TO STAND UP AND CUT TO CAMERA 1 WHEN HE GETS UP

PAGE TOTAL

b. standard A/V script of brief feature story on the value of books (excerpt only)

1b	0	0	0	0	0
			11		

Agency	Hot Stuff	Writer	Mary Smart
Client	Papermill Creek Publishing	Producer	Maurice Smart
Project	Book Promotion	Director	Chul Heo
Title	Books Are Alive!	Art Director	Buzz Palmer
Subject		Medium	EFP HDTV
Job #	011	Contact	Smart
Code #	HZWB10	Draft	2

VIDEO	AUDIO
CU Becky	BECKY:
	[No, books are certainly not dead.
	On the contrary, 20 percent more
	books were printed worldwide last
	year than in any previous year.]
Fade in sound of	Cue Becky to go to bookcase and look
printing presses	at some books.
CU of Peter. Must	PETER:
look annoyed.	[Says something about digital
	storage being so much better than
	clumsy books.]
Sound of books	BECKY:
being dropped	CU of her dropping books.
	Well, I think you are an ignorant
	nerd. How many books do you own?
	PETER:
	None!
Sound of Becky	
laughing	

P	A	G	E	
T	0	TA	1	

c. fact sheet

SHOW: Tech News DATE: Aug. 20 HOST: Larry W.

PROPS: New Extreme Printer (operational)

- 1. New super color laser printer.
- 2. Medium shot of open printer. Zoom in on ink cartridges. Prints are permanent. Will outlast Grandma's chemical photos.
- 3. Pan right to operating panel. Easy, intuitive operation. Just follow the instructions.
- 4. CU of operation manual.
- 5. CU of Larry:

LARRY: Let's do some printing right now and see how easy it is.

[Larry plugs printer into his laptop.]

Larry [looks enthusiastic]: As you can see, all I needed to do is access the picture on my laptop and click the Print command.

- 6. And it is quiet. [Larry cups his ears.]
- Extreme close-up of Larry.

LARRY: Be sure to take advantage of our introductory offer. But hurry! This once-in-a-lifetime opportunity expires on Thursday.

GO TO BLACK

1c 00000 9 10 11 12 13

SECTION TOTAL

REVIEW OF STORY STRUCTURE, CONFLICT, AND DRAMATURGY

Select the correct answers and fill in the bubbles with the corresponding numbers.

- 1. Select the most common four elements of the basic dramatic story structure: (14) theme, plot, story, characters (15) theme, plot, characters, environment (16) plot, characters, action, environment.
- 1 0 0 0
- 2. Read the following very brief treatment excerpts and indicate whether the conflicts are (17) plot-based or (18) character-based.
 - **a.** A drunk driver goes through a stoplight and hits a car in the intersection. By chance both drivers end up in the same emergency room. They begin discussing the physical danger of driving under the influence and the moral dilemma when somebody gets hurt.
 - b. A young doctor, who has been fascinated with Africa since elementary school, decides to switch from being a successful family care provider to an AIDS researcher at a San Francisco clinic. She finally can't bear the slow progress in the lab any longer and decides to make her first Africa trip to help stem the AIDS epidemic in Zwamumbu [fictitious name]. With the help of an international relief organization, she opens a clinic and, within a short time, has gained the respect and the love of hundreds of adults and children for the "miracles" she performs as a doctor. But during a political uprising of a neighboring warlord, the clinic is invaded and she is accidentally shot in the crossfire.
 - c. A young doctor is summoned by a world health organization to deliver AIDS medicine to a Zwamumbu international health clinic. This is a highrisk mission because the president of Zwamumbu has prohibited any use of AIDS medication. His justification is one of denial. In his words: "We do not have AIDS in our country." After several scary moments, such as the search at airport customs, the doctor not only manages to deliver the medicine but also helps administer it to the children who are already HIV infected. The president's secret service people learn about her activity and get permission to assassinate her. Despite tight security at the clinic, the order is carried out successfully. Posing as an AIDS patient, the assassin confronts the young doctor and, repeating the president's statement, shoots her.

2a	0	C
	17	18

2b	0	0
	17	18

2c	0	0
	17	18

P A G E T O T A L

3. Fill in the bubbles whose numbers correspond with the numbers in the diagram below, identifying the various principal developmental steps of a classical dramaturgy.

- a. rising action and additional conflicts
- b. resolution
- c. climax
- d. exposition
- e. falling action and consequences of major crisis
- f. point of attack

	19 O 22	20 ○ 23	21 0 24
3b	O	O	O
	19	20	21
	O	O	O
	22	23	24
3c	O	O	O
	19	20	21
	O	O	O
	22	23	24
3d	O	O	O
	19	20	21
	O	O	O
	22	23	24
3e	O	O	O
	19	20	21
	O	O	O
	22	23	24
3f	O	O	O
	19	20	21
	O	O	O
	22	23	24

A	GE	
ГО	TAL	

SECTION TOTAL

© 2009 Wadsworth Cengage Learning

REVIEW QUIZ

Mark the following statements as true or false by filling in the bubbles in the T (for true) and F (for false) column.

- 1. The script is an effective communication device for all three production
- 2. The fact sheet and the show format have identical script formats.
- 3. The process message is especially useful for programs that contain primarily goal-directed information.
- 4. The standard two-column A/V script shows the video information on the right side and the audio information on the left.
- 5. The difference between a standard two-column A/V script format and a partial two-column A/V script is that the latter contains no video information.
- 6. A plot can develop from outside-in or from inside-out.
- 7. The from-inside-out plots are primarily character-based.
- 8. In a classical dramaturgy, the point of attack marks the first major crisis.
- 9. The rising as well as the falling action can include a number of crises.
- 10. In the resolution phase, the hero is always condemned.
- 11. In a goal-directed program, the basic idea should lead to a precise process message.

	Т	F
1	0	C
	25	26

SECTION

PROBLEM-SOLVING APPLICATIONS

- **1.** Analyze three or four programs of a dramatic medical series and see whether the conflicts are character-based, plot-based, or both. Justify your analyses.
- 2. How can you use plot to develop character?
- **3.** Write a treatment of a one-hour special that includes all six elements of the classical dramaturgy.
- **4.** Analyze a single program of a dramatic or comedy series and list all situations (verbal or action) that create an obvious conflict.

Salahan in territoria

TO WASTE DO NOT BUILD WITH MAY BEEN THAT

Plant to the company of the continue of the co

This search of the second seco

and the second of the second property of the

B. There are great convicted and the resemble of the second of the secon

en de la company de la completa de la co Date

Name

4

Analog and Digital Television

REVIEW OF KEY TERMS

Match each term with its appropriate definition by filling in the corresponding bubble.

- 1. progressive scanning
 - g

12. codec

- 2. streaming
- 8. compression
- 13. aspect ratio

- 3. downloading
- 9. 720p

7. HDTV

14. refresh rate

4. field

10. 1080i

15. sampling

- 5. frame
- 11. analog 16. RGB
- 6. interlaced scanning
- **A.** A television standard with at least twice the picture detail of standard television
- 1 2 3 4 0 0 0 0 5 6 7 8 0 0 0 0 9 10 11 12 0 0 0

B. Delivering and receiving digital video as continuous data

3 O O O O O 1 2 3 4

13 14 15 16

- 0 0 0 0 5 6 7 8
 - 9 10 11 12
 - 0 0 0 0
- **C.** A system in which the electron beam starts scanning line 1, then line 2, then line 3, and so forth until all lines are scanned
- - O O O O
- P A G E T O T A L

- 7. HDTV 12. codec 1. progressive scanning 2. streaming 8. compression 13. aspect ratio 3. downloading 9. 720p 14. refresh rate 4. field 10. 1080i 15. sampling 11. analog 16. RGB 5. frame 6. interlaced scanning
- D. The scanning of all odd-numbered scanning lines and the subsequent scanning of all even-numbered lines
- **E.** The temporary rearrangement or elimination of redundant picture information for easier storage and signal transport

F. The transfer of files sent in data packets

G. One-half of a complete scanning cycle, with two of them necessary for a complete television frame

P A G E T O T A L

H. A complete interlaced scanning cycle

The basic colors of television

J. Progressive HDTV scanning system

K. A two-field interlaced scanning system for HDTV

- K 0000 1 2 3 4 0000 5 6 7 8 0000 9 10 11 12 0000 13 14 15 16
- L. Selecting from an analog system a great many equally spaced signal values
- L 0000 1 2 3 4 0000 5 6 7 8 0000 9 10 11 12 0000 13 14 15 16

P A G E T O T A L

- 1. progressive scanning 2. streaming 3. downloading 4. field
- 7. HDTV 8. compression 9. 720p
- 12. codec
- 13. aspect ratio
- 14. refresh rate
- 10. 1080i
- 15. sampling

- 6. interlaced scanning
- 11. analog 5. frame
- 16. RGB
- M. The width-to-height proportion of a television screen

N. Stands for compressing and decompressing digital data

O. The number of complete frames per second

P. Signal that fluctuates like the original stimulus

- M 0000 1 2 3 4 0000 0000 9 10 11 12
 - 0000 13 14 15 16
- N 0000 1 2 3 4 0000
 - 5 6 7 8 0000 9 10 11 12
 - 0000 13 14 15 16
 - 0 0000 1 2 3 4
 - 0000 5 6 7 8
 - 0000 9 10 11 12
 - 0000 13 14 15 16
 - 0000 1 2 3 4
 - 0000 5 6 7 8
 - 0000 9 10 11 12
 - 0000 13 14 15 16

PAGE TOTAL SECTION

REVIEW OF ANALOG AND DIGITAL TELEVISION

Select the correct answers and fill in the bubbles with the corresponding numbers.

- 1. Digital television (17) must use interlaced scanning (18) must use progressive scanning (19) can use either of the two systems.
- 2. The four major steps of digitizing an analog signal are (20) quantizing (21) analyzing (22) aliasing (23) anti-aliasing (24) compression (25) sampling (26) scanning (27) digital-to-analog conversion (28) coding. (Fill in four bubbles.)
- 3. The aspect ratio for wide-screen HDTV is (29) 4×3 (30) 16×9 (31) 16×4 .
- **4.** The standard television (STV) format is (32) 4×3 (33) 9×3 (34) 16×9 .
- 5. Standard NTSC television uses a (35) progressive (36) interlaced (37) compressed scanning system.
- 6. One of the major advantages of digital television is that (38) it still uses analog signals (39) its picture does not deteriorate over numerous generations (40) it always uses interlaced scanning.
- 7. Which of the diagrams below represents most appropriately a digital signal?

8. The two operational DTV systems are (44) 1080i (45) 1280p (46) 720p. (Fill in two bubbles.)

8	0
	44

0	
45	

19

0

31

0

34 0

0

0

00000 20 21 22 23 24

27 28

0

30

0

33

0

39

0000 26

0

29

0

32

© 2009 Wadsworth Cengage Learning

SECTION

REVIEW OF BASIC IMAGE CREATION AND THE COLORS OF THE VIDEO DISPLAY

Select the correct answers and fill in the bubbles with the corresponding numbers.

1.	The basic television image is created by an electron beam by scanning (47) pixels that are arranged in a stack of horizontal lines (48) vertical rows only (49) neither.	1	47	48	O 49
2.	All the colors that you see on the television screen are a mixture of (50) red, green, and yellow (51) red, blue, and yellow (52) red, green, and blue.	2	50	51	52
3.	The scanning of a single field takes (53) ½0 (54) ½0 (55) ½0 second.	3	53	O 54	O 55
4.	In progressive scanning, each scanning cycle produces (56) a field (57) a frame (58) an interlaced field.	4	56	57	58
5.	The scanning of a complete NTSC frame takes (59) 1/30 (60) 1/60 (61) 1/20 second.	5	O 59	60	61
6.	HDTV can use (62) interlaced and progressive scanning (63) only interlaced scanning (64) only progressive scanning.	6	62	63	64
7.	In progressive scanning (65) only the even-numbered lines are scanned (66) only the odd-numbered lines are scanned (67) each line is scanned in a top-to-bottom sequence.	7	65	66	67
8.	The refresh rate in progressive scanning (68) is fixed at 30 fps (69) is fixed at 60 fps (70) can be variable.	8	68	69	70
9.	All other factors being equal, the highest-quality HDTV pictures are delivered by the (71) 480p system (72) 720p system (73) 1080i system.	9	O 71	O 72	73

SECTION	
TOTAL	

REVIEW QUIZ

Mark the following statements as true or false by filling in the bubbles in the T (for true) or F (for false) column.

- 1. Digital signals are more robust but less complete than analog signals.
- 2. In the digital process, sampling must precede quantizing.
- 3. Assigning 0's and 1's to the sampled signal is part of anti-aliasing.
- 4. All digital video signals must be compressed before they can be recorded.
- 5. A codec is a specific compression system.
- 6. RGB are the basic primary colors of analog as well as digital television.
- 7. Analog recordings can tolerate more tape generations without noticeable loss than digital recordings.
- 8. The 16×9 aspect ratio is especially advantageous for showing widescreen movies.
- 9. Downloading allows you to view continuous images and sound while the process is ongoing.
- 10. All flat-panel displays use the LCD system.

PROBLEM-SOLVING APPLICATIONS

- 1. Your editor tells you that, contrary to sampling, which is an essential step in the digital process, compression is not compulsory. Do you agree with the editor? If so, why? If not, why not?
- 2. The same editor insists on all-digital equipment with as high a sampling ratio and as little compression as possible because your projects require extensive postproduction with a great number of complex effects. What is your reaction? Why?
- 3. Your friend, an ardent movie fan, is extremely happy about the new 16 x 9 aspect ratio because, according to him, it is especially well suited to playing back wide-screen movies. Do you agree with him? If so, why? If not, why not?
- **4.** Your organization intends to deliver video content via the Internet. Some members of the organization want the content streamed; others think that downloading is a better choice. List a few justifications for each argument.
- 5. Briefly list and explain the four-step process of digitization.
- 6. You have been asked to select one of the HDTV systems (720p or 1080i) for your television studio. Describe each and justify why you would choose one over the other.

5

The Television Camera

REVIEW OF KEY TERMS

Match each term with its appropriate definition by filling in the corresponding bubble.

- 1. camera control unit
- 2. camera chain
- 3. HDTV camera
- 4. resolution
- 5. pixel

- 6. sync generator
- 7. white balance
- 8. imaging device
- 9. beam splitter
- 10. standard television
- 11. high-definition video
- 12. hue
- 13. saturation
- 14. brightness
- A. The smallest single imaging element
- **B.** How much light a color reflects; how dark or light a color appears on a black-and-white television screen
- C. The sensor mechanism in a camera that changes light into electrical energy

11 12 13 14

11 12 13 14

P A G E T O T A L

11. high-definition video 1. camera control unit 6. sync generator 7. white balance 12. hue 2. camera chain 3. HDTV camera 8. imaging device 13. saturation 4. resolution 9. beam splitter 14. brightness 5. pixel 10. standard television D. A unit, separate from the camera, that is used to process signals coming from and going to the camera to ensure optimal television pictures 00000 6 7 8 9 10 0000 11 12 13 14 E 00000 E. Part of the camera chain; produces electronic synchronization signal 1 2 3 4 5 00000 6 7 8 9 10 0000 11 12 13 14 00000 F. A video camera that delivers superior resolution, color, and contrast 1 2 3 4 5 00000 6 7 8 9 10 0000 11 12 13 14 G 00000 G. The camera connected with the CCU, power supply, and sync generator 1 2 3 4 5 00000 6 7 8 9 10 0000 11 12 13 14 H 00000 H. The relative sharpness of the picture as measured by number of pixels 1 2 3 4 5 00000 6 7 8 9 10 0000 11 12 13 14 PAGE TOTAL

- Adjusting color circuits in a camera to produce a white color in lighting of various color temperatures

J. Color strength or richness

K. The color itself (such as red or yellow)

L. The television system based on NTSC scanning

- **M.** The television system that produces high-resolution pictures that are highly compressed
- N. Prism within a camera that separates white light into the three primary colors

© 2009 Wadsworth Cengage Learning

P A G E T O T A L

SECTION

REVIEW OF BASIC CAMERA ELEMENTS AND FUNCTIONS

Select the correct answers and fill in the bubbles with the corresponding numbers.

- 1. The three basic parts of the camera are (15) pedestal (16) viewfinder (17) VR (18) imaging or pickup device (19) lens (20) tally light. (Fill in three bubbles.)
- 2. Fill in the bubbles whose numbers correspond with the camera elements shown in the following figure.

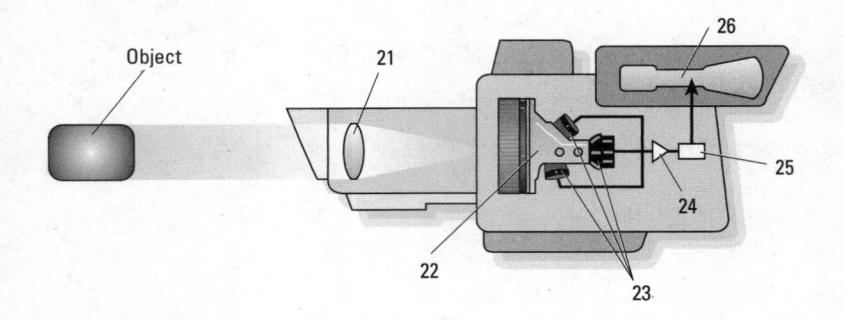

- a. converts signals back into visible screen images
- b. amplifies video signals
- c. transforms light into electric energy or video signals
- d. gathers and transmits the light
- e. splits the white light into red, green, and blue light beams
- f. processes video signal

1	O 15	16	0
	O 18	O 19	20

2a	O 21 O 24	O 22 O 25	23 0 26
2b	O 21 O 24	O 22 O 25	23 O 26
2c	O 21 O 24	O 22 O 25	23 O 26
2d	O 21 O 24	O 22 O 25	O 23 O 26
2e	O 21 O 24	O 22 O 25	23 0 26
2f	O 21 O 24	O 22 O 25	O 23 O 26

P A G E T O T A L

- 3. The camera imaging device is also called the (27) camera pickup device (28) chip (29) sensor. (Multiple answers are possible.)
- 3 0 0 0
- **4.** One of the following names describes a specific imaging device: (30) *CCU* (31) *CMOS* (32) *chip*.
- 4 0 0 0
- **5.** In some cameras the prism block is replaced by a (33) *CCD* (34) *lens* (35) *striped or mosaic filter array.*
- 5 0 0 0
- 6. The three basic parts of the camera chain are the (36) power supply (37) viewfinder (38) lens (39) sync generator (40) camera head (41) prism black (Fill in three bubbles).
- 0 0 0
- block. (Fill in three bubbles.)
- 36 37 38 O O O
- 7. To adjust a studio camera to produce optimal pictures, the VO must operate the (42) CCU (43) CCD (44) HDV.
- 39 40 41
- **8.** Digital cinema uses (45) 35mm film cameras (46) digital film cameras (47) high-end HDTV cameras.
- 42 43 44

0	0	0
45	46	47

© 2009 Wadsworth Cengage Learning

P A G E T O T A L

REVIEW OF ELECTRONIC OPERATIONAL FEATURES

Select the correct answers and fill in the bubbles with the corresponding numbers.

- Most HD cameras let you switch between the aspect ratios of (48) 4 x 9 and 16 x 9 (49) 4 x 3 and 16 x 9 (50) 4 x 9 and 16 x 3.
 Most cameras allow you to switch between these audio standards:

 1 O 48
 49

 48

 49
- 3. Short-distance cables commonly used for transporting digital signals are (54) IEEE 1394 and HDMI (55) FireWire and triax (56) triax and fiber-optic.
- **4.** XLR connectors are used for (57) audio cables only (58) audio and video cables (59) digital video cables only.
- 5. A focus-assist feature is (60) identical to auto-focus (61) especially important for focusing HDTV cameras (62) especially important for focusing small STV camcorders.

SECTION	
0 - 0 0	
TOTAL	
IOIAL	

0

0

0

62

REVIEW OF RESOLUTION, **CONTRAST, AND COLOR**

Select the correct answers and fill in the bubbles with the corresponding numbers.

- 1. Spatial resolution is determined by the number of (63) frames per second (64) scanning lines and pixels per line (65) vertical lines only.
- 0 0 0

0

- 2. Temporal resolution is determined by the (66) number of frames per second (67) relative speed of the moving object (68) number of horizontal lines.
- 67
- 3. In video "shading" means (69) controlling contrast (70) adjusting the lighting for more shadows (71) creating falloff electronically.
- 0 0 0 70 71
- 4. Contrast is a function of (72) hue (73) saturation (74) brightness.

0 0 72 73 74

5. The primary additive colors are (75) CMY (76) RGB (77) LED.

0 0 0 75 76 77

0

0

- 6. Television uses (78) additive color mixing (79) color filter mixing (80) subtractive color mixing.

0

- 7. The television color signal is processed as (81) luminance and brightness (82) luminance and chrominance (83) chrominance and color channels.
- 0 0 0
- 8. The Y signal is responsible for the (84) brightness (85) color (86) saturation information.
- 0 0 0
- 9. The C signal is responsible for the (87) brightness (88) color (89) saturation information.
- 0 0 87
- 10. White-balancing adjusts the (90) C channel (91) Y channel (92) z-axis.
- 0 10

© 2009 Wadsworth Cengage Learning

SECTION

REVIEW QUIZ

Mark the following statements as true or false by filling in the bubbles in the T (for true) and F (for false) column.

- 1. You can use a neutral density filter to reduce the intensity of bright light.
- 2. Digital data can be transferred by FireWire but not with an HDMI cable.
- 3. An XLR plug is an audio connector.
- 4. An S-video cable does not carry audio signals.
- 5. A 720p scan has a higher temporal resolution than a 480p scan.
- 6. White-balancing adjusts the Y signals.
- 7. RCA phono connectors can be used for digital video as well as audio signals.
- 8. A CMOS chip is similar in function to a CCD.
- 9. The camera imaging device transduces (changes) electrical energy into light.
- 10. Generally, studio cameras have higher-quality lenses than ENG camcorders.

1	T O 93	F 0 94
2	95	96
3	97	98
4	99	100
5	0	102
6	103	104
7	105	106
8	O 107	108

109

0

111

10

110

0

112

SECTION	
TOTAL	

PROBLEM-SOLVING APPLICATIONS

- 1. List and describe four major features that distinguish a professional camcorder from a consumer camcorder.
- 2. When on an ENG assignment, you are forced to shoot in an extremely dark environment. There is no time to turn on any auxiliary lights, and your camcorder is not equipped with a camera light. What, if anything, can you do to produce visible images however noisy they may be?
- 3. When moving from indoor studio lighting to midday outdoor light, the field reporter tells you not to worry about white-balancing the camera again because the outside light of the foggy day seems to match the studio lighting anyway. What is your response? Why?
- **4.** When watching a rehearsal of a dance company, the TD expresses concern because the dancers wear white leotards while performing a number in front of a black background. Is the TD's concern justified? If so, why? If not, why not? What are your recommendations?
- 5. The TD tells the camera operator that a high shutter speed needs a considerable amount of light. What does the TD mean by shutter speed? When do you need a high shutter speed? How, if at all, is it related to light levels?
- 6. Draw and describe the parts of the camera chain and their primary functions.

s	EC	т	10	N		
T	0	T	A	L		

© 2009 Wadsworth Cengage Learning

2. The generalization because the product of the configuration of the co

6

Lenses

REVIEW OF KEY TERMS

Match each term with its appropriate definition by filling in the corresponding bubble.

- 1. aperture
- 2. depth of field
- 3. fast lens
- 4. focal length
- 5. f-stop
- 6. field of view
- 7. normal lens
- 8. slow lens
- 9. wide-angle lens
- 10. zoom lens
- 11. calibrate
- 12. zoom range
- **A.** Variable-focal-length lens, which can change from a wide shot to a close-up and vice versa in one continuous movement
- A O O O O O O O O O O O
 - 5 6 7 8
- **B.** The area in which all objects, located at different distances from the camera, appear sharp and clear

O O O O O 9 10 11 12

- **C.** The calibration on the lens indicating the diaphragm opening—and therefore the amount of light passing through the lens

9 10 11 12

- **D.** The general lens focal length that approximates the spatial relationships of normal vision

P A G E T O T A L

- 5. f-stop 9. wide-angle lens 1. aperture 2. depth of field 6. field of view 10. zoom lens 7. normal lens 11. calibrate 3. fast lens 8. slow lens 12. zoom range 4. focal length E. The distance from the optical center of the lens to the front surface of the camera imaging device F. The extent of a scene that is visible through a particular lens G. A lens that at its maximum aperture permits a relatively great amount of light to enter and pass through
- to enter and pass through
 I. Same as short-focal-length lens, which gives a broad view of a scene
 J. Lens opening measured in f-stops

H. A lens that at its maximum aperture permits a relatively small amount of light

- E 0 0 0 0 0 1 2 3 4
 - 0 0 0 0 5 6 7 8 0 0 0 0 9 10 11 12
- F 0 0 0 0 1 2 3 4 0 0 0 0 0 5 6 7 8 0 0 0 0

9 10 11 12

- 1 0 0 0 0 1 2 3 4 0 0 0 0 5 6 7 8

9 10 11 12

P A G E

K. Shown in a focal-length ratio, such as 20:1

K O O O O 1 2 3 4 0000 5 6 7 8 O O O O 9 10 11 12

L. To make a lens keep focus throughout the zoom

 $\bigcirc \ \bigcirc \ \bigcirc \ \bigcirc \ \bigcirc \ \bigcirc \ \bigcirc$ $5 \ 6 \ 7 \ 8$ O O O O 9 10 11 12

P A G E T O T A L

SECTION TOTAL

	CHARACTERISTICS OF LENSES				
Sel	ect the correct answers and fill in the bubbles with the corresponding numbers.				
1.	In an optical zoom, the focal length is adjusted by (13) shifting certain lens elements (14) shifting the pixels (15) moving the camera closer to or farther away from the object.	1	O 13	0 14	O 15
2.	In a digital zoom, the focal length is adjusted by (16) shifting certain lens elements (17) cropping the image while magnifying it to its original size (18) moving the camera closer to or farther away from the object.	2	O 16	O 17	18
3.	The focal length of zoom lenses that are built into small camcorders is generally (19) not long enough when zoomed in (20) not short enough when zoomed out (21) fixed while zooming.	3	O 19	20	21
4.	Zoom lenses used for sports coverage need (22) a higher zoom ratio than (23) a lower zoom ratio than (24) the same zoom ratio as those used for studio work.	4	O 22	23	24
5.	A wide-angle lens has a (25) long (26) normal (27) short focal length.	5	O 25	O 26	O 27
6.	Select the three variables that influence depth of field: (28) focal length of lens (29) zoom speed (30) focus (31) camera-to-object distance (32) lens aperture (33) focus mechanism. (Fill in three bubbles.)	6	28 O 31	O 29 O 32	30
7.	When presetting (calibrating) the zoom lens, you (34) zoom in all the way, focus on the target object, and zoom back (35) zoom out all the way to a long shot, focus on the target object, and zoom back in again.	7	34	35	
8.	Large apertures (iris openings) contribute to a (36) great (37) shallow depth of field.	8	36	37	
9.	A 15x zoom lens means that you can increase the focal length (38) 1.5 times (39) 15 times (40) 150 times in one continuous zoom.	9	38	39	O 40
10.	Given a fixed camera-to-object distance, short-focal-length lenses, or zoom lenses in the wide-angle position, have a relatively (41) <i>shallow</i> (42) <i>wide</i> (43) <i>great</i> depth of field.	10	41	O 42	43
11.	The area in which all objects, although located at different distances from the camera, are in focus is called (44) depth of focus (45) field of view (46) depth of field.	11	0 44	45	46
12.	Telephoto prime lenses, or zoom lenses in a narrow-angle position, have a relatively (47) <i>shallow</i> (48) <i>narrow</i> (49) <i>great</i> depth of field.	12	O 47	O 48	O 49

>	A	G	Е
	OT	- A	L
- 13. Assuming maximum aperture, a fast lens (50) transmits an image faster (51) transmits an image more slowly (52) permits more light to enter (53) permits less light to enter than does a slow lens.
- 13 0000 50 51 52 53
- 14. Assuming maximum aperture, a slow lens (54) transmits an image faster (55) transmits an image more slowly (56) permits more light to enter (57) permits less light to enter than does a fast lens.
- 14 0000 54 55 56 57
- **15.** In the diagram below, select the most appropriate f-stop number for each of the four apertures (a through d) and fill in the bubbles with the corresponding number.

a. (58) f/1.4 (59) f/5.6 (60) f/22

15a 🔾	0	C
58	59	60

b. (61) *f*/1.4 (62) *f*/2.8 (63) *f*/16

c. (64) f/1.4 (65) f/4 (66) f/16

d. (67) f/1.4 (68) f/8 (69) f/22

15d O	0	C
67	68	69

PAGE	
SECTION T	

5	ECTION	
Г	OTAL	

REVIEW OF HOW LENSES SEE

Select the correct answers and fill in the bubbles with the corresponding numbers.

- 1. To make a small room look larger, we use (70) a wide-angle (71) a narrow-angle lens.
- 2. To apply selective focus, we need (72) a great (73) a shallow depth of field.
- 3. A narrow-angle lens makes objects positioned at different distances from the camera look (74) *more* (75) *less* crowded than they really are and (76) *increases* (77) *decreases* the speed of an object moving toward or away from the camera. (Fill in two bubbles.)
- 4. A wide-angle lens (78) *increases* (79) *decreases* the illusion of depth and (80) *increases* (81) *decreases* the speed of an object moving toward or away from the camera. (Fill in two bubbles.)
- 5. The figure below shows the camera zoomed out all the way for a wide-angle view and focused on object A. Object B will probably be (82) in focus (83) out of focus. The depth of field is therefore (84) great (85) shallow. (Fill in two bubbles.)

6. The figure below shows the camera zoomed in all the way for a telephoto view and focused on object A. Object B will probably be (86) in focus (87) out of focus. The depth of field is therefore (88) great (89) shallow. (Fill in two bubbles.)

- 1 O O 71
- 2 0 0
- 3 O O 74 75 O O 76 77
- 4 O O 78 79 O O 80 81
- 5 O O 82 83 O O 84 85

6 O O 86 87 O O

P A G E T O T A L

7. The screen image below displays a (90) great (91) shallow depth of field.

0 90

8. The screen image below shows that the camera's zoom lens was in a (92) wide-angle (93) narrow-angle position.

0 0

9. The opening shot of a documentary on city politics shows the city hall through a piece of sculpture. The camera operator used (94) a wide-angle (95) a narrow-angle position.

PAGE	
TOTAL	

10. Your preview monitors for cameras 1, 2, and 3 display the following images. Assuming that all three cameras are positioned right next to one another, which is the approximate zoom position for each? Choose among (96) wide angle (97) normal and (98) narrow angle. Camera 1 Camera 2 Camera 3	10	C1	97 9 97 9 97 9	08
11. The figure below simulates (99) an optical zoom (100) a digital zoom.	11	99	100	
12. When zoomed in on traffic approaching the camera, the cars seem to move (101) faster than (102) about the same speed as (103) slower than they actually do.	12	0 101	102	103
13. Assuming that your image stabilizer is disengaged, you can avoid handheld camera wobbles by (104) zooming all the way in (105) zooming all the way out (106) keeping the zoom lens in the narrow-angle position.	13	104	105	106
14. The closer the camera is to the object, the (107) <i>shallower</i> (108) <i>greater</i> (109) <i>wider</i> the depth of field becomes.	14	0	108	109
15. In the screen image below, the zoom lens was in the (110) wide-angle (111) narrow-angle (112) normal zoom position.	15	110	0	O 112
DOUGH WEST PRINTED TO THE COUNTY	P A T O	G E		
	SEC	TAL		

REVIEW QUIZ

Mark the following statements as true or false by filling in the bubbles in the T (for true) or F (for false) column.

- **1.** Compared with an optical zoom, a digital zoom permits a higher zoom ratio without picture deterioration.
- 2 0 0

0

0

- 2. An object moving toward the camera looks faster than normal when shot with a wide-angle lens.
- 2 0 0

3. Depth of field is influenced only by the focal length of the lens.

- 3 O O
- **4.** Digital stabilizers can absorb all picture wobble when you are shooting a narrow-angle picture.
- 4 O O 120

5. A slow lens is one with a very low f-stop number, such as f/1.4.

- O O 121 122
- **6.** When covering a news story with an ENG/EFP camera, you are best off with a shallow depth of field because there are few, if any, focusing problems.
- 6 O O 123 124
- **7.** After the initial calibration of a zoom lens, you need to preset it again each time the distance from object to camera changes substantially.
- 7 0 0
- 8. We can dolly most easily when the lens is in the extreme wide-angle position.
- O O 127 128
- **9.** A zoom can be simulated by gradually enlarging the image's center portion.
- 9 O O 130
- **10.** Because a 1080i HDTV image has so many scanning lines, the lens quality is relatively unimportant.
- 10 O O 131 132

11. Digital and optical zooms work on the same principle.

- 11 O O
- **12.** Each time you stop a zoom from one extreme position to the next, you get a different focal length.
- 12 O O 135 136

13. Auto-focus and focus-assist features are the same.

- **13** O O 137 138
- **14.** When calibrating a zoom lens, you must first zoom in on the target object and focus and then zoom out.
- **14** O O 140

15. Depth of field increases as focal length decreases.

15 O O 141 142

		The second secon
-		
5	OTAL	
-		
88.8	UIAL	

PROBLEM-SOLVING APPLICATIONS

Let us now put the theory to work. You can observe the optical and performance characteristics of lenses easily by using a camcorder or a still camera that can accept various lenses. Think through each production problem and consider the various options; then pick the most effective solution and justify your choice.

- 1. Zoom all the way out with the camcorder, or attach a wide-angle lens (28mm or less focal length) to the still camera, and focus on an object 4 to 6 feet away from you. Look at the background objects (20 or so feet away from you). Are they visible? Do they appear in fairly sharp focus? Or are they blurred? Now do the same observations by zooming all the way in or by attaching a telephoto lens (with a focal length of 200mm) to the still camera. Explain depth-of-field characteristics.
- 2. When watching television or a movie, try to figure out what lenses were used for some of the shots. For example, when you see someone running toward the camera yet seemingly not getting closer, what lens was used? Or when you see the happy couple approach the dinner table through the flowers and the candles in the foreground, what lens was probably used, assuming that the couple, as well as the candles and the flowers, are in focus? Such observations will certainly help you become more aware of focal lengths and their effects.
- 3. You are the AD of a live telecast of a modern dance program, which is performed on a dimly lighted stage. The operators of the two key cameras express some concern about their lenses. The new lens of the handheld ENG/EFP camera 1 has a 25× zoom range and a maximum aperture of f/5.6. Although the lens was used successfully during the past three football games, the operator feels that it might be too slow for this type of application. Camera 2 has a 10× lens with a 2× range extender. Its maximum aperture is also f/5.6. Are the operators' concerns justified?
- 4. The novice director asks you, the operator of camera 3, to get the opening shot by zooming back slowly from an extreme close-up of the title of a book to an extreme wide shot that shows a large part of the studio (the other cameras, the floor manager, the overhead lighting) as the background for the opening titles. The director sets up the wide shot first to make sure that it shows enough of the studio. When your extreme-narrow-angle zoom lens position does not produce the desired close-up of the book title, he asks you to "simply pop in a range extender before we punch up your camera." What are the potential problems, if any? Be specific.
- 5. While shooting a dramatic program in the studio, the director notices that in your camera shot the focus on the background walls is very sharp. The director asks you to compose the shot so that the walls have a soft focus on them. What would you do?

7

Camera Operation and Picture Composition

REVIEW OF KEY TERMS

Match each term with its appropriate definition by filling in the corresponding bubble.

- 1. close-up
- 2. closure
- 3. cross-shot
- 4. field of view
- 5. headroom
- 6. noseroom
- 7. leadroom

- 8. over-the-shoulder shot
- 9. z-axis
- 10. monopod
- 11. arc
- 12. dolly
- 13. cant
- 14. truck

- 15. camera stabilizing system
- 16. robotic pedestal
- 17. tilt
- 18. quick-release plate
- 19. pan
- 20. studio pan-and-tilt head
- A. A single pole onto which you can mount a camera

B. Portion of a scene visible through a particular lens; its vista

P A G E T O T A L

	2. closure 9 3. cross-shot 10 4. field of view 1 5. headroom 1 6. noseroom 1	8. over-the-shoulder shot 9. z-axis 0. monopod 1. arc 2. dolly 3. cant 4. truck	16. 17. 18. 19.	camera stabilizing system robotic pedestal tilt quick-release plate pan studio pan-and-tilt head		
Э.	The space left in front of the screen	of an object or a person r	novin	g toward the edge of	C	0 0 0 0 0 0 1 2 3 4 5 0 0 0 0 0 0 0 0 0 0 0 0 0 0 0 0 0 0
Э.	Similar to the over-the-scompletely out of the s	shoulder shot except tha	t the	camera-near person is	D	○ ○
.	The space left between	n the top of the head and	the u	ipper screen edge	E	0 0 0 0 0 0 1 2 3 4 5 0 0 0 0 0 0 0 0 0 0 0 0 0 0 0 11 12 13 14 15 0 0 0 0 0 0 16 17 18 19 20
	Object or any part of it	seen at close range			F	○ ○

- **G.** The space left in front of a person looking toward the screen edge
- **G** 00000 1 2 3 4 5
 - 00000 6 7 8 9 10
 - 00000 11 12 13 14 15
 - 00000 16 17 18 19 20

H. Imaginary line extending from the lens to the horizon

- - 6 7 8 9 10
 - 00000 11 12 13 14 15 00000

16 17 18 19 20

Mentally filling in spaces of an incomplete picture

- 00000 1 2 3 4 5
 - 00000 6 7 8 9 10
 - 00000
 - 11 12 13 14 15 00000
- 16 17 18 19 20
- J. Camera looks at the camera-far person with the back and shoulder of the camera-near person in the shot
- 00000 1 2 3 4 5

 - 00000
 - 11 12 13 14 15 00000 16 17 18 19 20

- K. To move the camera laterally by means of a mobile camera mount
- 00000 1 2 3 4 5
 - 00000 6 7 8 9 10
 - 00000 11 12 13 14 15 00000
 - 16 17 18 19 20

					Janes Str.
P	Α	G	Е		
-	0 7	- ^			

- 8. over-the-shoulder shot 15. camera stabilizing 1. close-up system 9. z-axis 2. closure 16. robotic pedestal 10. monopod 3. cross-shot 17. tilt 4. field of view 11. arc 18. quick-release plate 5. headroom 12. dolly 19. pan 6. noseroom 13. cant 20. studio pan-and-tilt head 7. leadroom 14. truck
- L. To move the camera in a slightly curved dolly or truck
- M. Camera mount that helps produce jitter-free pictures even when the camera operator runs with it

N. To tilt a handheld camera sideways

O. To point the camera up or down

16 17 18 19 20

P A G E T O T A L

P. To move the camera toward or away from an object

- 00000 1 2 3 4 5 00000
 - - 00000 11 12 13 14 15
 - 00000 16 17 18 19 20

Q. Computer-controlled camera pedestal

S. Horizontal turning of the camera

- 0 00000 1 2 3 4 5
 - 00000 6 7 8 9 10 00000
 - 11 12 13 14 15 00000 16 17 18 19 20

- R. Mounting head for heavy cameras that permits extremely smooth movements
- 00000 1 2 3 4 5
 - 00000
 - 6 7 8 9 10 00000
 - 11 12 13 14 15 00000
 - 16 17 18 19 20
- 00000
- 1 2 3 4 5 00000
 - 6 7 8 9 10
 - 00000 11 12 13 14 15
 - 00000 16 17 18 19 20

T. Device to attach an ENG/EFP camera to the mounting head

- 00000 1 2 3 4 5
 - 00000
 - 6 7 8 9 10 00000
 - 11 12 13 14 15 00000
 - 16 17 18 19 20

P A G E T O T A L

SECTION

REVIEW OF CAMERA MOVEMENT AND CAMERA SUPPORTS

Select the correct answers and fill in the bubbles with the corresponding numbers.

1. Fill in the bubbles whose numbers correspond with the camera movements indicated in the following figure.

a.	dol	IV
u.	uoi	ı y

d. pan

b. truck

e. pedestal

c. tilt

f. arc

1a	O 21 O 24	22 0 25	23 0 26
1b	O 21 O 24	O 22 O 25	23 0 26
1c	O 21. O 24	O 22 O 25	O 23 O 26
1d	O 21 O 24	O 22 O 25	23 0 26
1e	O 21 O 24	O 22 O 25	23 0 26
1f	O 21 O 24	O 22 O 25	O 23 O 26

P A G E

(42) jib arm (43) robotic pedestal (44) camera stabilizing system.

2. The spreader (27) helps spread the tripod legs as much as possible 0 0 28 (28) minimizes the spread of the tripod legs (29) keeps the tripod legs from spreading too far. 3. The (30) jib arm (31) monopod (32) leveling bowl helps maintain a camera in 0 0 a horizontal position. 4. Mounting heads facilitate (33) smooth tilts and pans (34) dollies and trucks 0 0 (35) arcs and zooms. 5. A (36) wedge mount (37) robotic pedestal (38) quick-release plate makes it 0 possible to quickly detach an ENG/EFP camera from the tripod. 6. Compared with a tripod, a studio pedestal allows these additional camera 0 moves: (39) canting (40) raising and lowering the camera while on the air (41) dollying and trucking. (Multiple answers are possible.) 7. To simultaneously boom, tongue, pan, and tilt the camera, you need a 0 0

© 2009 Wadsworth Cengage Learning

P A G E T O T A L	
SECTION TOTAL	

43

42

	REVIEW OF HOW TO WORK A CAMERA				
Sel	ect the correct answers and fill in the bubbles with the corresponding numbers.				
1.	When dollying with a studio camera, or walking with an EFP camera, the depth of field should be as (45) great (46) shallow (47) narrow as possible.	1	O 45	O 46	O 47
2.	When dollying with a studio camera, or walking with an EFP camera, the zoom lens should be in a (48) <i>narrow-angle position</i> (49) <i>telephoto position</i> (50) <i>wide-angle position</i> .	2	48	49	50
3.	After having calibrated the zoom lens, you need to preset it again (51) only when the camera moves (52) only when the object moves relative to the camera (53) whenever camera or object moves relative to the other.	3	51	52	53
4.	During a test recording with your ENG/EFP camcorder, you should (54) leave the lens cap on but check the audio (55) make sure all camera features are working (56) ask the reporter to count to 10.	4	54	55	56
5.	When panning with a shoulder-mounted ENG/EFP camera, you should point your knees toward (57) the starting point of the pan (58) the end point of the pan (59) either direction.	5	57	58	O 59
6.	When operating a camcorder in the field, you should always have the camera mic (60) on (61) off (62) replaced by a shotgun mic.	6	60	61	62
7.	When loading a VTR cassette for recording, the safety tab (63) should be in place or in the closed position (64) should be removed or in the open position (65) does not matter because it is primarily meant for playback protection.	7	63	64	65
8.	When on an ENG assignment, you should record ambient sound (66) only if somebody is talking (67) always (68) only if there is no background noise.	8	66	67	68
9.	To calibrate a zoom lens (69) zoom in, focus, zoom out to shot (70) zoom out, focus, zoom in to shot (71) adjust focus continuously while zooming.	9	69	O 70	O 71
10.	You should lock the camera mounting head (72) every time you leave it (73) only when temporarily leaving the camera (74) at the end of the shoot.	10	O 72	O 73	O 74
11.	To achieve critical focus when operating an HDTV studio camera, you should (75) adjust the viewfinder's sharpness (76) engage the auto-focus feature (77) engage the focus-assist feature.	11	75	O 76	O 77
12.	When calibrating a zoom lens, the tally light should be (78) on (79) off (80) ignored.	12	O 78	79	80
		РА	G E		

- **13.** When trying to preserve battery power, you should switch off (81) only the foldout screen (82) only the image stabilizer (83) both the foldout screen and the image stabilizer.
- **14.** When operating the camcorder in EFP, you should engage the audio AGC (84) *always* (85) *never* (86) *only when necessary.*
- **15.** When operating a studio camera, the electronic adjustments for optimal picture quality are made for you by the (87) VO (88) TD (89) AD.
- 13 O O O S 81 82 83 83 84 85 86

0

0

15 🔾

© 2009 Wadsworth Cengage Learning

The state of the s	
PAGE	
TOTAL	
SECTION	
TOTAL	

REVIEW OF FRAMING EFFECTIVE SHOTS

1. Using the set of numbered images below, fill in the bubbles for each of the following fields of view or shot designations.

90

93

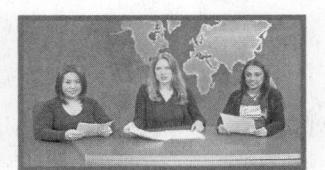

94

95

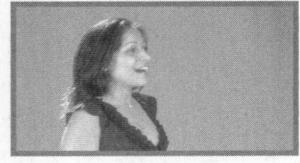

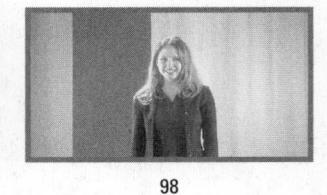

- a. ELS (extreme long shot)
- **b.** LS (long shot)

- 1a O O O O O O 90 91 92 93 94 0000 95 96 97 98
- 1b 00000 90 91 92 93 94 0000 95 96 97 98

PAGE TOTAL

- c. MS (medium shot)
- d. bust shot
- e. knee shot
- f. three-shot
- g. ECU (extreme close-up)
- h. CU (close-up)
- i. over-the-shoulder shot

- 1c 00000 90 91 92 93 94 0000 95 96 97 98
- 1d 0 0 0 0 0 90 91 92 93 94 0000 95 96 97 98
- 1e 00000 90 91 92 93 94 0000 95 96 97 98
- 1f 00000 90 91 92 93 94 0000 95 96 97 98
- 1g 00000 90 91 92 93 94 0000 95 96 97 98
- 1h 00000 90 91 92 93 94 0000 95 96 97 98
- 11 00000 90 91 92 93 94 0000 95 96 97 98

© 2009 Wadsworth Cengage Learning

 Evaluate the framing of shots in the next five figures by filling in the bubbles with the corresponding numbers. (Note: There may be more than one correct answer for some parts of a problem.)

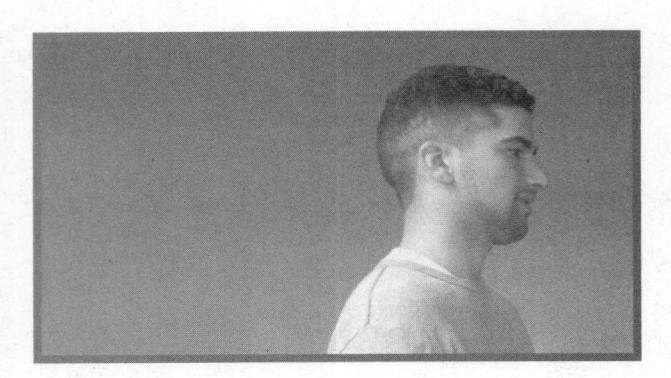

a. This shot is (99) acceptable (100) unacceptable because it has (101) sufficient noseroom (102) insufficient noseroom (103) sufficient headroom (104) insufficient leadroom. If unacceptable, you should (105) pan left (106) pan right (107) tilt up (108) tilt down (109) pedestal up (110) pedestal down.

b. This CU is (111) acceptable (112) unacceptable because it has (113) no headroom (114) too much headroom (115) adequate headroom (116) adequate noseroom. If unacceptable, you should (117) tilt up (118) tilt down (119) pan left.

2a	99		0	
	22		100	
		0		
	101	102	103	104
		0		
	105	106	107	
		0	STATE OF THE STATE	
	108	109	110	

2b	0		O 112	
		0	SHADOW SERVICE STATE OF THE SHADOW	Call Street, San Line
	_	0	_	

P A G E

c. This shot is (120) acceptable (121) unacceptable because it has (122) no headroom (123) too much headroom (124) no noseroom (125) no leadroom (126) insufficient clues for closure in off-screen space. If unacceptable, you should (127) tilt up (128) tilt down.

d. This over-the-shoulder shot is (129) acceptable (130) unacceptable. If unacceptable, you should (131) zoom out (132) pedestal up (133) arc left (134) arc right.

2d	129	130		
		132		

e. This shot is intended to emphasize the car's speed and risky driving. Its framing is, therefore, (135) acceptable (136) unacceptable. If unacceptable, you should (137) level the horizon line (138) zoom out.

2e	135	136	
	137	138	
P A	GETAL		

3. This framing is (139) acceptable (140) unacceptable in terms of closure.

4. This shot makes (141) *good* (142) *poor* use of screen depth. If depth improvement is needed, you should (143) *add* (144) *delete* foreground objects.

3	0	0
	139	140

4	0	0
	141	142
	0	0
	143	144

PT	A	G T A	E	
_				

© 2009 Wadsworth Cengage Learning

REVIEW QUIZ

Mark the following statements as true or false by filling in the bubbles in the T (for true) or F (for false) column.

- 1. The drag controls on a mounting head are used to lock down the camera.
- 2. Before the studio or remote production, you should check the tightest and widest field of view of the zoom lens from the principal camera position.
- **3.** Because an ENG camera can be shoulder-mounted, the operator has no need for a tripod.
- **4.** You should unlock the pan-and-tilt mechanism at the beginning of the show and lock it again every time you leave the camera unattended.
- 5. A robotic pedestal is motor-driven and remotely controlled.
- 6. The medium shot is also called a bust shot.
- **7.** Once balanced, the wedge mount ensures that the camera is mounted in an optimally balanced position for each subsequent use.
- **8.** If your camcorder has an LCD panel, you should use it to focus whenever possible.
- 9. Dolly and truck movements show up as similar movements on-screen.
- 10. HDTV cameras are easier to focus than standard cameras.
- 11. To boom up means to raise the camera pedestal.
- **12.** When operating an ENG/EFP camera, walking backward will make it easier to keep the camera steady than walking forward.
- 13. The studio pedestal permits very-low-angle shots.
- 14. Leadroom and noseroom fulfill similar framing (compositional) functions.
- 15. The jib arm and the camera crane can make the camera move in similar ways.
- **16.** Field of view refers to how far or close the object appears relative to the camera.
- 17. Tilting a shoulder-mounted camera sideways is called panning.
- 18. Psychological closure always ensures good composition.

	BEING CONTRACTOR
SECTION	
TOTAL	4

T

17 0

F

PROBLEM-SOLVING APPLICATIONS

- 1. Locate the pan and the tilt drag controls and the pan-and-tilt lock controls of the mounting head. Adjust them so that you can pan and tilt the camera as smoothly as necessary. When do you need to use the lock mechanism?
- 2. Pedestal up and down to see how high and low the camera will go. What can happen if you move the camera too fast to either end of vertical travel?
- **3.** You are to set up a tripod on an uneven, slightly sloping field. How can you make sure that the tripod and, with it, the EFP camera are level?
- 4. The director wants you to follow the new mayor up the flight of stairs in city hall without shaking the ENG/EFP camera. What camera mount would you suggest?
- 5. You are shooting a documentary-style program, and you don't have a tripod at the shoot. What focal length would be most effective if you want relatively steady shots? What other techniques could you consider for getting steady shots?
- 6. You have been asked to recommend the types of camera mounting equipment for a four-camera studio production. The director wants one camera to get a moving overhead shot and another camera that can physically move around the floor in a smooth arcing motion. The other two cameras will be shooting a variety of typical long shots and close-ups. Another consideration is that there will be only three camera operators available during the production. List the types of mounting equipment you would recommend for each camera and why.
- 7. During the remote coverage of the World Computer Fair, the novice director tells you to zoom in to an ECU of a computer display and then arc the tripod dolly around the display table to show the other computers. What are the potential problems, if any?
- 8. In a multicamera studio dance program, the same director tells you, the operator of camera 3, that you should listen only to calls that concern your camera and ignore commands to all the other cameras. Do you agree?

 If so, why? If not, why not?
- **9.** As you are leaving the studio, the producer states that a spare battery for your ENG/EFP camera is not needed because the story you are to cover will have, at best, a 20-second slot in the newscast. What is your response?
- **10.** The producer tells you to be sure to keep enough headroom when framing an ECU. Do you agree? Why? If not, why not?
- **11.** The director tells you, the camera operator, to change from an over-the-shoulder shot to a cross-shot. How can you accomplish such a shot change?

8

Audio: Sound Pickup

REVIEW OF KEY TERMS

Match each term with its appropriate definition by filling in the corresponding bubble.

- 1. cardioid
- 2. flat response
- 3. ribbon microphone
- 4. polar pattern
- 5. pickup pattern
- 6. condenser microphone
- 7. dynamic microphone
- 8. unidirectional
- 9. omnidirectional
- 10. impedance
- 11. frequency response
- 12. system microphone
- **A.** A microphone that can pick up sounds better from one direction—the front—than from the sides or back
- **B.** A microphone whose diaphragm consists of a plate that vibrates with the sound pressure against another fixed plate (the backplate)
- **C.** A microphone whose sound pickup device consists of a thin band that vibrates with the sound pressures within a magnetic field

P A G E T O T A L

10. impedance 2. flat response 6. condenser microphone 11. frequency response 3. ribbon microphone 7. dynamic microphone 8. unidirectional 12. system microphone 4. polar pattern D. The range of frequencies a microphone can hear and reproduce 0000 O O O O O 9 10 11 12 E O O O O E. A specific pickup pattern of unidirectional microphones 0000 0000 9 10 11 12 0000 A microphone that can pick up sounds equally well from all directions 1 2 3 4 0000 5 6 7 8 0000 9 10 11 12 G 0 0 0 0 1 2 3 4 G. The territory around the microphone within which the microphone can "hear" well, or has optimal sound pickup 0000 5 6 7 8 0000 9 10 11 12 H 0000 H. A microphone whose sound pickup device consists of a diaphragm that is 1 2 3 4 attached to a movable coil 0000 5 6 7 8 O O O O 9 10 11 12

9. omnidirectional

5. pickup pattern

1. cardioid

P A G E T O T A L

- I. The measure of a microphone's ability to hear equally well over its entire frequency range
- $\bigcirc \bigcirc \bigcirc \bigcirc \bigcirc \bigcirc \bigcirc$ $1 \quad 2 \quad 3 \quad 4$ 0000 5 6 7 8 O O O O 9 10 11 12

J. Uses a base and different heads for various pickup patterns

0000 5 6 7 8

O O O O 9 10 11 12

- K. The two-dimensional representation of a microphone pickup pattern
- $\bigcirc \bigcirc \bigcirc \bigcirc \bigcirc \bigcirc \bigcirc \bigcirc$ $5 \quad 6 \quad 7 \quad 8$ O O O O 9 10 11 12

L. A type of resistance to a signal flow: high-Z or low-Z

 $\bigcirc \ \bigcirc \ \bigcirc \ \bigcirc \ \bigcirc \ \bigcirc \ \bigcirc \ \bigcirc$ $5 \ \ 6 \ \ 7 \ \ 8$ 0000 9 10 11 12

© 2009 Wadsworth Cengage Learning

P A G E T O T A L

SECTION

REVIEW OF HOW MICROPHONES HEAR

1. Fill in the bubbles whose numbers correspond with the polar patterns in the figure below.

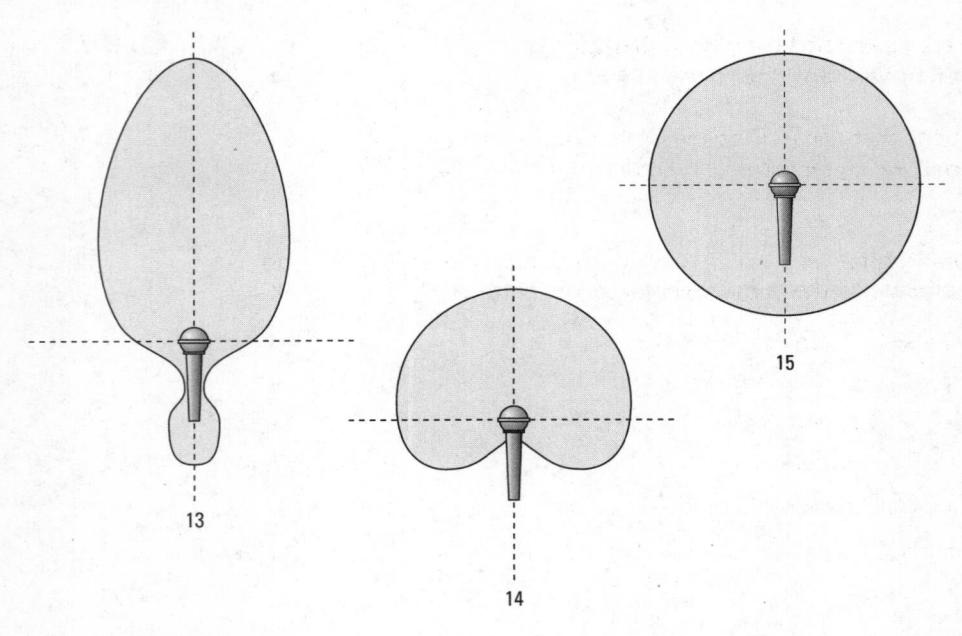

- a. omnidirectional
- b. cardioid
- c. hypercardioid

Select the correct answers and fill in the bubbles with the corresponding numbers.

- 2. In general, dynamic microphones are (16) more rugged than (17) less rugged than (18) equally sensitive as ribbon microphones.
- **3.** Normally, shotgun microphones have (19) an omnidirectional (20) an extremely directional (21) a nondirectional pickup pattern.
- 4. Select the three types of microphones as classified by their generating element: (22) dynamic (23) unidirectional (24) cardioid (25) ribbon (26) hypercardioid (27) condenser. (Fill in three bubbles.)
- **5.** To eliminate sudden breath pops when speaking close to the microphone, we use a (28) pop filter (29) windscreen (30) frequency filter.

	16	17	18
3	O 19	O 20	21
4	O 22 O 25	O 23 O 26	O 24 O 27
_	0	0	0

2 0 0 0

0

1a O

0

1c O

P A G E

29

30

- **6.** Microphones that require a battery or phantom power for their output signal are (31) *dynamic* (32) *ribbon* (33) *condenser.*
- 6 O O O O 31 32 33
- 7. The hand microphones used in ENG normally have (34) an omnidirectional (35) a cardioid (36) a hyper- or supercardioid pickup pattern.
- 7 0 0 0
- **8.** Faraway speech sounds are picked up best with (37) a shotgun mic (38) an omnidirectional hand mic (39) a ribbon mic.
- 8 O O O
- **9.** The element in a microphone that converts sound waves into an electrical signal is the (40) sound-generating element (41) sound amplifying chip (42) pickup device.
- 9 0 0 0
- **10.** The two-dimensional representation of a microphone's sound pickup area is the (43) safe area (44) polar pattern (45) pickup pattern.
- 10 0 0

© 2009 Wadsworth Cengage Learning

P A G E T O T A L	
SECTION	

	REVIEW OF HOW MICROPHONES ARE USED				
Sele	ect the correct answers and fill in the bubbles with the corresponding numbers.				
1.	The large shotgun microphone on a perambulator boom has (46) an omnidirectional (47) a cardioid (48) a hyper- or supercardioid pickup pattern.	1	46	O 47	48
2.	Two high-quality hand microphones that are normally used for singers are (49) dynamic (50) ribbon (51) condenser. (Fill in two bubbles.)	2	49	50	51
3.	The most appropriate mics for the voice pickup of a four-member news team (two anchors, a weathercaster, and a sportscaster) are (52) boom mics (53) desk mics (54) lavaliers.	3	52	53	54
4.	You are to set up microphones for a six-member panel discussion. All participants sit in a row at a table. Normally, you would use (55) boom mics (56) hand mics (57) desk mics for this production.	4	55	56	57
5.	When you're setting up the mics for a panel show, the audio engineer advises you to place them in such a way that they will not cause "multiple-microphone interference." This means that the mics must be placed so that they will not (58) block the faces of the panel members (59) cancel some of one another's frequencies (60) multiply the ambient noise.	5	58	59	60
6.	To achieve a good and efficient voice pickup during the video recording of four people sitting around a table in a small office, talking about effective sound handling in ENG/EFP, you should use a (61) <i>large shotgun mic</i> (62) <i>parabolic reflector mic</i> (63) <i>boundary mic</i> .	6	61	62	63
7.	Parabolic microphones are especially effective for picking up (64) faraway sounds (65) especially soft sounds (66) extremely close sounds.	7	64	65	66
8.	When doing a live report from an accident scene, the most practical mic is a (67) stand mic (68) lavalier mic (69) hand mic.	8	67	68	69
9.	The sound pickup of a dramatic scene of two people sitting at the dinner table is best done with a (70) fishpole and pencil mic (71) fishpole and large shotgun mic (72) plant mic.	9	70	71	72
		SE	CTION		

© 2009 Wadsworth Cengage Learning

REVIEW QUIZ

Mark the following statements as true or false by filling in the bubbles in the T (for true) or F (for false) column.

- 1. The parabolic reflector microphone is especially appropriate for intimate, high-quality sound pickup with a high degree of sound presence.
- **2.** A balanced mic cable is less susceptible to electronic interference than an unbalanced one.
- 3. Dual redundancy refers to a backup microphone in case a microphone fails.
- **4.** Dynamic mics are generally less sensitive to shock and temperature extremes than ribbon mics.
- **5.** Because the boundary, or pressure zone, microphone needs a sound-reflecting surface, it should not be used as a hanging mic.
- **6.** Because wireless microphones operate on their own frequency, they are immune to interference from other radio frequencies.
- 7. A windsock fulfills the identical function as a pop filter.
- 8. Blowing into a microphone is a good way to test whether it is turned on.
- 9. All professional microphones use three-pronged XLR connectors.
- 10. A hand mic clipped to a desk stand can serve as a desk mic.
- **11.** Because lavalier microphones are highly sensitive, they work best when hidden under a shirt or blouse.
- **12.** Using an impedance transformer (a direct box) allows you to play an electric guitar into a mixer.
- 13. Ribbon mics are especially good for the pickup of a bass drum.
- **14.** The pickup pattern of a system mic can be changed by attaching a different head.
- 15. Lavaliers can have a dynamic or condenser sound-generating element.

SECTION	
TOTAL	

0

0

0

77

0

0

0

87

0

0

11 0

0

0

13

15

14 0

10

0

0

0

0

0

0

0

0

0

0

0

0

0

98

0

100

0

102

PROBLEM-SOLVING APPLICATIONS

- 1. You are to provide optimal sound pickup for a preschool children's live-recorded show. The show consists of a host who moves among five to seven children seated on little chairs. The chairs are grouped around a small rug on which the children also play or dance from time to time. The dance music and other recorded audio portions are piped into the studio through the S.A. system. What microphone setup would you suggest for the host and the children? What problems might the S.A. system cause, if any?
- 2. You are in charge of audio for a show that consists of several intimate numbers by a singer and a small band. After the rehearsal an observer in the control room tells you that the singer holds the mic much too close to her mouth and that she should hold the mic lower and sing across rather than into it. What is your reaction? Why?
- 3. You are responsible for audio pickup for the live remote coverage at the airport during the Thanksgiving rush. Basically, you will have a host walking among the people waiting at the ticket counters, briefly interviewing some of the travelers. What type of mic would you use? Why?
- 4. An official at your former high school asks you to help with the audio for the championship basketball game. Somehow, so the official claims, the visiting spectators seem much louder on television than the home audience, although the latter is actually much larger and noisier than the guests. What can you do to accurately reflect the supportive cheering of the two sides? What specific microphone setups would you use?
- 5. You are doing a documentary on police patrols in your city. You first want to hear the conversation and the police radio inside the patrol car and then capture the sounds of conversations, yelling, or any other audio when the officers leave the patrol car to confront a suspect. What microphones would you need for optimal sound pickup in these situations?
- **6.** You are to conduct an interview with the university president in her office. What microphones would you use? Why?

Audio: Sound Control

REVIEW OF KEY TERMS

Match each term with its appropriate definition by filling in the corresponding bubble.

1. automatic gain control

4. digital audiotape

2. MP3

3. mixing

- 5. VU meter
- 6. equalization
- 7. sweetening
- 8. mix-minus
- 9. figure/ground
- 10. calibrate
- 11. sound perspective
- 12. ambience

- A. A common codec for digital audio
- B. Emphasizing the most important sound source over other sounds
- C. A variety of quality adjustments of recorded sound in postproduction

- 0000 9 10 11 12
- 0000 0000 5 6 7 8 0000 9 10 11 12
- 0000 5 6 7 8 0000 9 10 11 12

- 1. automatic gain control
 2. MP3
 3. mixing
 4. digital audiotape
 5. VU meter
 6. equalization
 7. sweetening
 8. mix-minus
 9. figure/ground
 10. calibrate
 11. sound perspective
 12. ambience
- D 0000 D. Regulates the audio or video levels automatically, without using pots 1 2 3 4 0000 5 6 7 8 0000 9 10 11 12 E 0000 E. Controlling the audio signal by emphasizing certain frequencies and 1 2 3 4 eliminating others 0000 5 6 7 8 0000 9 10 11 12 0000 F. Combining two or more sounds in specific proportions as determined by the 1 2 3 4 event context 0000 5 6 7 8 0000 9 10 11 12 G 0000 G. Far sounds go with long shots; close sounds with close-ups 1 2 3 4 0000 5 6 7 8 0000 9 10 11 12 H 0000 H. Making all VU meters respond in the same way to a specific audio signal 1 2 3 4 0000 5 6 7 8 0000 9 10 11 12

P A G E T O T A L I. Encodes and records sound signals in digital form

0000 0000

J. Measures the relative loudness of sound

- J 0 0 0 0 1 2 3 4 0000 5 6 7 8 0000
- K. Type of multiple audio feed missing the part that is being recorded
- 0000 5 6 7 8 0000 9 10 11 12

L. Environmental sounds

L 0000 1 2 3 4 $\bigcirc \ \bigcirc \ \bigcirc \ \bigcirc \ \bigcirc \ \bigcirc \ \bigcirc \ \bigcirc$ $5 \ \ 6 \ \ 7 \ \ 8$ 0000 9 10 11 12

P A G E T O T A L

SECTION TOTAL

REVIEW OF STUDIO AND FIELD AUDIO PRODUCTION EQUIPMENT

Select the correct answers and fill in the bubbles with the corresponding numbers.

- **1.** The trim control on the modules of studio consoles regulates the strength of the (13) *outgoing audio signal* (14) *final mix* (15) *incoming audio signal*.
- 2. All professional video-editing systems let you control and mix (16) only one audio track (17) two or more audio tracks (18) no audio tracks unless you interface it with special audio software.
- 3. A television audio console lets you (19) synchronize audio and video in postproduction (20) punch up the audio source with the corresponding video (21) adjust the volume of each audio input.
- **4.** The appropriate place that marks the beginning of the "overload zone" is (22) –5 VU (23) –2 VU (24) 0 VU.

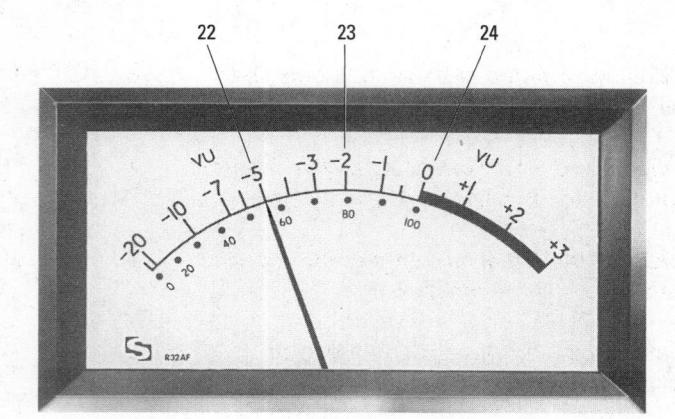

1	13	O 14	O 15
2	O 16	O 17	18
3	O 19	20	O 21
4	O 22	O 23	O 24

P A G E T O T A L **5.** Fill in the bubble whose number identifies the type of head in the head assembly below:

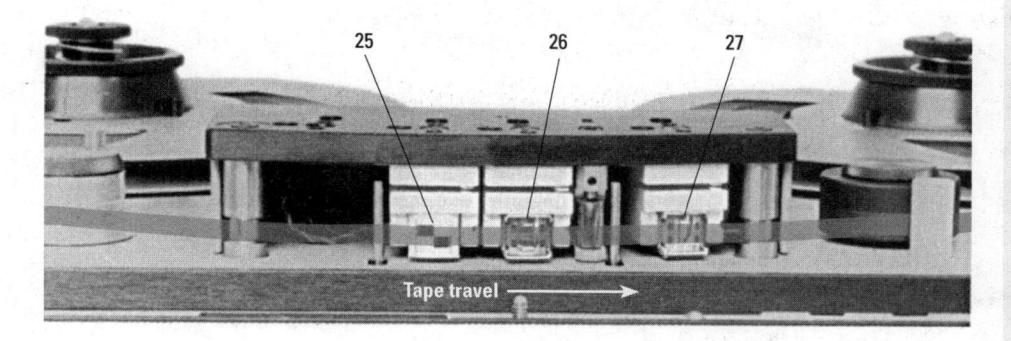

- a. playback head
- b. record head
- c. erase head
- **6.** Most professional video- and sound-editing software lets you (28) only see (29) only hear (30) both see and hear the audio track.
- **7.** A 16 \times 2 audio console has (31) 16 inputs and 2 outputs (32) 16 slide faders and 2 monitor systems (33) 16 VU meters and 2 mix buses.
- **8.** Phantom power means that the power is (34) *virtual but not real* (35) *not necessary* (36) *not supplied by battery but by some other source.*
- **9.** When an incoming audio signal is routed to the mic-level input, it will be amplified (37) *more than* (38) *less than* (39) *equally* when routed to the line-level input.
- **10.** The equalization controls on console modules (40) bring all sounds to the same volume level (41) bring all incoming sounds to line-level strength (42) emphasize or de-emphasize certain frequencies.
- **11.** The advantage of flash memory devices over a DAT recorder is that they (43) have no moving parts (44) can store digital and analog audio signals (45) can record MP3.
- **12.** The advantage of hard disks over a DAT recorder is that the audio information can be (46) *digital* (47) *analog or digital* (48) *accessed randomly*.

P A G E T O T A L

0

0

0

0

0

0

27

0

27

0

0

0

0

0

0

5a O

25

5b O

25

5c O

0

10

0

0

ECTI	ON	
OT	AL	

REVIEW OF AUDIO CONTROL

Select the correct answers and fill in the bubbles with the corresponding numbers.

1. Indicate the most common place to cut the digital audio track shown below.

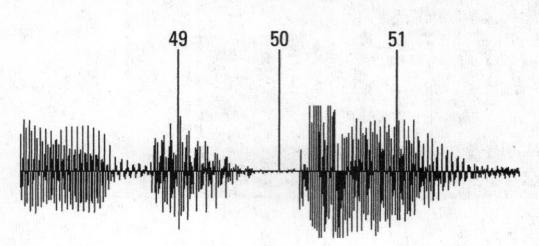

- 2. When using a CD player as an additional audio source, it must be connected to the (52) mic (53) line (54) neither the mic nor the line input on the mixer.
- 3. The AGC (55) discriminates automatically between figure and ground (56) works especially well in noisy surroundings (57) automatically boosts audio levels if they fall below preset levels.
- **4.** The audio control tone, which gives a reference level of the recorded material, should be set at (58) 0 VU (59) +3 VU (60) -3 VU.
- **5.** When recording sound during an outdoor EFP, you should (61) avoid all ambient sounds (62) record ambient sounds on a separate track (63) re-create the ambient sounds in postproduction.
- 6. The correct patches as shown in the figure are: (64) (65) (66) (67) (68) (69). (Multiple answers are possible.)

	64	65		66	/	57		
0		0	0	P	/ 0	0	0	
0	0	0	0	0	0	0	0	
0	e/	0	6	9	0	0	0	
0	0	9	0	9	0	0/	6	
				68	65			

1	O 49	50	O 51

3	0	0	0
	55	56	57

4	0	0	
	58	59	6

5	0	0	C
	61	62	63

6	0	0	0
	64	65	66
	0	0	0
	67	68	69

P A G E T O T A L
- 7. Audio-system calibration normally refers to (70) adjusting the audio input VU meter of the VR to the VU meter of the console output (71) adjusting the zoom lens so that it stays in focus (72) having the VU meter of the VR peak at a much higher level than the VU meter of the console output.
 - 0
- 8. The flash memory device (flash drive) can store (73) only analog (74) only digital (75) both analog and digital audio signals.

9. The proper steps for audio system calibration are:

- (76) 1. Activate the control tone on the console or mixer.
- - 2. Turn up the volume control for the incoming sound on the VR to 0 VU.
 - 3. Bring up the control tone fader on the console or mixer to 0 VU.
 - 4. Bring up the master fader on the console or mixer to 0 VU.
- (77) 1. Turn up the volume control for the incoming sound on the VR to 0 VU.
 - 2. Bring up the control tone fader on the console or mixer to 0 VU.
 - 3. Bring up the master fader on the console or mixer to 0 VU.
 - 4. Activate the control tone on the console or mixer.
- (78) 1. Activate the control tone on the console or mixer.
 - 2. Bring up the master fader on the console or mixer to 0 VU.
 - 3. Bring up the control tone fader on the console or mixer to 0 VU.
 - 4. Turn up the volume control for the incoming sound on the VR to 0 VU.
- 10 0 0
- 11. The least critical speaker placement in a 5.1 surround-sound system is the (82) front-center speaker (83) front-side speakers (84) subwoofer.

10. Taking a level is (79) not necessary when the AGC is engaged (80) not

necessary when recording digital sound (81) always necessary.

- 0 0 0
- 12. Recording several minutes of room tone or ambient field sounds during a field production is especially important for (85) establishing continuity in postproduction (86) helping set volume levels in postproduction (87) boosting aesthetic energy.
- 12 0 0 0

ပ္ပ
Wadsworth
2009
0

igage Learning

P A G E T O T A L	
SECTION	

REVIEW QUIZ the following statements as true or false by filling in the hubbles in the

	ork the following statements as true or false by filling in the bubbles in the for true) or F (for false) column.			
1.	The VU meter or the PPM will give an accurate reading of sound perspective.	1	T O 88	F
2.	A flat response means that the dynamics are equalized.	2	90	91
3.	Environmental sounds are always interfering in EFP.	3	92	93
4.	A cardioid pickup pattern is closer to an omnidirectional pattern than a unidirectional one.	4	94	95
5.	On multitrack ATRs each track has its own VU meter.	5	96	97
6.	In EFP we should try to mix all sound inputs as much as possible to minimize the need for postproduction mixing.	6	98	99
7.	I/O consoles have an output channel for each input channel.	7	0	0
8.	On large multichannel consoles, each input channel has its own quality controls.	8	102	0 103
9.	In contrast to large audio consoles, audio mixers have only one input but several outputs.	9	O 104	105
10.	All analog recording systems are tape-based.	10	O 106	107
11.	Digital audio signals can be recorded on tape or computer disks.	11	108	0
12.	A solo switch on the console lets you listen to a single incoming sound while silencing all others.	12	0	0
13.	One function of the audio console is to route the combined signals to a specific output.	13	O 112	O 113
14.	An audio field mixer has quality controls similar to those of a console.	14	O 114	O 115
15.	When recording digital audio, the master fader level should be kept somewhat below 0 VU.	15	0	O 117
6.	The .1 speaker in the 5.1 surround sound system is the subwoofer.	16	O 118	O 119
17.	Adding rhythmic sound is one of the primary techniques for establishing visual continuity.	17	O 120	O 121
8.	DAT recorders allow random access.	18	O 122	O 123
		SEC	TION	

PROBLEM-SOLVING APPLICATIONS

- 1. When setting up for videotaping a small rock group, you notice that the microphones and other audio sources exceed the number of inputs on the audio console. What can you do?
- 2. During rehearsal of the same production, you discover that the audio inputs that need the most attention are widely spread apart on the board. How can you get them closer together on the console so that their respective volume controls are adjacent to one another?
- **3.** During the digital recording of a concert, the VU meters occasionally peak into the +2 red zone. The director is very concerned about overmodulation. What is your response?
- **4.** During a small segment of an EFP in an auto assembly plant, the novice director tells you to be especially careful to mix the ambient sounds and the voices of the reporter and the plant supervisor with the portable mixer so as to facilitate postproduction editing. What is your response?
- **5.** You, the audio technician, overhear the floor manager telling the anchorpersons that they do not need to be on the I.F.B. system because it is, after all, his job to relay messages to the talent. What is your response?
- **6.** You have been asked to calibrate the audio system in your studio. Briefly describe the process step-by-step.
- 7. The director of the evening news would like you, the audio technician, to construct a playlist of all the bumpers for an automated and sequenced playback during the newscast. What piece of widely used audio equipment do you need to accomplish this assignment?
- **8.** Some of the incoming audio signals during a rock concert are so hot (strong) that they bend the needle even at very low fader settings. What can you do to correct this problem without going to the source?
- 9. How can you control the input levels before they reach the camcorder?
- **10.** During postproduction the director insists on laying in a low but highly rhythmical music track, even under the dialogue, to boost the aesthetic energy of the scene. What is your reaction?

10

Lighting

REVIEW OF KEY TERMS

Match each term with its appropriate definition by filling in the corresponding bubble.

- 1. barn doors
- 2. baselight
- Z. baseligh
- 3. spotlight
- 4. reflected light
- 5. incident light
- 6. dimmer
- 7. foot-candle
- 8. floodlight
- 9. cookie
- 10. lumen

- 11. lux
- 12. softlight
- 13. incandescent
- 14. fluorescent
- 15. ND filter
- **A.** A lighting instrument that produces diffused light with a relatively undefined beam edge
 - beam edge
- **B.** Light that is bounced off the illuminated object
- C. A lighting instrument that produces directional, relatively undiffused light

- A \(\cap \) \(\cap \

P A G E T O T A L

- barn doors
 baselight
 spotlight
 reflected light
- dimmer
 foot-candle
- 11. lux
- 12. softlight
- floodlight
 cookie
- incandescent
 fluorescent

- 5. incident light
- 10. lumen
- 15. ND filter
- **D.** Even, nondirectional (diffused) light necessary for the camera to operate optimally
- **E.** Metal flaps in front of lighting instruments that control the spread of the light beam

F. A metal cutout for a pattern projection

- - 6 7 8 9 10 O O O O 11 12 13 14 15

G. Light that strikes the object directly from its source

- **H.** The American unit of measurement of illumination, or the amount of light that falls on an object

11 12 13 14 15

I. Light produced by a glowing tungsten filament

P A G E T O T A L

- J. The intensity of one candle (or any other light source radiating isotropically)
- 00000 1 2 3 4 5
 - 00000
 - 00000 11 12 13 14 15

K. Lamps that generate light by activating a gas-filled tube

- 00000 1 2 3 4 5 00000
 - 6 7 8 9 10 O O O O O O 11 12 13 14 15

L. European standard for measuring light intensity

- 00000 1 2 3 4 5
 - 00000 00000

11 12 13 14 15

M. Floodlight that produces extremely diffused light

- M 00000
 - 00000
 - 6 7 8 9 10 00000 11 12 13 14 15

N. A device that controls light intensity

- 00000
- 00000
 - 00000 11 12 13 14 15

O. Reduces incoming light without distorting colors

- 00000
 - 6 7 8 9 10 00000
 - 11 12 13 14 15

P A G E

REVIEW OF STUDIO LIGHTING INSTRUMENTS AND CONTROLS

Select the correct answers and fill in the bubbles with the corresponding numbers.

- 1. The beam of softlights can be adjusted by (16) an egg crate (17) a focus control (18) moving the lamp assembly toward or away from the reflector.
- 2. To flood (spread) the light beam of a Fresnel spotlight, you need to move the lamp-reflector unit (19) toward (20) away from the lens.
- 3. With the use of the patchboard (or computer patching), you (21) must link only one instrument (22) can link several instruments (23) must link all available instruments simultaneously to a specific dimmer regardless of circuit capacity.
- **4.** Fill in the bubbles whose numbers correspond with the appropriate lighting instruments shown below.

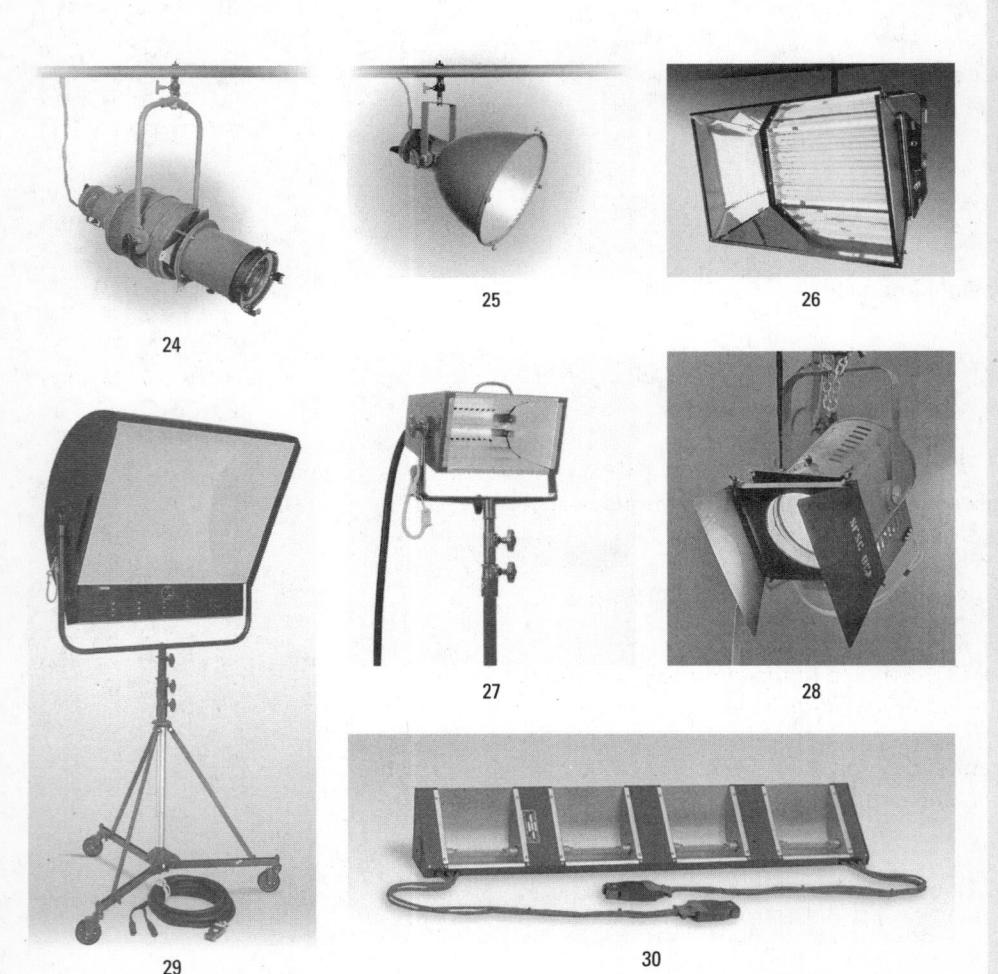

1	O 16	O 17	O 18
2	O 19	O 20	
3	0	0	0

P A G E T O T A L

a. strip, or cyc, light

b. fluorescent floodlight bank

c. Fresnel spotlight

000

d. scoop

O O O 28 29 30

e. ellipsoidal spotlight

4e \bigcirc \bigcirc \bigcirc \bigcirc \bigcirc \bigcirc 24 25 26 27 \bigcirc \bigcirc \bigcirc

28 29 30

f. softlight

28 29 30

g. broad

28 29 30

- **5.** You can make a fluorescent light beam somewhat directional by attaching (31) barn doors (32) a filter (33) an egg crate.
- 5 O O O

6. Scoops have (34) a Fresnel lens (35) a plain lens (36) no lens.

- 6000
- 7. A dimmer controls the (37) wattage of the lamp (38) voltage flowing to the lamp (39) amperes flowing to the lamp.
- 34 35 36 7 O O O 37 38 39
- **8.** To diffuse the light beam of a scoop even more, you can attach (40) a scrim (41) color media (42) an egg crate.
- 8 O O O O 41 42

P	A	G	Е	
T	0	TA	L	

9. Fill in the bubbles whose numbers correspond with the numbers identifying the various parts of the spotlight shown below.

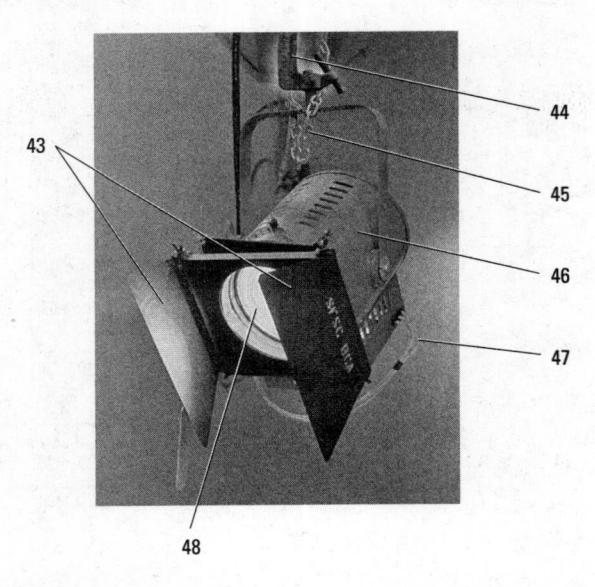

- a. C-clamp
- b. Fresnel lens
- c. two-way barn doors
- d. safety chain
- e. power cord
- f. lamp housing

9a	43 0 46	44	45
9b	0	O	0
	43	44	45
	0	O	0
	46	47	48
9c	0	O	0
	43	44	45
	0	O	0
	46	47	48
9d	0	O	0
	43	44	45
	0	O	0
	46	47	48
9e	0	O	0
	43	44	45
	0	O	0
	46	47	48
9f	O	O	0
	43	44	45
	O	O	0
	46	47	48

PAGE TOTAL

SECTION TOTAL

REVIEW OF FIELD LIGHTING INSTRUMENTS AND CONTROLS

Select the correct answers and fill in the bubbles with the corresponding numbers.

- **1.** Portable light stands must always be secured with (49) a safety cable (50) sandbags (51) counterweights.
- 1 O O O 51
- 2. The easiest way to reduce the light intensity of a portable spot is to (52) use a small dimmer (53) use a smaller lamp (54) move the light farther away from the object.
- **3.** One common way to diffuse the light of an open-face spot is to (55) attach a scrim to the barn doors (56) attach color media (57) use a dimmer.
- 3 O O O O 55 56 57
- **4.** The diffusion umbrella fulfills a similar function to (58) a dimmer (59) a soft box (60) barn doors.
- 4 O O O O O 60

© 2009 Wadsworth Cengage Learning

P A G E T O T A L

5. Fill in the bubbles whose numbers correspond with the appropriate instruments shown below.

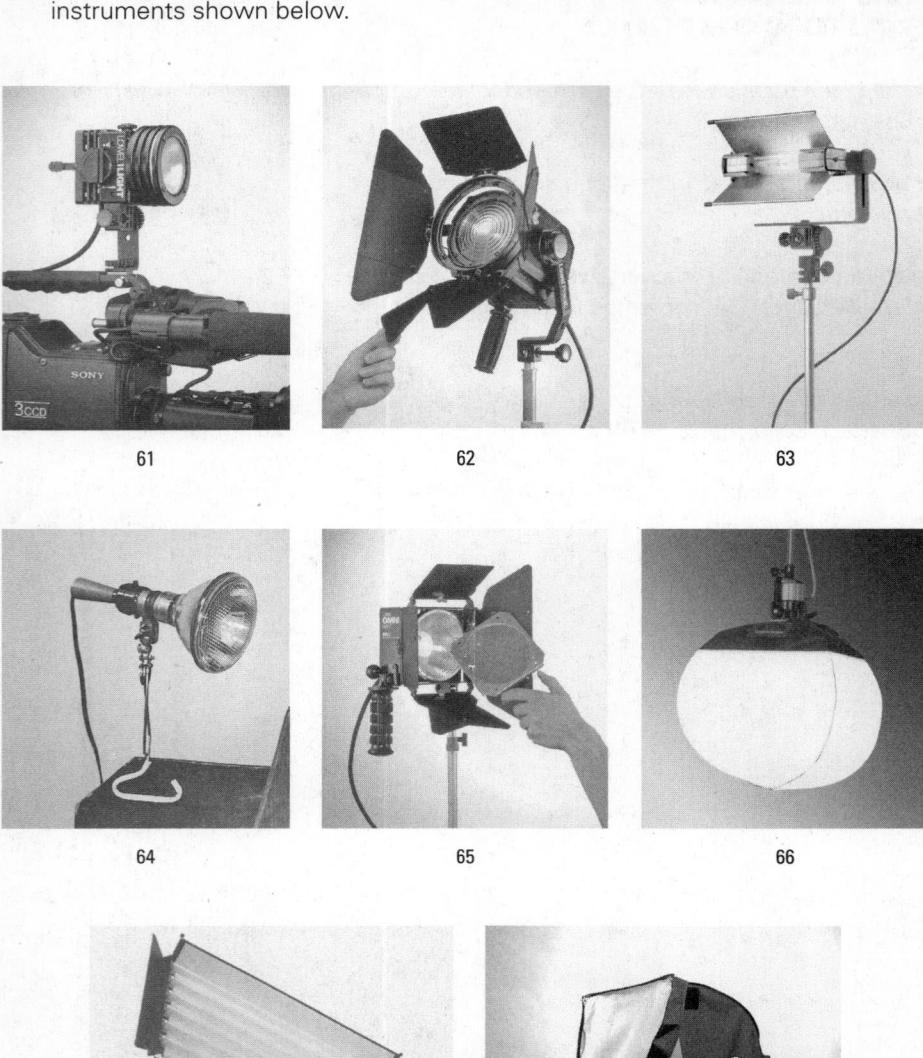

68

67

- a. Chinese lantern
- b. open-face spot
- c. portable fluorescent
- d. internal reflector light
- e. camera light
- f. soft box
- g. V-light
- h. small Fresnel spot

P A G E T O T A L

SECTION TOTAL

REVIEW OF LIGHT INTENSITY, LAMPS, AND COLOR MEDIA

Select	the correc	t answers	and fill in to	he bubbles	with the	corresponding	g numbers.

- 1. One foot-candle is approximately (69) 1 (70) 10 (71) 100 lux.
- 2. When measuring baselight, you need to read (72) incident (73) reflected (74) directional light.
- 3. When measuring incident light, you point the foot-candle or lux meter (75) toward the set (76) toward the camera lens (77) close to the lighted object.
- **4.** When reading reflected light, you point the light meter (78) close to the lighted object (79) into the lights (80) toward the camera lens.
- **5.** The beam of softlights (81) cannot be sharply focused (82) can be adjusted by attaching a Fresnel lens (83) can be adjusted by moving the lamp-reflector unit toward or away from the reflector.
- **6.** To flood (spread) the light beam of a Fresnel spotlight, you need to move the lamp-reflector unit (84) toward (85) away from the lens.
- 7. Colors are inevitably distorted by (86) inadequate baselight levels (87) low-contrast lighting (88) lack of shadows.
- 8. Quartz lamps fall into the (89) fluorescent (90) incandescent (91) HMI category.
- **9.** The advantage of a quartz lamp is that it (92) burns at a lower temperature (93) does not change color temperature over time (94) will not burn out over time.
- **10.** Most fluorescent tubes (95) burn at exactly 3,200K and 5,600K (96) approximate the indoor and outdoor color temperature standards (97) do not burn with a color temperature at all.
- **11.** When aiming two different-colored light beams on a neutral-colored background area, they (98) mix additively (99) mix subtractively (100) do not mix.
- **12.** When aiming a colored light beam on a colored object, they (101) *mix additively* (102) *mix subtractively* (103) *do not mix*.

SECTION	
TOTAL	

10 0

11 0

12 0

© 2009 Wadsworth Cengage Learning

REVIEW QUIZ

Mark the following statements as true or false by filling in the bubbles in the T (for true) or F (for false) column.

- 1. An open-face instrument has no lens.
- 2. To illuminate a large area with even light, we use a variety of Fresnel spots.
- 3. Barn doors are primarily used for intensity control.
- 4. Focusing a light results in sharper shadows.
- 5. Portable fluorescent banks are used to illuminate areas with even light.
- 6. When necessary, the beam of softlights can be focused.
- 7. The shutters on an ellipsoidal spot can shape its beam.
- 8. A flag has a similar function to barn doors.
- Incident light can be measured by pointing the light meter into the lights or toward the camera lens.
- **10.** Regardless of the type of dimmer control, all patching must be done with patch cords for each instrument.
- 11. An HMI light needs an external ballast to function.
- 12. A tungsten-halogen lamp is a fluorescent luminant.
- 13. You can use egg crates to further soften the beam of softlights.
- 14. LED lights can be used to illuminate small areas for close-ups.
- **15.** One effective method of turning a spotlight into a floodlight is to shine its beam into a diffusion umbrella.
- **16.** A sliding rod and pantograph fulfill similar functions.
- 17. A reflector can substitute for a fill light.
- 18. The inverse square law is independent of how much the light is collimated.
- **19.** Putting a red and green gel in front of the same Fresnel spot will yield yellow light.

SECTION	
TOTAL	

11 0

13 0

PROBLEM-SOLVING APPLICATIONS

- 1. You are asked to raise the baselight level in a classroom for optimal camera performance. Even though the small portable spotlights are in the maximum flood position, the additional illumination is not even. What other methods do you have available to achieve further diffusion?
- 2. You are asked to produce extremely sharp beams that reflect as precise pools of light on the studio floor. What type of lighting instruments would you use?
- 3. When checking the general baselight level and the amount of foot-candles (or lux) falling on the subject, the lighting assistant first stands next to the lighted subject and points the light meter toward the principal camera position and then at the various lighting instruments illuminating the subject. Will the assistant's action produce the desired results? If so, why? If not, why not?
- **4.** You are asked to assemble a lighting kit that will be useful for lighting indoor interviews in small rooms, such as hotel rooms and offices. What instruments and other necessary equipment would you recommend?
- 5. You are asked to dim all spotlights simultaneously and then do the same thing immediately thereafter with all floodlights. How can you best accomplish this task?
- **6.** The producer asked you to shine a yellow light on a blue commercial display to make one side look "greenish." What is your reaction?
- 7. The basketball coach of the local high school asks the television production teacher to flood the gym with HMI lights. What are your concerns, if any?

11

Techniques of Television Lighting

REVIEW OF KEY TERMS

Match each term with its appropriate definition by filling in the corresponding bubble.

- 1. silhouette lighting
- 2. fill light
- 3. background light
- 4. back light
- 5. side light

- 6. kicker light
- 7. high-key
- 8. low-key
- 9. key light
- 10. color temperature
- 11. falloff
- 12. photographic lighting principle
- 13. floor plan
- 14. light plot
- A. Illuminates the set, set pieces, and backdrops
- B. Dark background, with a few selective light sources on the scene
- C. Illumination from behind and above the subject and opposite the camera

P A G E T O T A L

6. kicker light 11. falloff 1. silhouette lighting 12. photographic lighting 2. fill light 7. high-key principle 8. low-key 3. background light 13. floor plan 4. back light 9. key light 14. light plot 5. side light 10. color temperature 00000 D. The speed with which a light picture portion turns into shadow area 1 2 3 4 5 00000 6 7 8 9 10 0000 11 12 13 14 00000 E. Unlighted subject in front of a brightly illuminated background 1 2 3 4 5 00000 6 7 8 9 10 0000 11 12 13 14 00000 F. Light background and ample light on the scene 00000 6 7 8 9 10 0000 11 12 13 14 00000 G. The triangular arrangement of the three major light sources used to illuminate a subject 00000 6 7 8 9 10 0000 11 12 13 14 00000 H. The relative reddishness or bluishness of white light 00000 6 7 8 9 10 0000 11 12 13 14

> P A G E T O T A L

- I. Additional light that illuminates shadow areas and thereby reduces falloff

J. Principal source of illumination

- **K.** A plan that shows each lighting instrument used relative to the scene to be lighted

L. Directional light from the side of an object

- M. Directional light coming from the side and the back of the subject, usually from below

N. A diagram of scenery and major properties drawn onto a grid

PAGE TOTAL

SECTION TOTAL

REVIEW OF LIGHTING TECHNIQUES

Select the correct answers and fill in the bubbles with the corresponding numbers.

1. The arrangement of the lighting instruments shown in the following figure is generally called (15) four-point lighting (16) photographic lighting principle (17) field lighting principle.

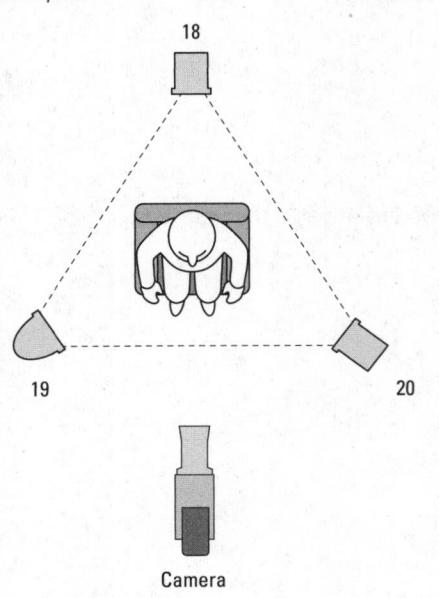

- 2. Fill in the bubbles whose numbers correspond with the functions of the lighting instruments shown in the figure above and whether they are usually (S) spotlights or (F) floodlights.
 - a. key
 - b. back
 - c. fill

2a	0	19	0
	. 18	19	20
	S O 18	F	
	S		
2b	0	0	20
	18	19	20
	O S	O F	
	S	F	
2c	0	0	0
	18	19	20
	O S	O F	
	S	F	

P A G E T O T A L

3. What major light sources were used to illuminate the host of a sports show in the following four pictures? In the diagrams, circle the instrument(s) used; then fill in the bubbles whose numbers correspond with the instruments used to light the subject.

a.

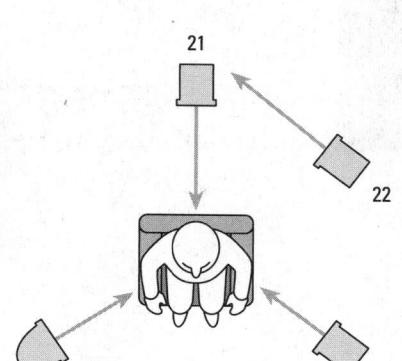

Camera

3a O O O O O 21 22 23 24

b.

Camera

3b O O O O 25 26 27 28

P A G E T O T A L

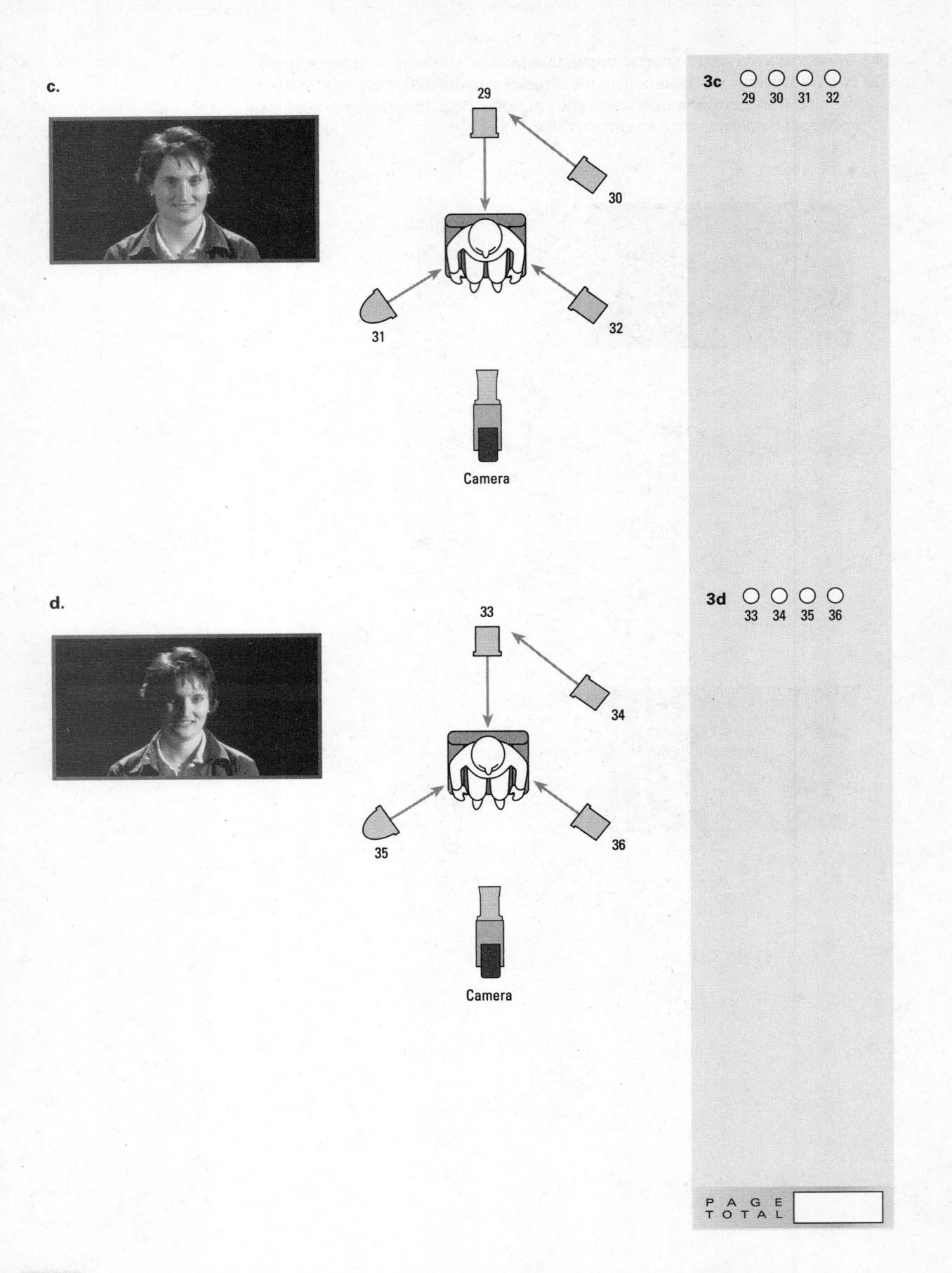

- **4.** You are to evaluate normal lighting setups. In the following six figures, cross out the lighting instruments that are unnecessary or most likely to interfere with the intended lighting effects; then fill in the bubbles whose numbers correspond with the instruments *needed*.
 - a. newscast

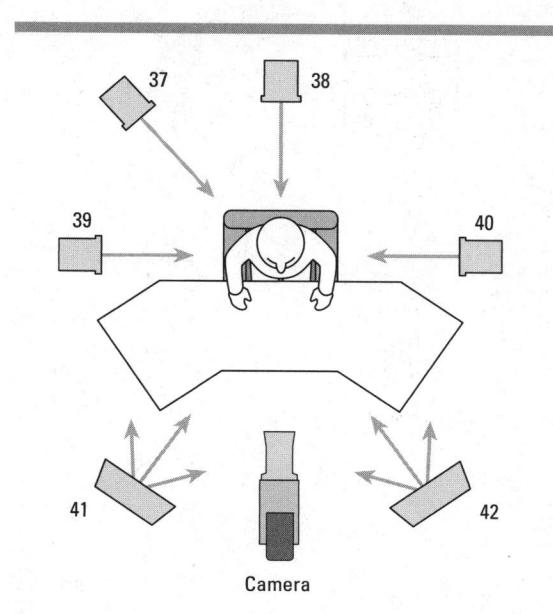

b. dancer in silhouette

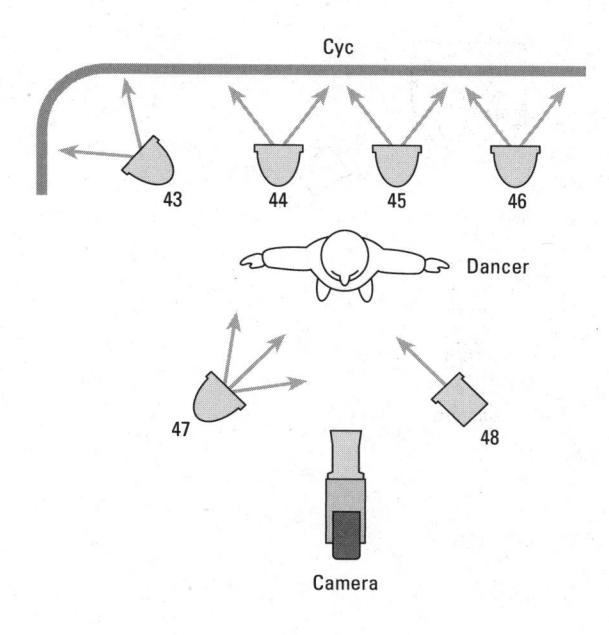

4a	0	0	0
	37	38	39
	0	0	0
	40	41	42

4b	0	0	0
	43	44	45
	0	0	0
	46	47	48

	Α	G	F		
T	Ó.	T ^	ī		
	O	. ~	L		

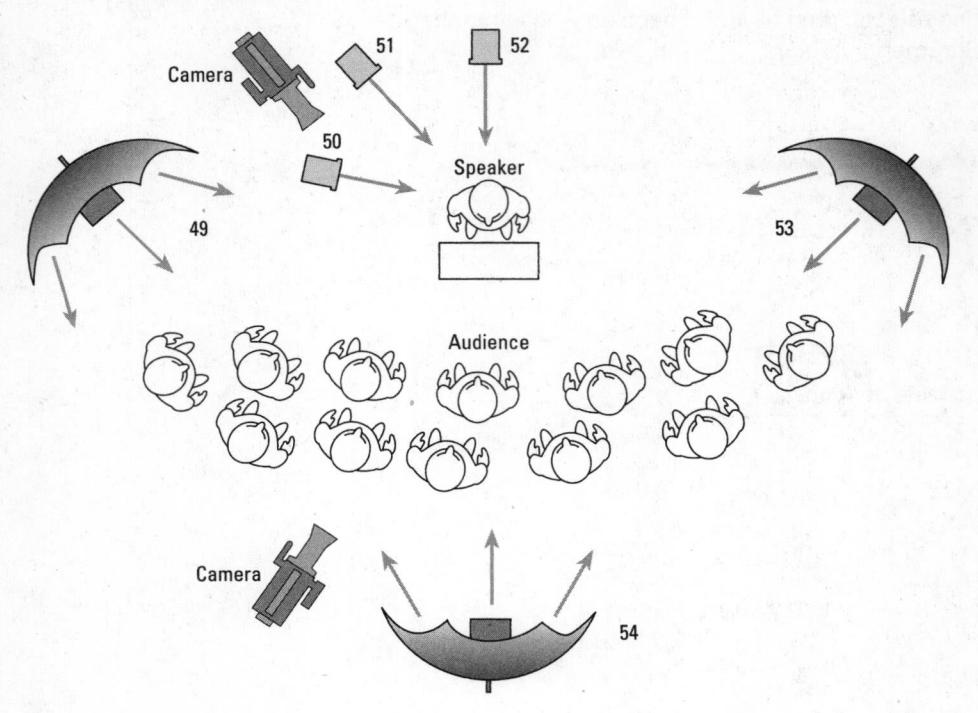

4c O O O 49 50 51 O O O 52 53 54

d. cameo lighting

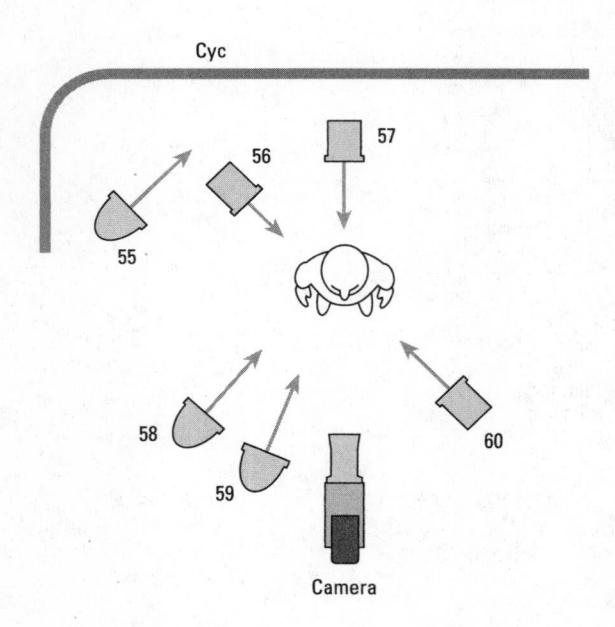

P A G E

e. chroma-key-area lighting

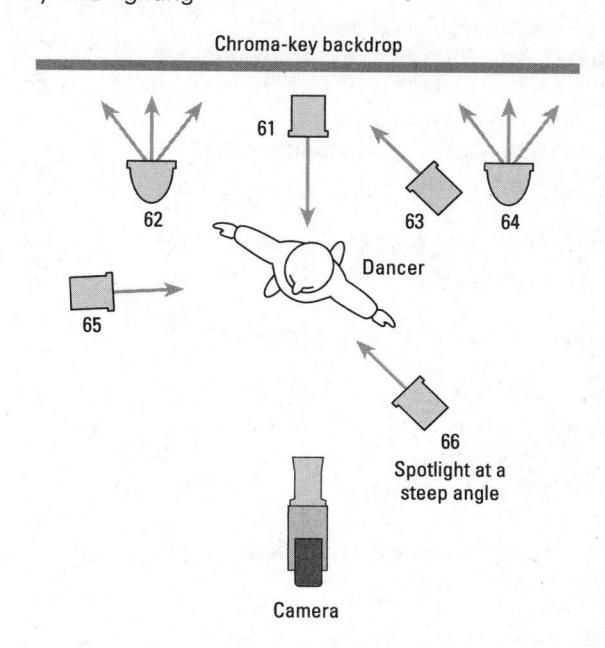

f. small still-life lighting

4e	61	62	63
	0	02	0
	64	65	66

4f	0	0	()	()
				70

AG	E	
OTA	1	

5.	Excessive dimming (more than 10 percent of full power) will (71) increase (72) decrease (73) not affect the color temperature. This means that the white light will (74) remain basically unchanged (75) turn reddish (76) turn bluish. (Fill in two bubbles.)	5 .	O 71 O 74	72 0 75	73 0 76	
6.	To figure the total wattage that a circuit can safely carry, you should multiply the number of amps by (77) 15 (78) 75 (79) 100.	6	0	O 78	O 79	
7.	To light the backdrop for a chroma key, you need (80) ellipsoidal spotlights (81) Fresnel spotlights (82) floodlights.	7	80	O 81	O 82	
8.	The color temperature of a light can be raised by using (83) an orange gel (84) a blue gel (85) an amber gel.	8	83	84	85	
9.	Having somebody stand in front of a brightly illuminated building will (86) provide much needed back light (87) help separate the person from the background (88) cause an undesirable silhouette effect.	9	86 .	87	88	
10.	When shooting an ENG interview in bright sunlight, the most convenient fill light is (89) an HMI spot (90) a quartz scoop (91) a reflector.	10	89	90	91	
11.	The standard color temperature for outdoor light is (92) 3,200K (93) 3,600K (94) 5,600K.	11	92	93	94	
12.	These lights fulfill similar functions: (95) key and fill (96) back light and kicker (97) background light and kicker.	12	95	96	97	
13.	To make a model's hair look especially glamorous, you need a high-intensity (98) key light (99) background light (100) back light.	13	98	99	100	
14.	The usual power rating per circuit of ordinary household wall outlets is (101) 15 amps (102) 50 amps (103) 150 amps.	14	101	102	103	
15.	To achieve fast falloff, you need to use primarily (104) <i>spotlights</i> (105) <i>floodlights</i> (106) <i>fluorescent lights</i> .	15	104	105	106	
		D ^	6 -			
			TAL			
		SEC	TION			

© 2009 Wadsworth Cengage Learning

REVIEW QUIZ

Mark the following statements as true or false by filling in the bubbles in the T (for true) or F (for false) column.

- 1. High-key lighting means that the key light strikes the subject from above eye level.
- 2. In multiple-function lighting, the key light can act as a back light, and the side light as key, depending on the position of the camera relative to the subject.
- 3. The photographic lighting principle, or triangle lighting, uses a key light, a kicker light, and a back light.
- 4. Low-key lighting is best achieved with low-hanging softlights.
- 5. Back lights and background lights fulfill similar functions.
- 6. The more fill light, the slower the falloff.
- 7. Low-key lighting means that the lighting is soft and even, with extremely slow falloff.
- **8.** Color temperature measures the relative reddishness and bluishness of white light.
- 9. All cameo lighting is highly directional.
- 10. In most cases, a reflector can substitute for a fill light.
- 11. An LED panel simulates more a spotlight than a floodlight.
- 12. Cast shadows can suggest a specific locale.
- **13.** Plugging portable lights into different wall outlets means that they are automatically on different power circuits.
- 14. Two side lights function similarly to a key and a fill.
- **15.** The background light must strike the background from the same side as the key light.

	Т	F
1	0	C
	107	108

- 2 0 0
- 3 0 0
- 4 0 0
- 113 114 5 O O
 - 115 116
- 6 O O 117 118
- 119 120
 - 8 O O
 - 9 0 0
 - 123 124 10 O O
 - 125 126 11 O O 127 128
 - 127 128 12 O O 129 130
 - 13 O O
- **14** \bigcirc \bigcirc \bigcirc 133 134
- **15** \bigcirc \bigcirc \bigcirc 135 136

SECTION

PROBLEM-SOLVING APPLICATIONS

- 1. You are asked to do the lighting for a shampoo commercial. The director wants you to make the model's blond hair look especially brilliant and glamorous. Which of the three instruments of the lighting triangle needs special attention to achieve the desired result?
- 2. The show is a brief address by the CEO. Prepare a light plot for the floor plan shown below. Sketch the type and the locations of the instruments used, as well as the general direction of the light beams.

- 3. You (the camera operator) and a field reporter are sent by the assignment editor to the Plaza Hotel to interview a famous soprano in her room. The field reporter will remain off-camera during the interview. The lighting in the hotel room is inadequate, so you need additional lighting. Besides the camera light, you have only one Omni light at your disposal. Where would you place the Omni light? Why?
- **4.** You are the LD for an indoor springtime fashion show. The studio audience is seated along both sides of the runway. The novice director suggests low-key lighting to give the show some extra sparkle. Do you agree with the director's suggestion? If so, why? If not, why not? What are your recommendations?
- 5. You are the LD for a dance number. The dancers wear off-white leotards. The choreographer wants them to appear first in cameo as illuminated figures against a dark blue background and then, in one continuous take, as black silhouettes moving against a bright red background. Can you fulfill the choreographer's request? If so, how? If not, why not?
- **6.** You will be shooting an interview with the CEO of a large software company. Her office has a large window without any curtains. How would you light this interview while taking advantage of the daylight coming through the window? List specific lights, their locations, and all necessary support equipment.
- 7. You are covering the dedication of a new library. It is a cloudless, sunny day with the sun reflecting off the brilliantly white building. The dedication is planned to happen right in front of the building. What are your concerns regarding lighting? What would you suggest to minimize some of the problems?
- **8.** You are to light a two-anchor news set in which the two co-anchors (a dark-haired man and a blond woman) sit side-by-side. The man is worried about his wrinkles, especially because his co-anchor has perfectly smooth skin. What lighting would you suggest? Draw a rough light plot that indicates the type and the approximate locations of the instruments used.

12

Video-recording and Storage Systems

REVIEW OF KEY TERMS

Match each term with its appropriate definition by filling in the corresponding bubble.

- 1. time base corrector
- 2. composite system
- 3. Y/C component system
- 4. control track
- 5. Y/color difference component system
- 6. compression
- 7. tapeless VR
- 8. field log
- 9. framestore synchronizer
- 10. MPEG-2
- 11. flash memory device
- 12. JPEG
- 13. ESS system
- 14. codec
- **A.** All digital video recorders that record or store information on a hard drive or read/write optical disc
- B. A list of shots taken during the recording
- C. A solid-state read/write digital storage media that has no moving parts

P A G E T O T A L

7. tapeless VR 2. composite system 11. flash memory device 3. Y/C component system 8. field log 12. JPEG 9. framestore 13. ESS system 4. control track synchronizer 5. Y/color difference 14. codec component system D 00000 **D.** Electronic accessory to a VTR that makes playbacks or transfers stable 00000 6 7 8 9 10 0000 11 12 13 14 E 00000 **E.** A video signal in which luminance (Y), chrominance (C), and sync information 1 2 3 4 5 are encoded into a single signal 00000 6 7 8 9 10 0000 11 12 13 14 00000 F. A system in which the luminance (Y) and the R-Y and B-Y signals are kept 1 2 3 4 5 separate throughout the video-recording process 00000 6 7 8 9 10 0000 11 12 13 14 **G.** A compression system generally used for digital television G 00000 1 2 3 4 5 00000 6 7 8 9 10 0000 11 12 13 14 H. Image stabilization and synchronization system that stores and reads out one H 00000 1 2 3 4 5 complete video frame 00000 6 7 8 9 10 0000 11 12 13 14

10. MPEG-2

6. compression

1. time base corrector

- I. The track on a videotape that contains synchronization information
- 1 0 0 0 0 0 1 2 3 4 5 0 0 0 0 0
 - 6 7 8 9 10
 - 11 12 13 14

J. Reducing the amount of digital data for recording or transmission

- 1 2 3 4 5
 0 0 0 0
 6 7 8 9 10
 0 0 0 0
 11 12 13 14
- **K.** A system in which the luminance (Y) and chrominance (C) signals are kept separate during the encoding and decoding processes but are recorded together

L. A video compression method mostly for still pictures

- - 6 7 8 9 O O O O 11 12 13 14

M. A specific compression standard

11 12 13 14

- N. An electronic device that can grab and digitally store a single frame from any video source

11 12 13 14

SECTION TOTAL

REVIEW OF TAPE-BASED AND TAPELESS VIDEO RECORDING

Select the correct answers and fill in the bubbles with the corresponding numbers.

sei	ect the correct answers and fill in the bubbles with the corresponding numbers.				
1.	Digital recording systems can be (15) linear (16) nonlinear (17) linear or nonlinear, depending on the recording system.	1	O 15	O 16	0
2.	In contrast to digital recordings, analog recordings (18) experience quality loss (19) remain the same (20) lose only color hue from one generation to the next.	2	18	19	20
3.	Digital video signals can be recorded (21) only on videotape (22) only on a computer disk (23) on tape as well as disk.	3	O 21	O 22	O 23
4.	The NTSC signal is based on a (24) composite (25) Y/C component (26) Y/color difference component signal.	4	24	25	O 26
5.	Disk-based recording systems are always (27) linear only (28) nonlinear only (29) both linear and nonlinear.	5	27	28	29
6.	All tapeless systems (30) have no moving parts (31) can record digital information only (32) can record video only.	6	30	31	32
7.	An ESS system stores individual frames in (33) analog only (34) digital only (35) both analog and digital form.	7	33	34	35
8.	The type of compression that looks for redundancies from one frame to the next is (36) <i>intraframe</i> (37) <i>interframe</i> (38) <i>lossless</i> .	8	36	37	38
9.	You can use a ¼-inch DV mini-cassette for recording (39) standard digital signals only (40) HDV only (41) standard and HDV signals.	9	39	40	O 41
10.	The control track is essential for (42) videotape recordings only (43) disk recordings only (44) both tape and disk recordings.	10	O 42	O 43	O 44
11.	An ESS system can store (45) individual video frames only (46) short video clips only (47) both frames and clips.	11	O 45	46	O 47
12.	The Y/C component signal separates the (48) color and luminance signals (49) audio and video signals (50) yellow and cyan color signals.	12	O 48	49	50

				100000000000000000000000000000000000000
P	Α	G	E	
Т	0 1	ГΑ	1	

13. The illustration below shows a (51) Y/C component signal (52) Y/color difference component signal (53) composite signal.

14 O O O

Luminance (Y)

- **14.** The best color fidelity is achieved through a (54) 4:2:2 (55) 4:1:1 (56) 4:0:0 sampling ratio.
- 14 0 0 0
- **15.** Intraframe compression eliminates (57) various frames (58) temporal redundancy in each frame (59) spatial redundancy in each frame.
- **15** ○ ○ 57 58 59

© 2009 Wadsworth Cengage Learning

P A G E T O T A L

TOTAL

REVIEW OF HOW VIDEO RECORDING IS DONE

Select the correct answers and fill in the bubbles with the corresponding numbers.

1.	Because color bars help the videotape operator match the technical aspects of the playback VTR and the playback monitor, you should record them (60) at the beginning of the video recording (61) right after the video leader (62) at the end of the video recording for at least (63) 10 seconds (64) 30 seconds (65) 5 minutes. (Fill in two bubbles.)	1	60 63	O 61 O 64	62 65
2.	The field log is normally kept by the (66) TD (67) VO (68) VR operator.	2	66	67	O 68
3.	To protect a cassette recording from being accidentally erased, the cassette tab (69) must be removed or in the open position (70) must be in place or in the closed position (71) cannot prevent erasure.	3	69	70	71
4.	Nonlinear editing requires the transfer to the computer hard drive (72) of only analog source tapes (73) of only digital source tapes (74) of both analog and digital source tapes.	4	O 72	73	74
5.	The clapboard aids in (75) starting the countdown (76) synchronizing audio and video (77) marking the first video frame.	5	O 75	O 76	077
6.	Two essential items on a slate or clapboard are (78) title and take number (79) producer and date (80) title and executive producer.	6	78	O 79	80
7.	When using a nontape recording device, locating certain takes for recording checks is (81) <i>quicker than</i> (82) <i>slower than</i> (83) <i>about the same as</i> using videotape.	7	81	82	83
8.	When beginning a recording, (84) servers (85) optical discs (86) videotape recorders need to reach operating speed to avoid video breakup.	8	84	85	0 86
9.	Leader numbers are especially helpful for accurate cueing of (87) servers (88) optical discs (89) videotape.	4	87	88	89
0.	The video leader (90) should (91) should not contain a 0 VU audio tone and (92) should (93) should not include the slate. (Fill in two bubbles.)	10	90 0 92	91 O 93	

SECTION	
TOTAL	

© 2009 Wadsworth Cengage Learning

REVIEW QUIZ

Mark the following statements as true or false by filling in the bubbles in the T (for true) or F (for false) column.

- 1. NTSC signal and composite signal mean the same thing.
- 2. When dubbing videotapes, analog systems produce much more noise in subsequent generations than do digital ones.
- **3.** In a Y/color difference component system, the Y and R–Y/B–Y signals are kept separate throughout the entire recording process.
- **4.** The Y/C component system means that the color yellow has been added to the color signals.
- 5. You can use videotape to record both analog and digital signals.
- 6. You can use a hard disk to record both analog and digital signals.
- 7. In analog recording, each video frame is marked by two sync pulses.
- **8.** When a camera feeds a switcher in addition to its own VR, it is no longer an iso camera.
- 9. The video leader includes a 0 VU test tone.
- 10. You should use prerecorded color bars for the video leader.
- 11. A codec signifies a specific digital compression standard.
- 12. A control track pulse marks each video frame.
- 13. A framestore synchronizer and a TBC fulfill similar functions.
- 14. MPEG-2 is an intraframe compression technique.
- **15.** When digital information is stored on videotape, it allows random access.
- **16.** All tapeless storage systems allow random access.
- 17. All videotapes provide at least two audio tracks.
- **18.** DV mini-cassettes have no record protection.
- **19.** Some camcorders use optical discs for video and audio recording.
- **20.** A 4:1:1 sampling ratio means that the color luminance signal is sampled four times as often as each color signal.

SECTION	

11 0

14 0

16 0

17 0

PROBLEM-SOLVING APPLICATIONS

- 1. The venerable news department head tells you not to bother with nonlinear editing systems because they are so much slower than linear cuts-only systems and, besides, not much more accurate. What is your reply?
- 2. You are asked to produce a brief instructional video on diagnosing specific skin rashes. The physician in charge insists that you use recording equipment that has a 4:2:2 sampling standard. Why is she so insistent about the sampling?
- 3. Because the extreme conditions under which the digital movie will be shot necessitate extensive audio postproduction and ADR, the editor insists on equipment that uses intraframe rather than interframe compression. Why do you think the editor specifies the compression system?
- **4.** The department head asks you to defend the switch to a totally tapeless operation. What are your major arguments?
- **5.** The novice digital cinema director tells you not to bother with videotape because it loses quality each time you dub it to another storage media. What is your reply?
13

Switching, or Instantaneous Editing

REVIEW OF KEY TERMS

Match each term with its appropriate definition by filling in the corresponding bubble.

- 1. preview/preset bus
- 2. program bus
- 3. M/E bus
- 4. fader bar
- 5. delegation controls
- 6. switching
- 7. downstream keyer
- 8. key bus
- 9. auto-transition
- 10. matte key
- 11. genlock
- 12. DVE
- 13. super
- 14. wipe
- 15. chroma key
- **A.** Control that allows a title to be keyed over the line-out image as it leaves the switcher
- **B.** A button that triggers the function of a fader bar
- **C.** Rows of buttons used to select the upcoming video and route it to the preview monitor

- O O O O O O 11 12 13 14 15

11 12 13 14 15

11 12 13 14 15

P A G E T O T A L

- 1. preview/preset bus 6. switching 11. genlock 2. program bus 7. downstream keyer 12. DVE 3. M/E bus 8. key bus 13. super 4. fader bar 9. auto-transition 14. wipe 5. delegation controls 10. matte key 15. chroma key
- 00000 D. A change from one video source to the next 00000 6 7 8 9 10 00000 11 12 13 14 15 00000 E. A row of buttons that can serve a mix or an effects function 00000 6 7 8 9 10 00000 11 12 13 14 15 00000 F. Electronically cut-in title whose letters are filled with shades of gray or a 1 2 3 4 5 specific color 00000 6 7 8 9 10 00000 11 12 13 14 15 00000 G. A double exposure of two images 1 2 3 4 5 00000 6 7 8 9 10 00000 11 12 13 14 15 H 00000 H. Controls on a switcher that assign specific functions to a bus 1 2 3 4 5 00000 6 7 8 9 10 00000 11 12 13 14 15 00000 I. A lever on the switcher that activates preset functions such as dissolves, 1 2 3 4 5 fades, and wipes of varying speeds 00000 6 7 8 9 10 00000 11 12 13 14 15

P A G E T O T A L

- J. Effect that uses color (usually blue or green) for the backdrop, which is replaced by the background image
- J 0 0 0 0 0 0 1 2 3 4 5 0 0 0 0 0
 - 0 0 0 0 0 6 7 8 9 10 0 0 0 0 0
- K. A bus used to select the video source to be inserted into a background image
- 11 12 13 14 15
- 1 2 3 4 5 O O O O O 6 7 8 9 10 O O O O

11 12 13 14 15

- L. Transition in which the new image is revealed in a pattern or shape
- L 0 0 0 0 0 0 1 2 3 4 5 0 0 0 0 0 0
 - 6 7 8 9 10 O O O O O 11 12 13 14 15
- M. The bus on a switcher whose inputs are directly switched to the line-out
- - O O O O O O O O O O O

11 12 13 14 15

- N. Visual effects generated by computer or the software in the switcher
- N 0 0 0 0 0 0 1 2 3 4 5

 - O O O O O O 11 12 13 14 15

- **O.** Synchronization of video sources or origination sources to prevent picture breakup
- 0 0 0 0 0 0 1 2 3 4 5 0 0 0 0 0
 - 6 7 8 9 10 O O O O O 11 12 13 14 15

P A G E T O T A L

SECTION TOTAL

REVIEW OF BASIC SWITCHER LAYOUT AND OPERATION

1. Fill in the bubbles whose numbers correspond with the appropriate parts of the switcher shown in the following figure.

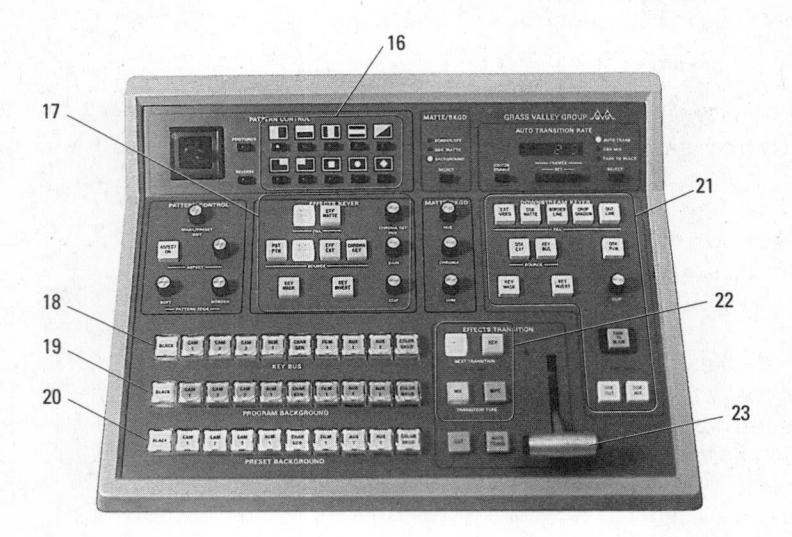

- a. program bus
- b. preview/preset bus
- c. fader bar
- d. key bus
- e. delegation controls (mix/effects transition)
- f. wipe pattern selector
- g. downstream keyer controls
- h. key/matte controls

а	0 16 0 20		0 18 0 22	19 0 23	
b	16	O 17 O 21	18	19	
С	16	O 17 O 21	18	0	
d	0 16 0 20	O 17 O 21	18	O 19 O 23	
e	0 16 0 20		O 18 O 22	19	
f	0 16 0 20	O 17 O 21	O 18 O 22	19	
g	0 16 0 20	17	0 18 0 22	19	
h	0	17	0	19	

- Select the correct answers and fill in the bubbles with the corresponding numbers.
- 2. The program bus will direct the selected video source to the (24) preview monitor (25) mix bus (26) line-out.
- **3.** To select the functions of a specific bus or buses, you need to activate the (27) *joystick* (28) *wipe mode selectors* (29) *delegation controls*.
- 4. To switch from C1 (camera 1) to C3 by pressing only one button, you need to press the (30) C3 button on the preview bus (31) C3 button on the key bus (32) C3 button on the program bus. (This assumes that the appropriate buses have already been delegated a mix/effects function.)
- **5.** Assuming that the final C.G. credits are keyed with the DSK, you can go to black by (33) pressing the black button on the program bus (34) pressing the black button on the key bus (35) pressing the black button in the downstream keyer section.
- **6.** To dissolve from C3 to VR (with the auto-transition in the *off* position), you (36) press the VR button on the preview bus; then press the cut button (37) press the VR button on the preview bus; then move the fader bar to the opposite position (38) press the VR button on the key bus; then move the fader bar to the opposite position.
- 7. To have C3 appear on the preview monitor before switching to it from C1, you need to (39) press C3 on the preview bus (40) press C3 on the preview bus; then press the key button (41) press C3 on the program bus; then move the fader bar to the opposite position.

2	0	0	0
	24	25	26

- 3 O O O O 29
- 4 O O O O 30 31 32
- 5 0 0 0
- 6 O O O 36 37 38
- 7 0 0 0

P A G E

8. Identify the proper preview and line monitor images you would expect to see from the switcher output by filling in the corresponding bubble. The highlighted buttons on the following switcher have already been pressed. C1 is focused on the host, C2 on the dancers (see the monitor images below).

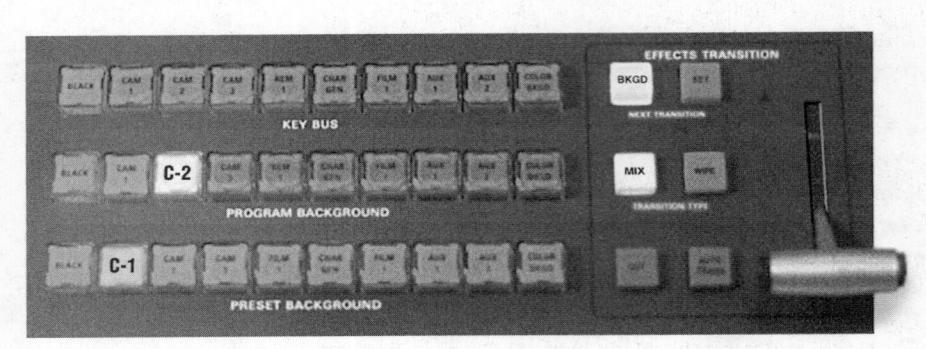

42

Preview

Line

43

Line

Preview

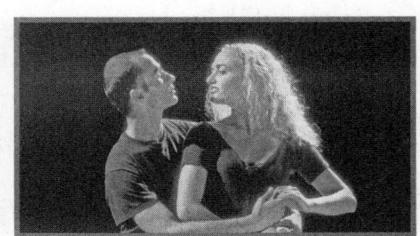

Line

9. Identify the proper preview and line monitor images you would expect to see from the switcher output and fill in the corresponding bubble.

O 47

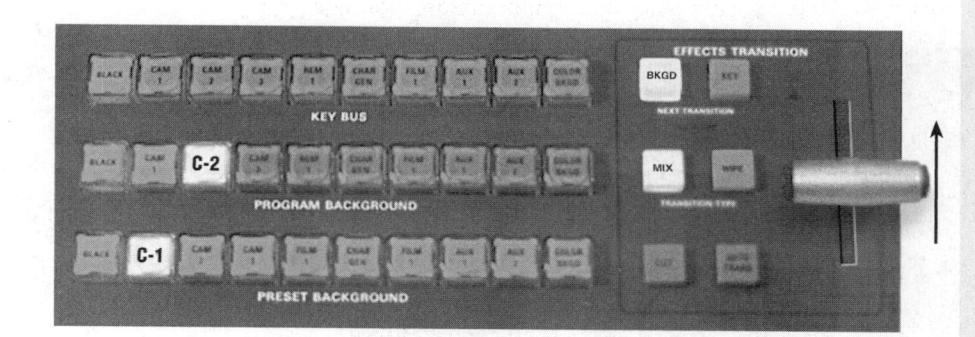

45

Preview

Line

46

Preview

Line

Preview

Line

		PAGE	

10. Identify the proper preview and line monitor images you would expect to see from the switcher output at the end of the previous dissolve and fill in the corresponding bubble.

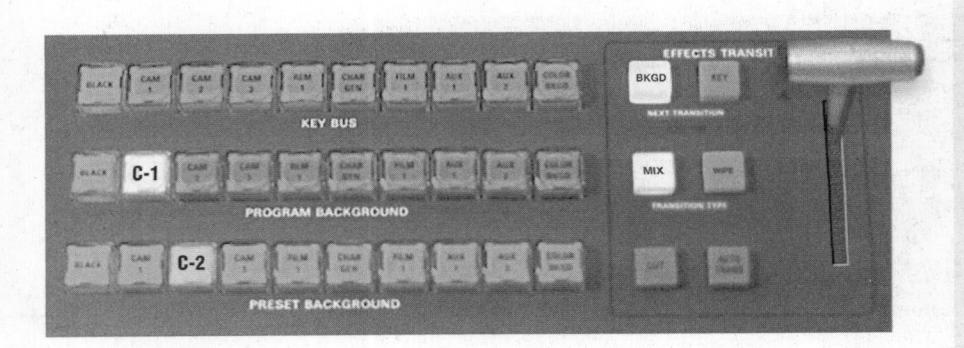

48

Preview

Line

49

Preview

Line

Preview

Line

P A G E T O T A L	
SECTION	

REVIEW OF ELECTRONIC EFFECTS AND SWITCHER FUNCTIONS

1. Fill in the bubbles whose numbers correspond with the appropriate key effects shown in the following figures.

54

- a. matte key
- b. drop-shadow mode
- c. outline mode
- d. edge mode

1a	0	0	0	C
	51			

1b
$$\bigcirc \bigcirc \bigcirc \bigcirc \bigcirc$$
 \bigcirc \bigcirc \bigcirc 51 52 53 54

P A G E T O T A L

2. Fill in the bubbles whose numbers correspond with the appropriate electronic effects illustrated in the following figures.

- a. multiple frames
- **b.** echo effect
- c. shrinking
- d. peel effect
- e. vertical wipe
- f. horizontal wipe
- g. posterization
- h. vertical stretching
- i. mosaic

- 2a 0 0 0 0 0 55 56 57 58 59 0000 60 61 62 63
- 2b 0 0 0 0 0 55 56 57 58 59 0000 60 61 62 63
- 2c 0 0 0 0 0 55 56 57 58 59 0000 60 61 62 63
- 2d 0 0 0 0 0 55 56 57 58 59 0000 60 61 62 63
- 2e 0 0 0 0 0 55 56 57 58 59 0000 60 61 62 63
- 2f 00000 55 56 57 58 59 0000 60 61 62 63
- 2g 00000 55 56 57 58 59 0000 60 61 62 63
- 2h 00000 55 56 57 58 59 0000 60 61 62 63
- 2i 00000 55 56 57 58 59 0000 60 61 62 63

P A G E T O T A L

3. Fill in the bubbles whose numbers correspond with the button you would have to press on the pattern selector to create the various effects illustrated in the following figures.

b.

3a	0	0	0
	64	65	66
	0	0	0
	67	68	69

3b	64	65	66
	O 67	68	69

P A G E T O T A L

f.

3c	0	0	0
	64	65	66
	0	0	0
	67	68	69

3d	64	65	66
	O 67	68	O 69

3е	0	0	0
	64	65	66
	0	0	0
	67	68	69

3f	0	0	0
	64	65	66
	0	0	0
	67	68	69

P	А	G		
Т	0 1		L	

Sele	ect the correct answers and fill in the bubbles with the corresponding numbers.				
4.	The two most frequently used backdrop colors for studio chroma-key effects are (70) yellow and blue (71) blue and red (72) green and blue.	4	70	O 71	O 72
5.	A peel effect (73) strips the picture of detail (74) reveals the picture underneath (75) covers the current picture.	5	73	O 74	O 75
6.	To create echo, stretching, and compression effects, you need (76) DVE (77) an SEG (78) a TBC.	6	O 76	0	O 78
7.	A secondary frame (screen within a screen) (79) can have a vertical aspect ratio (80) must have a 4×3 horizontal aspect ratio (81) must have a 16×9 HDTV aspect ratio.	7	79	80	81
8.	Shrinking effects differ from box wipes because (82) they maintain the total picture and aspect ratio during the reduction (83) the reduction can get smaller than a box wipe (84) they need a blue background.	8	82	83	84
9.	During posterization (85) the brightness values are reduced (86) the saturation is reversed (87) all brightness values are reversed.	9	85	86	87
10.	When the talent insists on wearing blue for a standard chroma-key effect, the backdrop color must be (88) blue (89) green (90) yellow.	10	88	89	90
		PA	A G E		
		ТО	TAL		

© 2009 Wadsworth Cengage Learning

REVIEW QUIZ

Mark the following statements as true or false by filling in the bubbles in the T (for true) or F (for false) column.

- 1. The clip control allows you to adjust the hue and the saturation of the image selected on the program bus.
- 2. Electronically cutting out portions of a background image and filling them with color is called a superimposition.
- 3. Through delegation controls, you can assign a preview function to the program bus.
- **4.** It is impossible to have both preset and program buses activated at the same time.
- **5.** With DVE you can change the size and the aspect ratio of a picture insert without losing any portion of the picture.
- **6.** The downstream keyer can add a title key only if there are no other keys present in the line-out picture.
- 7. In a mosaic effect, you can change the size of the tiles (image squares) electronically.
- 8. The auto-transition fulfills the same function as the fader bar.
- 9. The switcher has a separate button for each video input.
- **10.** Assuming that the DSK is inactive, the black button from the program bus will put the line into black.
- 11. The preview bus can also be used as a mix bus, if so delegated.
- **12.** Assuming that you are not using auto-transition, the speed of a dissolve depends on how fast the fader bar is moved up or down.
- **13.** The DSK black button will put the switcher output to black regardless of what source feeds the line-out.
- **14.** A drop shadow makes lettering look three-dimensional.
- **15.** You can achieve a split-screen effect simply by stopping a horizontal wipe midway.

SECTION	
TOTAL	

10 0

15 0

12 0

14 0

PROBLEM-SOLVING APPLICATIONS

- 1. The director asks you, the TD, to superimpose a long shot of a dancer over a close-up of her face. The director wants to first have the long shot be the more prominent image and then slowly shift the emphasis to the close-up. How, if at all, can you accomplish such an effect?
- 2. The director wants you to perform four dissolves that are identical in speed from one dancer to the next. Are such identical dissolves possible? If so, how can they be accomplished? If not, why not?
- **3.** You have keyed the credits over the base picture with the downstream keyer. When the director calls for a fade to black, you press the black button on the program bus. What will you see on the line monitor? Why?
- **4.** The director wants you to do fast cuts between the CUs of the interviewer and the guest during a lively discussion. How can you best accomplish such fast cuts between the two?
- 5. When checking the chroma key of a weathercaster standing in front of a weather map, you, the TD, discover that the key is not "clean." The talent's dark hair seems to have a blue and purple halo, and the outline of her head and shoulders is not sharp against the map. Assuming that the problem does not lie with the chroma-key equipment, what is the problem? What, if anything, can you do to minimize or eliminate it?
- **6.** The preview monitor shows that the outline-mode title key is hard to read over the busy background. How could you, the TD, make the title more readable without changing the font or the background?
- 7. When you, the TD, preview the key of a C.G. title, the white letters tear at the edges. How can you correct this problem?
- 8. The AD informs you, the director, that a dancer, who is supposed to be chroma-keyed over a videotaped landscape scene, wears a saturated medium-blue leotard. The AD is very concerned about this, but the TD assures you that he has already taken care of the problem. What was the potential problem? What did the TD do to solve it?
- **9.** The new news producer would like you, the director, to use a circle wipe to close each story. How would you respond? Why?
- **10.** The same director suggests peel effects between the stories of a headline news teaser. How would you respond? Why?

Design

REVIEW OF KEY TERMS

Match each term with its appropriate definition by filling in the corresponding bubble.

- 1. graphics generator
- 2. flat
- 4. floor plan
- 3. C.G.

- 5. essential area
- 6. scanning area
- 7. props
- 8. floor plan pattern
- 9. color compatibility
- 10. grayscale
- 11. letterbox
- 12. pillarbox
- A. The picture area usually seen on the camera viewfinder and the preview monitor
- B. Furniture and other objects used for set decorations or by actors or performers
- C. Colors with enough brightness contrast for good monochrome reproduction
- D. Computer software that allows a designer to draw, color, animate, store, and retrieve images electronically
- 0000 1 2 3 4 0000 0000

0000 5 6 7 8 O O O O 9 10 11 12

0000

1 2 3 4 0000 5 6 7 8 0000

PAGE TOTAL

9 10 11 12

10. grayscale 6. scanning area 2. flat 11. letterbox 3. C.G. 7. props 12. pillarbox 8. floor plan pattern 4. floor plan E 0 0 0 0 1 2 3 4 E. The section of the television picture, centered within the scanning area, that the home viewer sees O O O O O 9 10 11 12 F 0 0 0 0 1 2 3 4 **F.** Fitting a 16×9 aspect ratio into a 4×3 screen without cropping or distortion 0000 5 6 7 8 O O O O 9 10 11 12 G 0 0 0 0 1 2 3 4 G. A plan of the studio floor with the grid but without a set design O O O O O 9 10 11 12 H 0 0 0 0 1 2 3 4 H. A spectrum showing the intermediate steps from TV white to TV black O O O O 9 10 11 12 A piece of standing scenery used as a background or to simulate a wall $\bigcirc \bigcirc \bigcirc \bigcirc \bigcirc \bigcirc \bigcirc \bigcirc$ $5 \quad 6 \quad 7 \quad 8$ O O O O 9 10 11 12 J 0 0 0 0 1 2 3 4 J. A diagram of scenery and major set properties drawn on a grid O O O O O 9 10 11 12

9. color compatibility

5. essential area

1. graphics generator

P A G E T O T A L

- **K.** Fitting a 4×3 aspect ratio into a 16×9 screen without cropping or distortion nforespecial of the parameter of annual of another section of the section of the
- K 0000 1 2 3 4 4 0000 5 6 7 8 0000 9 10 11 12
- L. A dedicated computer that electronically produces letters, numbers, and simple graphic images for video display
- L 0000 1 2 3 4 0000 5 6 7 8 0000 9 10 11 12

		ì
		c
		č
		5
		5
		5
		ς
		2
		C
	٥	Ľ
		_
	÷	Ì
		Ŀ
		ç
		₹
		õ
	•	t
		ō
	3	Š
	:	5
	è	1
	è	×
	Ċ	
	¢	5
	,	_
	ę	4

PAGE TOTAL

SECTIO	N	
TOTA		
IUIA		

REVIEW OF TELEVISION GRAPHICS

Select the correct answers and fill in the bubbles with the corresponding numbers.

- 1. To store a great many video frames for instant access, you need (13) an ESS system (14) DVE (15) an SEG.
- 2. Color compatibility refers to using colors that differ distinctly as to (16) hue (17) saturation (18) brightness.
- 3. The whiteboard writing shown in the photo below is (19) appropriate (20) inappropriate because it (21) is within the scanning area (22) does not permit good CUs. (Fill in two bubbles.)

- **4.** Dead zones are (23) uninteresting picture areas (24) the empty vertical bars when showing standard TV on HDTV (25) a sound problem in studio areas.
- **5.** All lettering must be contained within the (26) scanning area (27) screen area (28) essential area.
- **6.** The aesthetic energy of a color is principally determined by (29) hue and brightness (30) the color itself (31) saturation and brightness.
- 7. Normally, low-energy colors are used more for the (32) foreground (33) middleground (34) background in a scene.
- 8. On a normal grayscale (nine-step or seven-step), 1 represents (35) TV white (36) TV black (37) 100 percent reflectance.
- **9.** The standard television aspect ratio is (38) 4×3 (39) 8×12 (40) 16×9 . For HDTV it is (41) 4×3 (42) 8×12 (43) 16×9 . (Fill in two bubbles.)

	13	14	15
2	O 16	O 17	0
3	O 19 O 21	O 20 O 22	
4	O 23	O 24	O 25
5	O 26	O 27	O 28
6	O 29	30	31
7	O 32	33	34

P A G E T O T A L

39

0

0

40

10. Fill in the bubbles whose numbers correspond with the appropriate aspect ratio or frame adjustments in the figure.

- a. letterbox
- **b.** pillarbox
- **11.** The vertically oriented diagram below is (46) acceptable (47) not acceptable for shooting with a studio camera because (48) it is not in proper aspect ratio (49) the camera can tilt in a close-up. (Fill in two bubbles.)

12. The edge distortion as shown in the figure below is called (50) *anti-aliasing* (51) *aliasing* (52) *pixel distortion*.

10a	0	0
	44	45

10b	0	0
IUD		\cup
	44	45

11	0	0
	46	47
	0	0
	48	49

12	0	0	(
12	\circ		\sim
	50	51	52

PAC	E	
1 0 1	AL	

13. Fill in the bubbles whose numbers correspond with the appropriate title areas in the following figure.

- a. total graphic screen area
- b. essential area
- c. scanning area

3a O 53	O 54	O 55
3b \bigcirc_{53}	O 54	O 55
3c O	O 54	O 55

14. Fill in the bubbles whose numbers correspond with the type of distortion that results from adjusting one aspect ratio to fit another.

56

57

- **a.** a 16×9 shot viewed full-screen on a 4×3 monitor
- **b.** a 4×3 shot viewed full-screen on a 16×9 monitor

14a	0	0
	56	57

P A G E T O T A L

15. The following six figures show various television graphics displayed on well-adjusted preview monitors. These monitors show the entire scanning area. For each figure state whether you would (58) accept (59) not accept the television graphic because it has (60) inappropriate style (61) enough contrast between figure and ground (62) scattered information (63) good grouping of words (64) letters that are too small (65) information that lies outside the essential area (66) letters that get lost in the busy background. (Fill in the two bubbles that seem most appropriate for each graphic.)

Design by Gary Palmatier Nuclear Grisis

a.

b.

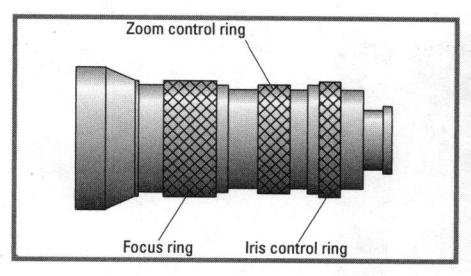

C.

d.

e.

© 2009 Wadsworth Cengage Learning

f.

15a				
	60	61	62 66	63
15b	58 60 64	6165	596266	63
1 5 c	0		596266	63
15d	58 60 64		59 62 66	63
15e	60	O 61	59 62 66	0
5f	58 60 64		59 62 66	63

SECTION

REVIEW OF SCENERY AND SCENIC DESIGN

 For the simple sets shown below, select the floor plan shown on the facing page that most closely corresponds and fill in the appropriate bubbles. (Assume that the camera shoots straight-on. Note that there are floor plans that do not match any of the set photos. The floor plans are not to scale.)

1f	67		O 70	
		O 73	O 75	

P A G E T O T A L

Date ____

Name

67

© 2009 Wadsworth Cengage Learning

2. Fill in the bubbles whose numbers correspond with the numbers identifying the various set pieces shown below.

- a. square pillar
- b. periaktos
- c. round pillar
- d. pylon
- e. sweep
- f. screen

2a	76 0 79	O 77 O 80	78 0 81
2b	○ 76 ○ 79	O 77 O 80	78 0 81
2c	○ 76 ○ 79	O 77 O 80	78 ○ 81
2d	○ 76 ○ 79	O 77 O 80	○ 78 ○ 81
2e	○ 76 ○ 79	O 77 O 80	78 0 81
2f	○ 76 ○ 79	O 77 O 80	○ 78 ○ 81

P A G E T O T A L Select the correct answers and fill in the bubbles with the corresponding numbers.

- **3.** The standard backgrounds to simulate interior and exterior walls are called (82) cycs (83) flats (84) drops.
- **4.** The continuous piece of canvas or muslin along two, three, or even all four studio walls to form a uniform background is referred to as (85) a drop (86) canvas backing (87) a cyclorama.
- **5.** Pictures and draperies are (88) set dressings (89) set decorations (90) hand props.
- **6.** To elevate scenery, properties, or action areas, we use (91) *periaktoi* (92) *platforms* (93) *pylons*.
- 7. The usual height for standard set units is (94) 7 feet (95) 10 feet (96) 14 feet. For studios with low ceilings, it is (97) 6 feet (98) 8 feet (99) 12 feet. (Fill in two bubbles.)

3	0	0	0
	82	83	84

- 4 O O O S
- 5 O O O
- 6 0 0 0
- 7 O O O O 94 95 96 O O

© 2009 Wadsworth Cengage Learning

P A G E T O T A L	
SECTION	

REVIEW QUIZ

Mark the following statements as true or false by filling in the bubbles in the \mathbf{T} (for true) or \mathbf{F} (for false) column.

15. Brightness differences are relatively unimportant in digital cinema.

			т	F
1.	The scanning area is contained within the essential area.	1	0	10
2.	There is an inevitable picture loss when wide-screen movies are shown in their true aspect ratio on a traditional (4 x 3) television screen.	2	102	10
3.	A black drape makes an ideal chroma-key backdrop.	3	O 104	10
4.	A periaktos looks like a large pylon.	4	106	10
5.	The energy of a color is determined primarily by hue.	5	108	10
6.	Distinctly different hues (such as red and green) guarantee good brightness contrast.	6	O 110	11
7.	For normal screen titles, all written information must extend beyond the scanning area.	7	O 112	11
8.	A floor plan must show the location of flats but can omit the set properties.	8	O 114	11
9.	A good floor plan will aid the LD in the lighting design.	9	O 116	11
10.	Hardwall scenery is preferred for permanent sets.	10	O 118	11
11.	Pillarboxing is used to fit a 4×3 aspect ratio into a 16×9 screen without distortion.	11	120	12
12.	Screen clutter can be avoided by grouping related information in specific screen areas.	12	122	12
13.	Bold lettering is especially important for mobile TV screens.	13	O 124	12
14.	Writing across a whiteboard from edge to edge facilitates CUs of the entire text.	14	126	12

SECTION	

15 O 128

PROBLEM-SOLVING APPLICATIONS

- 1. You are asked to direct a variety of shows and evaluate the location sketch or floor plans (see a through c). Please be specific as to the potential problems in scale (sets and props), camera accessibility and acceptable shots, lighting, and talent traffic.
 - a. Here is a floor plan for a two-camera live-on-tape production of a panel discussion by six prominent businesspeople and a moderator.

b. This floor plan is for a two-camera live interview set for a morning show.

c. This location sketch shows the office of the CEO, who would like to make her monthly 11 a.m. live-satellite TV report from behind her desk.

- 2. Draw a floor plan for a weekly interview show dealing with the art and media scene in your city. The host will interview guests from stage, screen, and radio. Include a detailed prop list. (Use one of the floor plan patterns provided at the back of this book.)
- 3. Draw a floor plan for a morning news set. The anchors are a woman and a man, and the news content is geared more toward local gossip than international politics. (Use one of the floor plan patterns provided at the back of this book.)
- **4.** The general manager of your corporation would like you to use a highly detailed photo of the latest computer design as the background for the opening and closing titles. Can you accommodate the request and still make the titles optimally readable?
- **5.** The art director proudly shows you the dancing Chinese-like lettering he has created with his titling software for the name identification of the new Chinese consul. Would you use such a title key? If so, why? If not, why not?

15 Television Talent

REVIEW OF KEY TERMS

Match each term with its appropriate definition by filling in the corresponding bubble.

1. actor

- 4. cue card
- 7. teleprompter

2. talent

3. performer

- blockingcake
- 8. pan-stick
- A. Carefully worked-out position, movement, and actions by the talent
- A O O O O O 1 2 3 4 O O O O O 5 6 7 8

B. A person who appears on-camera in a nondramatic role

C. A person who appears on-camera in a dramatic role

D. A large, hand-lettered card that contains on-air copy

D O O O O O 1 2 3 4 O O O O O 5 6 7 8

P A G E T O T A L

- 1. actor
- 2. talent 3. performer
- 4. cue card 5. blocking
- 7. teleprompter

- - 6. cake

8. pan-stick

E. All people who regularly appear on television

E O O O O $\bigcirc \bigcirc \bigcirc \bigcirc \bigcirc \bigcirc \bigcirc \bigcirc$ $5 \quad 6 \quad 7 \quad 8$

F. A water-soluble foundation makeup

 $\bigcirc \bigcirc \bigcirc \bigcirc \bigcirc \bigcirc \bigcirc \bigcirc$ $5 \quad 6 \quad 7 \quad 8$

G. Foundation makeup with a grease base

 $\bigcirc \ \bigcirc \ \bigcirc \ \bigcirc \ \bigcirc \ \bigcirc \ \bigcirc \ \bigcirc$ $5 \ \ 6 \ \ 7 \ \ 8$

H. Also known as auto-cue

H O O O O

REVIEW OF PERFORMING TECHNIQUES

1. The following pictures show various time cues given to the talent by the floor manager. From the list below, select the specific cue illustrated and fill in the bubble with the corresponding number.

(9) standby

(13) stretch

(16) 5 minutes left

(10) cue

(14) wind up

(15) cut

(17) 30 seconds left (18) 15 seconds left

(11) speed up (12) on time

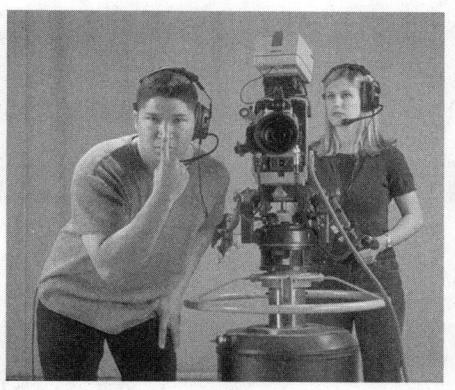

00000 9 10 11 12 13

1a 00000 9 10 11 12 13 00000 14 15 16 17 18

1b 00000 9 10 11 12 13 00000 14 15 16 17 18

> 00000 14 15 16 17 18

1d O O O O O O 9 10 11 12 13 00000 14 15 16 17 18

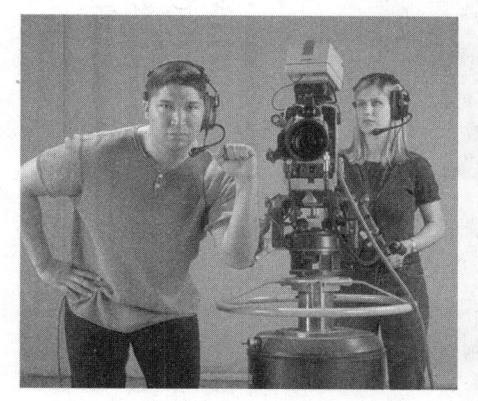

c.

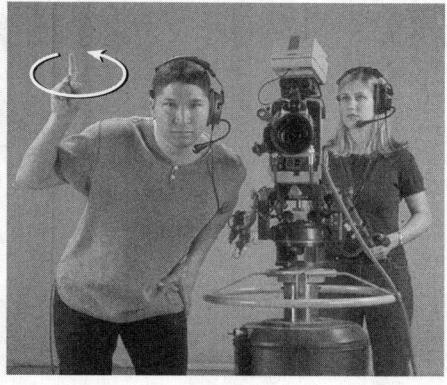

d.

P A G E T O T A L

(9) standby

(10) cue (11) speed up

(12) on time

(13) stretch

(14) wind up (15) cut (16) 5 minutes left

(17) 30 seconds left

(18) 15 seconds left

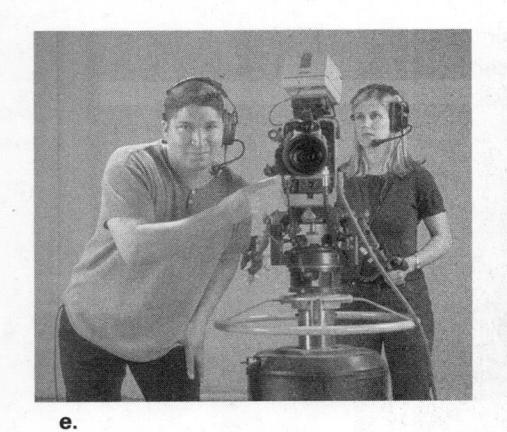

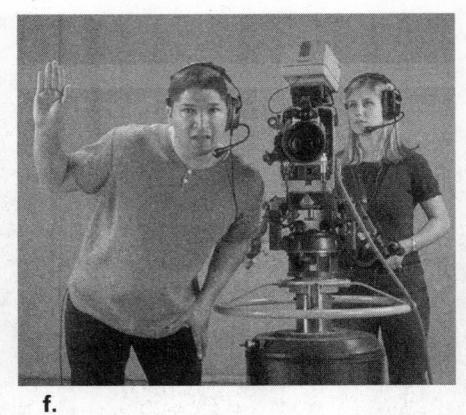

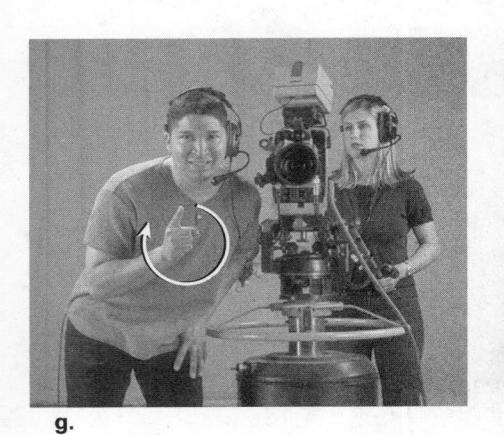

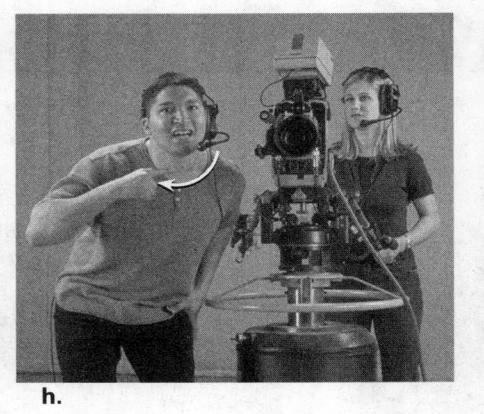

1g O O O O O O 9 10 11 12 13 O O O O O O 14 15 16 17 18

1h O O O O O O 9 10 11 12 13 O O O O O O 14 15 16 17 18

PAGE

2. The following pictures show various directional and audio cues given to the talent by the floor manager. From the list below, select the specific cue illustrated and fill in the bubble with the corresponding number.

(19) closer

(22) OK

(25) closer to mic

(20) step back

(23) speak up

(26) keep talking

(21) walk

(24) tone down

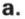

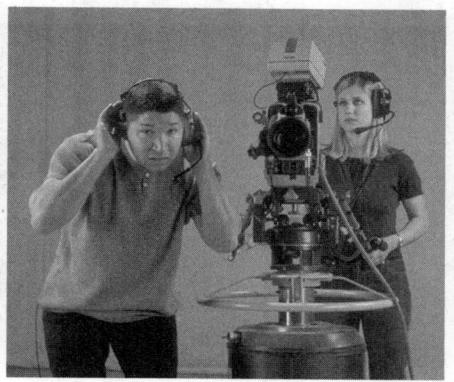

b.

O O O O 19 20 21 22 0000 23 24 25 26

2b 0000 19 20 21 22 0000 23 24 25 26

2d	0	0	0	(
	19	20	21	2

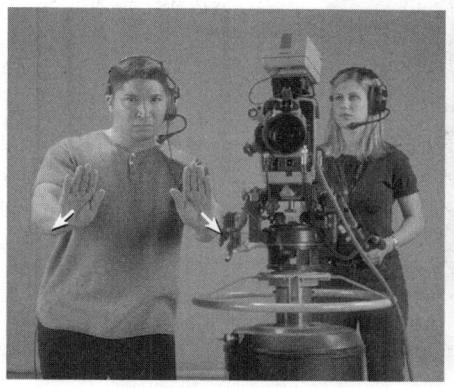

(19) closer (20) step back

(23) speak up (24) tone down

(22) OK

(25) closer to mic (26) keep talking

(21) walk

O O O O O 19 20 21 22 O O O O 23 24 25 26 2f O O O O O 19 20 21 22

O O O O 23 24 25 26

2g O O O O O 19 20 21 22 O O O O 23 24 25 26

2h ○ ○ ○ ○ ○ 19 20 21 22 O O O O O 23 24 25 26

g.
Select the correct answers and fill in the bubbles with the corresponding numbers.

3. From the list below, select the microphone most appropriate for the various performance and acting tasks and fill in the bubbles with the corresponding numbers.

(27) lavalier

(30) fishpole mic

(33) wireless hand mic (34) wireless lavalier

(28) boom mic (29) hand mic (31) stand mic (32) desk mic

a. interview with a celebrity at a busy airport gate

b. news anchors who remain seated throughout a studio newscast

31 32 33 34

31 32 33 34

c. moderating a panel discussion with six people

3c O O O O O 27 28 29 30

d. lead guitarist with a rock band, who also sings and talks to the audience

3d O O O O O 27 28 29 30

e. singer who is also dancing, accompanied by a large band

0000

 ${f f.}$ sounds of breathing and skis on snow during a downhill race

g. multiple-camera scene in a soap opera, involving three actors

31 32 33 34 3g O O O O

h. two actors doing an outdoor scene

31 32 33 34

27 28 29 30

ii. two actors doing an outdoor scen

31 32 33 34

P A G E T O T A L

4.	When demonstrating a product during a two-camera live show, you should orient the product toward the (35) <i>medium-shot camera</i> (36) <i>close-up camera</i> and keep looking at the (37) <i>medium-shot camera</i> (38) <i>close-up camera</i> . (Fill in two bubbles.)	4	35 0 37	36 O 38	
5.	When demonstrating a small object, you should (39) hold it as close to the lens as possible (40) keep it as steady as possible on the display table (41) lift it up for optimal camera pickup.	5	39	40	O 41
6.	When you receive cues during the actual video recording that differ from the rehearsed ones, you should (42) execute the action as rehearsed (43) promptly follow the floor manager's cues (44) check with the director.	6	O 42	O 43	O 44
7.	When wearing a lavalier mic, you should (45) maintain your voice level regardless of how far the camera is away from you (46) increase your volume when the camera gets farther away from you (47) speak more softly when the camera is relatively close to you.	7	45	46	47
8.	For the talent the most accurate indicator of the camera's field of view is the (48) relative distance between talent and camera (49) floor manager's cues (50) studio monitor.	8	48	49	50
9.	When asked for an audio level, you should (51) quickly count to 10 (52) say one sentence with a slightly lower voice than when on the air (53) speak with your on-the-air voice until told that the level has been taken.	9	51	52	53
0.	When you notice that you're looking into the wrong (not switched on-the-air) camera, you should (54) look down and then up again into the on-the-air camera (55) glance immediately over to the on-the-air camera (56) keep looking into the wrong camera until it is punched up on the air.	10	54	55	56
			G E T A L		
		SEC	TION		

© 2009 Wadsworth Cengage Learning

REVIEW OF ACTING TECHNIQUES				
Select the correct answers and fill in the bubbles with the corresponding numbers				
1. When on a close-up, you should (57) slow down (58) accelerate (59) change the rehearsed blocking of your actions.	1	O 57	58	59
2. The television camera looks at you primarily in (60) long shots (61) close-ups (62) low-level shots.	2	60	61	62
3. When acting for television, you should project your motions and emotions as you would on the stage (63) every time the camera is relatively far away (64) never (65) when there is a prolonged dialogue pause.	3	63	64	65
4. When blocked in the camera-far position in an O/S shot, you must make sure that you see the (66) <i>key light</i> (67) <i>floor manager</i> (68) <i>camera lens</i> .	4	66	67	68
5. A "blocking map" is (69) a rough map drawn by the floor manager (70) a mental map to remember prominent positions (71) the lines drawn on the floor by the AD.	5	69	O 70	71
6. When auditioning for a television drama, you should (72) apply your theatre technique to show that you have stage training (73) wear something unusual so the director will remember you (74) internalize the role as much as possible.	6	72	73	74
7. Television plays are video-recorded (75) in the order of scenes from the beginning to the end of the script (76) in brief scenes, grouped by settings, characters involved, and so forth (77) according to the mood of the director.	7	O 75	O 76	0 77
8. After the blocking rehearsal with the director, you (78) can make minor changes if the camera operator concurs (79) must keep the exact blocking as rehearsed (80) can suggest a different blocking during the video recording.	8	O 78	79	80
9. When repeating action for close-ups (such as drinking a glass of milk), you (81) use the opportunity to improve on what you have done in the long or medium shots (82) get a new glass and have it refilled for each close-up (83) use the same props and have your glass filled to the level just before the close-up.	9	81	82	83
10. When you notice that the boom mic has not quite caught up with you, you should (84) wait for the mic (85) continue with the dialogue (86) speak louder.	10	84	85	86
The real state of the state of	SEC	TAL		

	REVIEW OF MAKEUP AND CLOTHING		11/4/24		6
Sei	lect the correct answers and fill in the bubbles with the corresponding numbers.				
1.	Under high-color-temperature lighting, use (87) warm (88) cool (89) neutral makeup colors.	1	87	88	89
2.	When applying makeup the ideal lighting conditions are the same as or close to those of (90) <i>your customary dressing room</i> (91) <i>the actual production environment</i> (92) <i>normal 3,200K studio lights.</i>	2	90	91	92
3.	You can counteract a heavy five-o'clock shadow by applying a light layer of (93) bluish (94) skin-colored (95) yellow pan-stick.	3	93	94	95
4.	One of the most widely used makeup foundations is (96) cake (97) grease base (98) pan-stick.	4	96	97	98
5.	When working with a small single-chip camcorder under low-light conditions, you should avoid wearing (99) red (100) green (101) blue.	5	99	100	101
6.	As a weathercaster you can wear blue so long as the chroma-key backdrop is (102) blue (103) green (104) white.	6	O 102	103	104
7.	The dress of a pop singer has many rhinestones that sparkle under the colored stage lights. This dress is (105) acceptable (106) not acceptable because (107) the color camera can handle small areas of bright light (108) there is too much brightness contrast (109) it will cause moiré patterns (110) it will help raise the baselight level. (Fill in two bubbles.)	7	O 105 O C 107 108	0 106 0 0 0 3 109 11	
8.	Clothing with thin, highly contrasting stripes or checkered patterns is (111) acceptable (112) not acceptable because (113) the camera CCD can handle such a contrast (114) it provides exciting patterns (115) it causes moiré color vibrations (116) it is too detailed for the camera to see. (Fill in two bubbles.)	8	O 111 O C 113 114	O 112 0 O C 1 115 11) 6
					•
		SEC	TION		

REVIEW QUIZ

Mark the following statements as true or false by filling in the bubbles in the T (for true) or F (for false) column.

- 1. Television actors always portray someone else.
- 2. When you work with a teleprompter, it is best to move the camera as close to the talent as possible.
- 3. What you wear when auditioning for a role is unimportant.
- **4.** When you are on the air in a dramatic role, you must follow the rehearsed blocking precisely.
- 5. Talent includes both performers and actors.
- **6.** When the camera is relatively far from you, you should walk toward it for good close-ups.
- 7. When on a close-up, you must pick up the item you are demonstrating and hold it close to the camera lens.
- **8.** In an unrehearsed show, you can give the crew and the director a verbal warning cue of what you are going to do next.
- **9.** When on a panel, you should always reposition the desk mic so that it points directly at you.
- 10. When asked to give an audio level, you should count quickly to 10.

SECTION	
TOTAL	

T

F

PROBLEM-SOLVING APPLICATIONS

- 1. To practice blocking, write down a series of moves that carry you around your kitchen. For example, you can start at the stove, then get the teakettle out of the cupboard, fill it with water, and put it on the stove, go back to pick up the telephone, put down the telephone to answer the door, and so forth. Try to hit the same marks each time you go through the routine. If possible, have a friend video-record your blocking maneuvers from the same camera position. You can then compare the recordings and check how accurate your blocking was. As part of the same exercise, you can use various props (kitchen utensils) to see how the camera's field of view (LS to ECU) will influence your handling of them.
- 2. Use a product of your choice and video-record your pitch. What do you like about your performance? What don't you like? How could you improve your performance?
- 3. Pretend that you, person A, are receiving a telephone call from person B. In this scene we see and hear only person A (you). Using exactly the same dialogue (see the script on the following page), adapt your delivery and acting style to at least two of the following circumstances:
 - a. B calls to tell you that he/she has just got an exciting new job.
 - b. B calls to tell you that he/she has just lost his/her job.
 - c. B has just had an accident with your new car.
 - d. B has broken the engagement.
 - e. B has won first prize in a video competition.

Locate the scene anywhere you like. You may do well to write the other part of the phone conversation so that you can "listen" to the virtual B part of the dialogue and respond more convincingly.

4. Have a friend take close-ups of you when you do the phone exercise and compare your expressions when the phone call brings happy news and unhappy news.

PHONE CONVERSATION

PERSON A

Hello?

Hi.

Fine, and you?

Good.

No.

No, really. It's always good to hear from you.

I beg your pardon?

You must be kidding.

Yes.

No.

What does Alex say to all this?

No. Should I?

I don't know.

Perhaps.

You want me to come over now?

Yes. Really.

Well, this changes things somewhat.

I think so.

I'm not so sure.

Yes. No. I...

All right. But not...

OK.

If you think this is...

Definitely.

Good-bye... When?

No. Really.

Good-bye.

The Director in Production: Preparation

REVIEW OF KEY TERMS

Match each term with its appropriate definition by filling in the corresponding bubble.

- 1. visualization
- 2. storyboard
- 3. sequencing
- 4. locking-in
- 5. facilities request
- 6. production schedule
- 7. time line
- 8. process message
- 9. medium requirements
- A. A series of sketches of the key shots
- B. All content elements, production elements, and people needed to generate the defined process message
- C. The control and the structuring of a series of shots during editing
- D. An especially vivid mental image—visual or aural—during script analysis that determines the subsequent visualizations and sequencing
- E. The mental image of a shot or several key images of a sequence

- 0000
- B 00000 0000
- 00000 1 2 3 4 5 \bigcirc \bigcirc
- 00000 1 2 3 4 5 0000
- 00000 1 2 3 4 5 0000

PAGE

- 1. visualization
- 2. storyboard
- 3. sequencing
- 4. locking-in
- 5. facilities request
- 6. production schedule
- 7. time line
- 8. process message
- 9. medium requirements
- **F.** The calendar that shows the preproduction, production, and postproduction dates and who is doing what, when, and where
- **G.** The message actually received by the viewer while watching a television program
- H. A list that contains all technical facilities needed for a specific production
- I. A breakdown of time blocks for various activities on the actual production day

- F 0 0 0 0 0 0 1 2 3 4 5 0 0 0 0 6 7 8 9
- H O O O O O 1 2 3 4 5 O O O O 6 7 8 9

P A G E T O T A L	
SECTION	

REVIEW OF PROCESS MESSAGE AND PRODUCTION METHOD

- 1. Evaluate to what extent the following four process messages will (10) help (11) not help you visualize key show elements and provide (12) clear (13) only very few or no clues to the various medium requirements. (Fill in two bubbles.)
 - a. The program should make people drive better.
 - **b.** The program should demonstrate to the target audience (daily commuters) the benefits of turn signals and the consequences of ignoring them in rush-hour traffic.
 - c. The program should show the skills of a racecar driver.
 - d. This program is a series of comedy shows.
 - e. The program should make non-sports viewers admire, if not feel, the ballet-like skills of basketball players.
 - f. The program should help children learn about safety when walking to school.
 - g. The program should show five different ways a family can save water during their morning shower and grooming.
 - h. The program should help people save water.

- 1a O 0 10 11
 - 12
- 1b O 0 10 0 0 12 13
- 1c O 0 10 11 0 0
- 1d O 0
- 0 0 12 13
- 1e O 0 10 11 0 0 12
- 1f O 0 10 11 0 0

12

13

- 1g O 10 11 0 0 13
- 1h O 0 10 11 0 0

2.	A valuable process message should include (14) a specific audience (15) specific production equipment (16) the intended effect on the audience. (Multiple answers are possible.)	2	14	15	16
3.	Look at process message 1e. It suggests (17) a recorded live pickup of a professional basketball game (18) an EFP with staged plays on the basketball court (19) a live game restaged in the studio.	3	17	18	19
4.	Process message 1b suggests (20) a series of location EFPs for extensive postproduction (21) a studio show (22) a single half-hour field pickup during which a videographer is riding with a highway patrol officer in rush-hour	4	20	21	22
5.	The translation of process message to video images is greatly aided by (23) location scouting (24) a storyboard (25) a floor plan.	5	23	24	25
		n	A G	F	
		Ŧ	O T A	I L	
			CTIO		

REVIEW OF SCRIPT MARKING

1. Match each field-of-view designation with its appropriate full term by filling in the bubble with the corresponding number.

(26) cross-shot

(29) extreme

(32) close-up

(27) over-the-shoulder

close-up

(33) medium

shot

(30) medium shot

close-up

(28) long shot

(31) extreme long shot

(34) two-shot

a. CU

b. ECU

c. MCU

d. MS

e. O/S

f. X/S

g. 2-S

h. LS

i. ELS

1a O O O O O O 26 27 28 29 30 O O O

31 32 33 34 1b 0 0 0 0 0 0

1c O O O O O O 26 27 28 29 30

O O O O O 31 32 33 34

1d O O O O O O O 26 27 28 29 30

O O O O O 31 32 33 34

31 32 33 34 1f O O O O

1g O O O O O O 26 27 28 29 30

O O O O O 31 32 33 34

31 32 33 34 i O O O O

26 27 28 29 30 O O O 31 32 33 34

P A G E T O T A L

Select the correct answers and fill in the bubbles with the corresponding numbers.

2. The script markings in the following figure are (35) acceptable (36) unacceptable because they (37) are too small (38) have unnecessary or redundant cues (39) are in the wrong place (40) show large, essential cues. (Fill in two bubbles.)

2	0		0	
	35		36	
	0	0	0	C
	37	38	39	40

JOHN

What's the matter?

Ready camera 1 Ready to cue Tammy

TAMMY

Nothing.

Cue Tammy and take camera 1

JOHN

What do you mean, "nothing"? I can feel something is wrong.

TAMMY Ready to cue John Ready to take camera 2

Well, I am glad you have some feeling left.

JOHN Cue John and take camera 2

What's that supposed to mean?

TAMMY

Please, let's not start that again.

JOHN

Start what again?

TAMMY Ready to take camera 3 for a two-shot

Well, I guess it's time to talk.

Take comera 3

JOHN

What do you think we have been doing all this time?

P	A	G	Е	
T	0	TA	L	

3. Mark the following show opening of a series on basic video production. Memorize the cues so that you can devote your attention primarily to the preview monitors rather than to the script.

VIDEO BASICS SERIES

SHOW NO. 7

RECORDING DATE: July 15 AIR DATE: August 15

VIDEO

AUDIO

Opening Server 2

Music SOS (sound on source)

:08 sec

CU of Phil

PHIL

Hi, I'm Phil Kipper. Welcome to the Broadcast and Electronic Communication

Arts Series, "Video Basics." As

promised last week, we will take you to a special room where magic takes place:

the editing suite.

Pull out to reveal

PHIL

editing suite. Phil introduces Hamid.
CU of Hamid.

Let me introduce to you the magician in charge, Hamid Khani, whose official title

is senior postproduction editor.

2-shot

(SAYS HELLO TO HAMID AND HAS HAMID SAY HELLO TO THE AUDIENCE)

4. Mark the following brief scene for a three-camera live-recorded studio production or for a single-camera film-style production. Add any additional video cues you deem necessary. The scene takes place in the small office of a busy advertising executive. Draw a floor plan and prepare a shot sheet.

KIM

(Bursts into Gary's office)

Let's go for coffee.

GARY

I don't have time.

KIM

Oh, shucks, make time.

GARY

You seem to be in a good mood today.

KIM

I'm always in a good mood...

GARY

Especially when I'm around.

KIM

I'm not so sure about that...but, yes, let's go.

GARY

I really don't...

KIM

(Walks behind Gary's desk and starts kissing his neck.)

Don't what?

GARY

Forget it. Let's go.

(The telephone rings. Gary turns to answer it, but then lets it ring. He puts his arm around her. They both leave the office.)

5. The shot sheet for (41) camera 1 (42) camera 2 is incorrect because it has (43) consecutive shot numbers (44) discontinuous shot numbers (45) an unworkable shot sequence (46) insufficient information for the director. (Multiple answers are possible.)

5	0		0	
	41		42	
	0	0	0	0
	43	44	45	46

4

Shot *

1 CU of Kim

2 Follow her

3 Zoom To ECU

4 Truck left

5 Zoom in To CU

6 Dolly out

42

ShoT *

9 CU of Gary

12 0/5 Gary/Kim

16 Follow Kim

20 MS door; pick up Kim leaving

21 Follow Frank coming in

P A G E T O T A L	
SECTION	

REVIEW OF INTERPRETING STORYBOARDS

1. Each of the following four storyboards shows one or several major problems. Fill in the bubbles whose numbers correspond with one or more of these major problems: (47) poor continuity and disturbance of the mental map (48) wrong field-of-view designation (49) wrong above- or below-eye-level camera position. (Note: Storyboards may exhibit more than one problem.)

Storyboard a

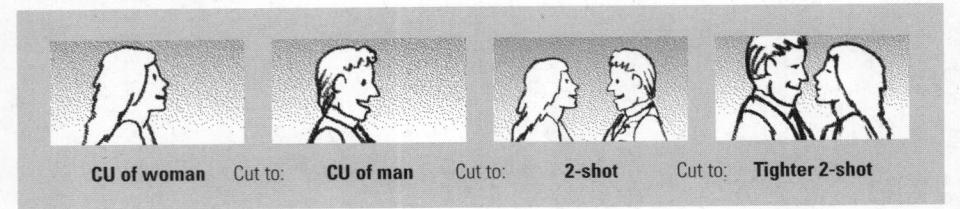

1a O O O 48 49

Storyboard b

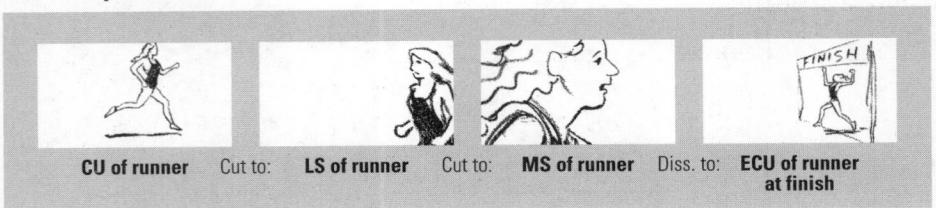

Storyboard c

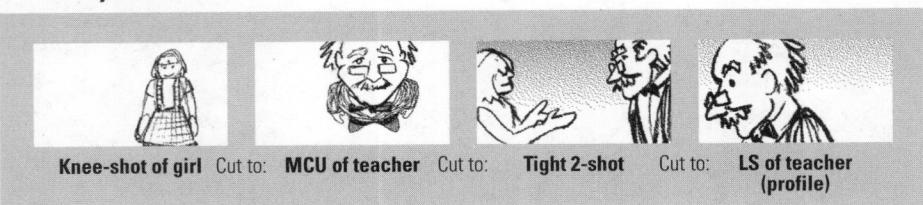

Storyboard d

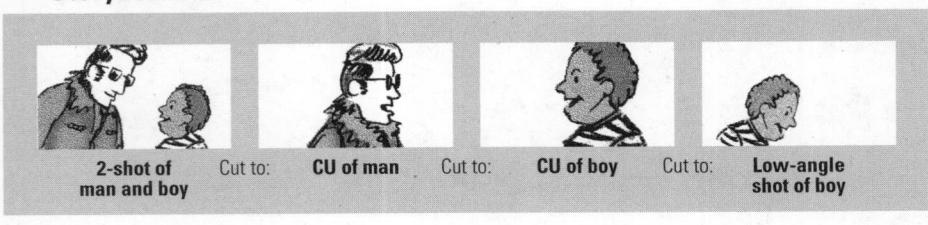

1d	0	0	0
	47	48	49

SECTION TOTAL

REVIEW OF SUPPORT STAFF

Identify the person mainly responsible for the following production activities and fill in the corresponding bubbles.

- 1. The novice news anchor would like to have the basic cues demonstrated. The cues should be demonstrated on the studio floor by the (50) floor manager (51) TD (52) director.
- 2. As the director, you want somebody to write down all major and minor problems that show up during rehearsal. For this job you would most likely ask the (53) *floor manager* (54) *producer* (55) *PA*.
- **3.** In the absence of a property manager, props are usually handled by the (56) *floor manager* (57) *art director* (58) *AD*.
- **4.** In elaborate multicamera productions or digital cinema, some of the scenes are sometimes directed by the (59) *floor manager* (60) *AD* (61) *PA*.
- **5.** To put up and dress the new lawyer's set is the responsibility of the (62) art director (63) floor manager (64) PA.

0	0	0
50	51	52

2	0	0	0
	53	54	55

3	0	0	0
	56	57	58

4	0	0	0
	59	60	61

5	0	0	0
	62	63	64

SECTION TOTAL

REVIEW OF TIME LINE

Select the correct answers and fill in the bubbles with the corresponding numbers.

- 1. Each of these time-line listings is (65) acceptable (66) unacceptable, because (67) the time allotted for this production activity is appropriate (68) it allots too much time for the specific production activity (69) it allots too little time for the specific production activity. (Fill in two bubbles.)
 - a. Time Line May 25: Live-recorded 20-minute interview with college president on a standard interview set. She brings a model of the new library building, which needs to be set up in an adjacent area.

(1)	8:15 a.m.	Crew call	1a	(1)	65 6	C
(2)	8:30–9:00 a.m.	Tech meeting	1a	(2)	65 6	O 66 O 68
(3)	9:00–11:00 a.m.	Setup and lighting	1a	(3)	65 6	S66 S68
(4)	11:00–11:30 a.m.	Lunch	1a	(4)	65 6	66 68
(5)	11:30–11:45 a.m.	Notes and reset	1a	(5)	65 (66 68
(6)	11:45 a.m.–12:00 p.m.	Briefing of president (Green Room)	1a	(6)	65 (66 68
(7)	12:00–12:30 p.m.	Run-through and camera rehearsal	1a	(7)	65	0 66 0 68
(8)	12:30–12:45 p.m.	Notes	1a	(8)	65	66 68

P	A	G	Е		
т	0 -	T A	1		

65 66 000 67 68 69

65 66 000 67 68 69

65 66 000 67 68 69

65 66 000 67 68 69

65 66 000 67 68 69

65 66 000 67 68 69

65 66 000 67 68 69

(8) 0 0 65 66 000 67 68 69 (9) 12:45-1:00 p.m.

Reset

1a (9) O O 65 66 000

(10) 1:00-1:10 p.m.

Break

1a (10) O O 65 66 000

67 68 69

67 68 69

000 67 68 69

(11) 1:10–1:45 p.m.

Record

1a (11) O O 65 66

(12) 1:45-1:55 p.m.

Spill

1a (12) O O

65 66 000 67 68 69

(13) 1:55-2:10 p.m.

Strike

- 1a (13) O O 65 66
 - 000 67 68 69
- b. Time Line June 2: Multicamera shoot for postproduction of two songs by a local rock group.
 - (1) 6:00 a.m.

Crew call

- 1b (1) O O 65 66
 - 000 67 68 69

(2) 6:15–6:35 a.m.

Tech meeting

- 1b (2) O O 65 66
 - 000

(3) 6:35–7:00 a.m.

(4) 7:00–9:30 a.m.

Setup and lighting

Production meeting

(5) 9:30 a.m.-12:30 p.m. First run-through with cameras

- 1b (3) O O 65 66
- 000 67 68 69 1b (4) O O
 - 65 66 000 67 68 69
- 1b (5) O O 65 66
 - 000 67 68 69

PAGE TOTAL

Each of these time-line listings is (65) acceptable (66) unacceptable, because (67) the time allotted for this production activity is appropriate (68) it allots too much time for the specific production activity (69) it allots too little time for the specific production activity. (Fill in two bubbles.)

(6)	12:30–2:30 p.m.	Lunch
(7)	2:30–2:45 p.m.	Record first song
(8)	2:45–3:30 p.m.	Notes and reset
(9)	3:30–5:00 p.m.	Record second song
(10)	5:00–6:00 p.m.	Strike

1b (6)	65	66		
1b (7)	65	66		
1b (8)	65	66		
1b (9)	65	66		
1b (10)	65	0 66 0 68	\sim	

P A G E T O T A L	
SECTION	

REVIEW QUIZ

Mark the following statements as true or false by filling in the bubbles in the T (for true) or F (for false) column.

- 1. Because the director is engaged in artistic activities, knowledge of technical production aspects is relatively unimportant.
- 2. Although the process message is important to the director in the production phase, it is relatively unimportant in preproduction.
- 3. Proper visualization is essential for correct sequencing.
- 4. A good floor plan will greatly facilitate camera and talent blocking.
- 5. Experienced floor managers will cue on their own if they think the director has missed a cue.
- 6. Whereas script marking is important when directing from a dramatic script, it is unnecessary when directing from a two-column A/V script.
- 7. When preparing camera shot sheets, the shots for each camera are listed in the order they appear in the script.
- 8. If the script marking simply indicates "(2)" for one shot and "(3)" for the next, it implies that you should give a "Ready three" cue and then call for a "Take three."
- 9. The locking-in point means that you conjure up a vivid visual or aural image while analyzing the script.
- **10.** A storyboard shows the key visualization points of an event.
- 11. Dramas are always fully scripted.
- 12. The drama script format requires the full dialogue of all actors but only a minimum of visualization cues.
- 13. In a properly scripted documentary, all audio information is on page-left and all video information is on page-right.
- 14. A good storyboard helps the director visualize a shot and determine camera positions.
- **15.** The time line and the production schedule are essentially the same.
- 16. In a complex multicamera show, the AD will normally give stand-by cues.

SEC	TIC		
0	TA	L	N. 3 34

F

0

0

73

0 75

0

77

0

0

0

0

85

0

0

0

91

0

0

0

0 99 0

101

0

0

72

0

0

76

0

0

0

0

0

12 0

14

15 🔾

16 100

90

0

11

PROBLEM-SOLVING APPLICATIONS

- 1. The director of a weekly live sports show (consisting of a host and a prominent guest) tells the producer that she does not need a detailed script but that a show format will do just fine. What is your reaction?
- 2. When asked to direct an on-location television adaptation of the current theater arts department stage play at the local park, you are advised that the director of the play will determine the number and the positions of the cameras because he, after all, knows the stage blocking better than you do. What is your reaction? What would you suggest?
- 3. The director of a live-recorded segment of a new situation comedy tells you, the producer, that she has great difficulty deciding on optimal camera positions and marking the script because the art director has not yet finished the floor plan. What is your reaction? What would you suggest?
- 4. While you, the director, are preparing an EFP of a documentary segment on the lumber industry, the producer tells you not to worry too much about shot continuity because he intends to put the show together in extensive postproduction editing. Do you agree with the producer? If so, why? If not, why not?
- 5. The novice director proudly shows you, the producer, his marked show format for a live-recorded studio interview. He wrote out in longhand all the ready and take cues as well as all the cues for special effects. His writing takes up more space than the information of the show format. What is your reaction? Why?
- **6.** The floor manager tells the new morning show director that she can't manage the setup of scenery and props because the art director has not yet provided her with a floor plan. What is your response?
- 7. If you were to describe to the producer the locking-in point when reading a dramatic script, what would you tell him?
- 8. The director of a number of successful digital movies tells you that "hearing" a shot can sometimes help the visualization process more than trying to "see" it. What does he mean by that?
- 9. Mark two or three scenes of a dramatic script, first for a three-camera liverecorded studio production and then for a single-camera studio production. Note the differences.
- 10. Prepare time lines for two studio productions and two EFPs.
- 11. Observe the scene while riding on a bus or train, waiting in line at an airport, eating lunch in a cafeteria, or sitting in a classroom listening to a lecture. How would you re-create one or all of these scenes for a multicamera or single-camera production?

The Director in Production: Directing

REVIEW OF KEY TERMS

Match each term with its appropriate definition by filling in the corresponding bubble.

- 1. running time
- 5. multicamera directing
- 8. intercom

- 2. walk-through
- 6. dress rehearsal

7. schedule time

9. single-camera directing

- 3. camera rehearsal
- 4. dry run

- A. A communication system widely used by all production and technical personnel so that they can communicate with one another during a show
- **B.** Duration of a program or program segment
- C. The times when a program starts and stops
- D. A full rehearsal with cameras and other pieces of production equipment
- E. An orientation session on the set with the production crew and talent

- 00000 0000
- 00000
- 00000 1 2 3 4 5 0000
- 00000 1 2 3 4 5 0000
- 00000 1 2 3 4 5 0000

PAGETOTAL

- 1. running time
- 2. walk-through
- 3. camera rehearsal
- 4. dry run

- 5. multicamera directing
- 6. dress rehearsal
- 7. schedule time
- 8. intercom
- 9. single-camera directing
- F. Full rehearsal with talent made-up and dressed
- **G.** The coordination of one camera for takes that are separately recorded for postproduction
- H. A rehearsal without equipment
- I. The simultaneous coordination of two or more cameras for instantaneous editing

- F 0 0 0 0 0 0 1 2 3 4 5 0 0 0 0 6 7 8 9

P A G E T O T A L SECTION

REVIEW OF DIRECTOR'S TERMINOLOGY

- 1. Director's visualization cues. From the list below, select the cue necessary to adjust the picture on the left screen to the picture on the right screen (in pairs from a through I) and fill in the bubbles with the corresponding numbers.
 - (10) tilt up
- (15) zoom out
- (19) pedestal up or

- (11) tilt down
- (16) truck right
- crane up

- (12) dolly in
- (17) arc left
- (20) pan left

- (13) dolly out
- (18) pedestal down
- (21) pan right

(14) zoom in

- or crane down

- 1a 0000 10 11 12 13
 - 0000 14 15 16 17
 - 0000 18 19 20 21

b.

- 1b 0000 10 11 12 13
 - 0000 14 15 16 17
 - 0000 18 19 20 21

- 1c 0000 10 11 12 13
 - 0000 14 15 16 17
 - 0000 18 19 20 21
- P A G E T O T A L

- (10) tilt up
- (11) tilt down
- (12) dolly in
- (13) dolly out
- (14) zoom in
- (15) zoom out
- (16) truck right
- (17) arc left
- (18) pedestal down or crane down
- (19) pedestal up or crane up
- (20) pan left
- (21) pan right

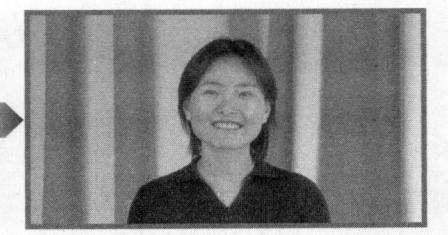

1d O O O O O 10 11 12 13 O O O O 14 15 16 17 O O O 18 19 20 21

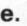

f.

P A G E T O T A L

1g 0000 10 11 12 13 O O O O 14 15 16 17 O O O O O 18 19 20 21

0000 10 11 12 13 O O O O 14 15 16 17 O O O O 18 19 20 21

O O O O O 10 11 12 13 O O O O 14 15 16 17 O O O O 18 19 20 21

1j O O O O O 10 11 12 13 O O O O 14 15 16 17 O O O O 18 19 20 21

P A G E

- (10) tilt up
- (11) tilt down
- (12) dolly in
- (13) dolly out
- (14) zoom in
- (15) zoom out
- (16) truck right
- (17) arc left
- (18) pedestal down or crane down
- (19) pedestal up or crane up
- (20) pan left
- (21) pan right

k

1.

2. Director's sequencing cues.

- **a.** From the list below, select the correct director's cues for transitions by filling in the corresponding bubbles. (**Multiple answers are possible.**)
 - (22) Ready to take camera two. Take camera two.
 - (23) Ready three. Take three.
 - (24) Ready one. Dissolve to one.
 - (25) Ready to go to black. Go to black.
 - (26) Ready wipe. Dissolve to two.
 - (27) Ready to change C.G. page. Change page.

2a	0	0	0
	22	23	24
	0	0	0
	25	26	27

P A G E

b. From the list below, select the director who uses the correct sequence of cues for the opening of a two-camera (C1 and C2) interview and fill in the corresponding bubble. (There is a title key for the guest. Assume that the crew has received a general standby cue and that bars and tone have already been recorded on the tape by the AD.)

(28) *Director A:* "Ready to take C.G. Slate. Take slate. Ready black. Black. Beeper. Ready to come up on one CU of host—take one. Cue host. Ready two [on guest]. Take two. Cue guest. Key title. Take one."

(29) *Director B:* "Ready to roll video recorder. Roll video recorder. Ready C.G. Slate. Take C.G. Read slate. Ready black. Ready beeper. Beeper. To black. Change page [C.G.]. One, CU of host. Ready to come up on one. Open mic, cue host, up on one. Two, CU of guest. Ready two. Ready key C.G. Take two, key. Lose key. Ready one, two-shot. Take one."

(30) *Director C:* "Ready to roll video recorder. Roll video recorder. Ready C.G. Slate. Ready slate. Ready black. Ready beeper. To black. Beeper. Ready to come up on one. Up on one. Ready two. Take two. Key. Lose key. Ready one. Take one."

- c. From the list below, select the correct director's cues to the floor manager by filling in the corresponding bubbles. The talent are Mary, Lisa, John, and Larry. (Multiple answers are possible.)
 - (31) Ready to cue Mary. Cue Mary.
 - (32) Ready to cue him. Cue him.
 - (33) Make him talk faster.
 - (34) Move her stage-right.
 - (35) Turn the sculpture counterclockwise.
 - (36) Give Lisa the wind-up.
- 3. Director's cues to floor manager concerning the positioning of props.

Select the appropriate cue to the floor manager to adjust the position of the prop shown on the left screen to that of the right screen and fill in the bubbles with the corresponding numbers.

- (37) turn the sculpture clockwise
- (38) turn the sculpture counterclockwise

3	0	0
	37	38

2b O

0

31

0

32

0

0

0

30

0

33

0

P	AG	Е	
Т	OTA	L	

(39) move talent to camera right

(40) pan right

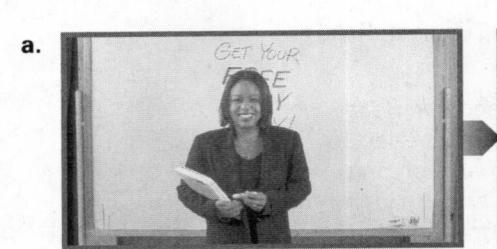

4a O C

- (41) have talent turn in [toward the camera]
- (42) have talent move left

4b O O

- (43) have woman turn to her left
- (44) have camera arc right

C.

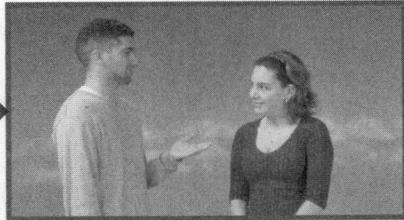

	0	
4C	0	C
	43	44

AGEOTAL

SECTION

© 2009 Wadsworth Cengage Learning

	REVIEW OF REHEARSAL TECHNIQUES				
Se	lect the correct answers and fill in the bubbles with the corresponding numbers.				
1.	When doing a walk-through/camera rehearsal combination from the studio floor, you should give (45) all cues as though you were directing from the control room (46) only the talent cues (47) only the camera cues.	1	O 45	O 46	O 47
2.	If pressed for time, you should call for (48) an uninterrupted camera rehearsal (49) a blocking rehearsal (50) a walk-through/camera rehearsal combination.	2	O 48	O 49	50
3.	Blocking rehearsals are most efficiently conducted from (51) the control room (52) the studio floor or rehearsal hall (53) the actual studio set.	3	51	52	53
4.	When doing a single-camera ENG or EFP, you should (54) always get a fair amount of cutaways (55) get cutaways only if you think your shots will not cut together well (56) not bother with cutaways if you have plenty of time for postproduction.	4	54	55	56
5.	When engaged in EFP, you need not worry about (57) talent and technical walk-throughs (58) cross-overs from one location to the next (59) the various camera positions.	5	57	O 58	59
6.	Camera rehearsal is conducted (60) similar to a dress rehearsal (61) for cameras only (62) for all technical operations but without talent.	6	60	61	O 62
7.	When scheduling "notes" segments in your time line, you need to also schedule (63) additional talent rehearsal time (64) reset time (65) additional technical rehearsal time.	7	63	64	65
8.	When breaking down an EFP script for a single-camera production, you should (66) try to maintain the narrative order of the scenes (67) combine all scenes that play at the same location and/or with the same talent (68) start with the most interesting parts to take advantage of the talent's creative energy.	8	66	67	68
9.	Rehearsals that combine walk-throughs and camera rehearsal are most efficiently conducted from the (69) studio floor (70) rehearsal hall (71) control room.	9	69	70	O 71
10.	When calling for a "take," you should pause between the "ready" and the "take" cues (72) as little as possible (73) until you see the TD put his finger on the correct switcher button (74) for at least five seconds.	10	O 72	73	74

SECTION TOTAL

REVIEW OF MULTICAMERA DIRECTING

1. Assume that the following six shots represent a sequence of video inputs on the preview monitor in the order you will switch them to the line-out. Using the floor plan below, specify the cameras and the other video inputs used for the shots. Note that one video input does not originate in the studio and another uses two video sources simultaneously. (Multiple answers are possible.)

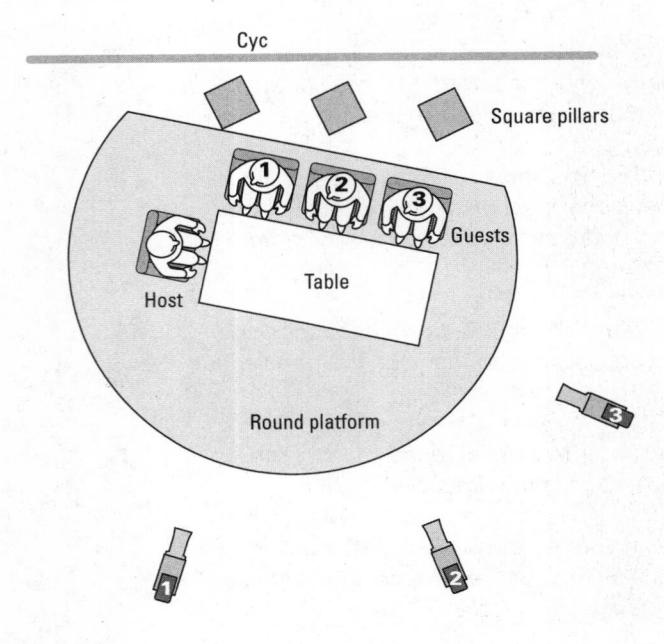

Sources:

(75) camera 1

(76) camera 2

(77) camera 3

(78) videotape 1

(79) C.G.

a.

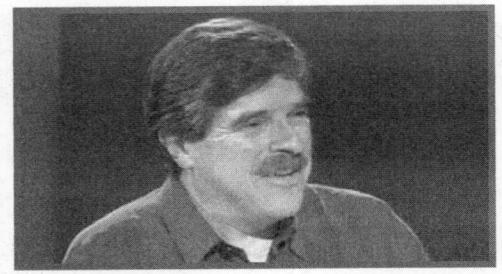

Host

1a O O O O O O 75 76 77 78 79

P A G E T O T A L b.

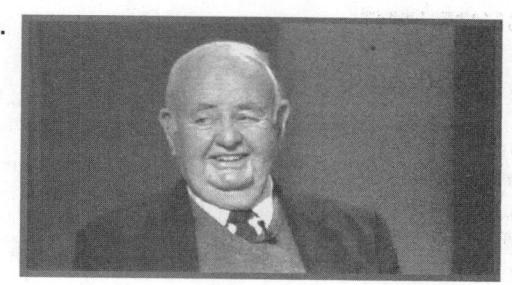

Guest 1

1c O O O O O O 75 76 77 78 79

d.

Guest 2

1d O O O O O O 75 76 77 78 79

Guest 3

1e O O O O O O 75 76 77 78 79

1f O O O O O O 75 76 77 78 79

P A G E T O T A L

SECTION TOTAL

	REVIEW OF TIMING				
ele	ect the correct answers and fill in the bubbles with the corresponding numbers.				
1.	The log indicates that the <i>Women: Face-to-face</i> program ends at 11:26:30. A large part of the program is taken up by a fashion show. The fashion coordinator would like a 1-minute, a 30-second, and a 15-second cue, as well as a cut at the end of her segment. The regular program host, who follows the fashion show with a 1½-minute closing, would like a 30-second and a 15-second cue and a cut at the end of the program. From the list below, select the correct clock times for the cues.	1	80	81	82
	(80) 11:24:00, 11:24:30, 11:24:45, 11:25:00 and 11:26:00, 11:26:15, 11:26:30				
	(81) 11:24:30, 11:25:00, 11:25:45, 11:26:00 and 11:26:15, 11:26:30				
	(82) 11:22:00, 11:23:00, 11:24:00, 11:24:30 and 11:25:00, 11:26:00, 11:26:15				
2.	In the noon newscast, you must switch to the first 3-minute satellite feed at exactly 3:45 minutes into the show and the second feed at 15:15 minutes after the end of the first one. You need to switch to the remote feeds at:	2	83	84	85
	(83) 12:03:45 and 12:19:00				
	(84) 12:03:45 and 12:22:00				
	(85) 12:03:45 and 12:15:15				
3.	Subjective time refers to (86) the running time of the show segment (87) how fast or slow it seems to move (88) how the parts of the segment relate to one another.	3	86	87	888
			CTION		
© 2009 Wadsworth Cengage Learning

REVIEW OF SINGLE-CAMERA DIRECTING

Select the correct answers and fill in the bubbles with the corresponding numbers.

- 1. When directing single-camera style, you (89) can visualize each shot independent of all others (90) can do away with cutaways (91) need to be concerned about continuity of widely dispersed shots.
- 2. In single-camera directing, camera placement is (92) not important because you are shooting from various angles anyway (93) very important to ensure continuity (94) determined primarily by where the actors are.
- **3.** When directing single-camera style, you should (95) rehearse all shots before ever activating the camera (96) rehearse each shot before the take (97) rehearse the shots in the order of the storyboard narrative.
- **4.** When directing single-camera style in the studio, you need to rehearse and direct each shot (98) always from the control room (99) always from the studio floor (100) from either the control room or the studio floor.
- **5.** When directing single-camera style in the field, you need (101) the camera hooked up to a field monitor (102) to use the camera viewfinder to correct shots (103) neither a field monitor nor a viewfinder.

1	89	90	91
2	92	93	94

3	0	0	C
	95	96	97

4	0	0	C
	98	99	100

5	0	0	0
	101	102	103

SECTION		
TOTAL	SECTION	
	TOTAL	

	REVIEW QUIZ			
	k the following statements as true or false by filling in the bubbles in the or true) or F (for false) column.			
1.	Keeping accurate running time is more important in directing a live multicamera show than a single-camera EFP.	1	T O 104	F O 105
2.	When directing a studio show, the S.A. system is more appropriate than the P.L. system.	2	106	107
3.	During a walk-through/camera rehearsal combination, the director rehearses primarily from the studio floor.	3	108	109
4.	When directing from the control room, you should address the name of the camera operator rather than the camera number to get efficient camera action.	4	110	O 111
5.	When directing a fully scripted show, you should pay more attention to the script than the preview or line monitors.	5	O 112	O 113
6.	When doing an EFP, the talent and technical walk-throughs are less important than when doing a studio show.	6	O 114	O 115
7.	When directing a daily newscast, you do not need a floor plan to preplan the camera shots.	7	116	O 117
8.	You should tell the floor manager whenever there is a technical problem that you need to solve from the control room.	8	O 118	119
9.	Even when doing an EFP, you should check the video recording to see whether the preceding scene was properly recorded before moving to the next location.	9	120	O 121
10.	Cutaways are especially important in film-style shooting.	10	122	O 123
11.	When directing a single-camera EFP, a properly working intercom system is one of the most essential setup items.	11	124	125
12.	Even with an efficient intercom system, the switcher should be located right next to the director's position.	12	126	O 127
13.	To save time in a studio rehearsal, you should use the S.A. system as often as possible.	13	128	O 129
14.	A separate monitor that carries the camera's video greatly facilitates single-camera directing.	14	130	131
15.	The floor manager's cues are especially important when engaged in single-camera EFP.	15	132	O 133
		SEC	CTION	

PROBLEM-SOLVING APPLICATIONS

- 1. Mark a scene from a fully scripted TV play and practice calling the shots.
- 2. During the video recording of the first scene of a demanding outdoor EFP for a car commercial, the audio person suggests doing a retake because she picked up a brief, distant jet sound. Would you recommend a retake? If so, why? If not, why not?
- **3.** During the evening news, the wrong video-recorded story comes up. What can you do?
- **4.** During an O/S sequence in a multicamera dramatic production, one of the actors has trouble hitting the blocking marks and is frequently obscured by the camera-near person. What advice would you give the actor?
- **5.** Get a published script of an episode of a drama or soap opera and mark it for three-camera and single-camera directing.
- **6.** The director uses one set of commands during rehearsal but switches to another when doing the on-the-air show. Which potential problems do you foresee, if any? Be specific.
- 7. The producer suggests that you not waste valuable time by doing a walk-through/camera rehearsal from the studio floor but skip right to the camera rehearsal from the control room. What is your reaction? Why?
- **8.** When checking all the intercom systems before a remote live telecast of a large political gathering at city hall, the talent's I.F.B. interrupts itself from time to time. What backup cueing device would you recommend that close to airtime?
- **9.** When pressed for time, the director decides to conduct the rehearsal from the studio floor. Would you agree or disagree with such a move? Be specific. How, if at all, would the director's request affect the studio equipment and the control room activities?
- **10.** The floor manager expresses her concern to you, the director, about the lack of adequate intercom facilities for an EFP of the local garden show. How would you respond?

1.1.2年中華 中国名"中国" (A) 1643 1645年

and the first of the second of

Field Production and Big Remotes

REVIEW OF KEY TERMS

Match each term with its appropriate definition by filling in the corresponding bubble.

- 1. broadband
- 2. Ku-band
- 3. mini-link
- 4. big remote
- 5. remote survey
- 6. uplink
- 7. downlink
- 8. instant replay
- 9. microwave relay
- 10. field production
- 11. direct broadcast satellite
- 12. iso camera
- A. A variety of information sent simultaneously over a fiber-optic cable
- B. A signal transport from the remote location to the station or transmitter in various transmission steps
- C. Repeating a key play or an important event for the viewer, through playing back by videotape or disk-stored video, immediately after its live occurrence
- D. A high-frequency signal used by satellites

- 0000 0000 5 6 7 8 0000
- 0000 1 2 3 4 0000 5 6 7 8 0000 9 10 11 12
- 0000 1 2 3 4 0000 5 6 7 8 0000 9 10 11 12
- 0000 1 2 3 4 0000 0000 9 10 11 12

AGOTA		
0 1 7	_	

10. field production 6. uplink 1. broadband 11. direct broadcast 2. Ku-band 7. downlink satellite 8. instant replay 3. mini-link 12. iso camera 9. microwave relay 4. big remote 5. remote survey $\bigcirc \bigcirc \bigcirc \bigcirc \bigcirc \bigcirc \bigcirc$ $1 \quad 2 \quad 3 \quad 4$ E. A production outside the studio to televise live and/or live-record a large scheduled event 0000 5 6 7 8 O O O O 9 10 11 12 F 0000 F. A satellite with a high-powered transponder 1 2 3 4 0000 5 6 7 8 0000 9 10 11 12 G 0000 G. Any production that occurs outside of the studio 1 2 3 4 0000 5 6 7 8 0000 9 10 11 12 H 0000 H. A preproduction on-location investigation of the existing facilities of a 1 2 3 4 scheduled telecast away from the studio 0000 5 6 7 8 0000 9 10 11 12 0000 I. An earth station transmitter used to send video and audio signals to a satellite 1 2 3 4 0000 0000 9 10 11 12 0000 J. An antenna and equipment that receives the signals coming from a satellite 1 2 3 4 0000 5 6 7 8

> P A G E T O T A L

9 10 11 12

- K. Often used in sports remotes; feeds into the switcher and its own video recorder
- $\bigcirc \bigcirc \bigcirc \bigcirc \bigcirc \bigcirc \bigcirc \bigcirc$ $1 \quad 2 \quad 3 \quad 4$ 0000 9 10 11 12
- L. A setup of several small microwave transmitters and receivers to transport the television signal around obstacles
- 0000 $\bigcirc \bigcirc \bigcirc \bigcirc \bigcirc \bigcirc \bigcirc \bigcirc \bigcirc$ $5 \quad 6 \quad 7 \quad 8$ O O O O 9 10 11 12

P A G E T O T A L	
SECTION	

	REVIEW OF FIELD PRODUCTION				
Sele	ect the correct answers and fill in the bubbles with the corresponding numbers.				
1.	A complex intercommunication system is most important for (13) <i>ENG</i> (14) <i>EFP</i> (15) <i>big remotes</i> .	1	O 13	O 14	O 15
2.	Using multiple cameras or camcorders in EFP means that they (16) run in sync (17) must feed a switcher (18) shoot a scene simultaneously.	2	O 16	O 17	18
3.	The most flexible type of field production that needs little or no preproduction is (19) ENG (20) EFP (21) big remotes.	3	19	20	O 21
4.	The field production that affords the most control over the event is (22) ENG (23) EFP (24) a big remote.	4	22	23	24
5.	A floor manager is most important in (25) ENG (26) EFP (27) big remotes.	5	O 25	O 26	O 27
6.	The directing procedure that most closely resembles multicamera studio production is (28) ENG (29) EFP (30) a big remote.	6	28	29	30
7.	The walk-through rehearsal is least important for (31) ENG (32) EFP (33) big remotes.	7	31	32	33
8.	A big-remote survey requires (34) only a production survey (35) only a technical survey (36) both a production and a technical survey.	8	34	35	36
9.	Instant replays are most common in (37) big remotes (38) EFP (39) ENG.	9	37	38	39
10.	Because the camera setup is done by technical personnel, the director is (40) not needed (41) very important (42) consulted only in emergencies for the specific locations of the key cameras.	10	O 40	O 41	O 42
11.	The remote system least likely to use signal transmission equipment is (43) ENG (44) EFP (45) big remotes.	11	43	O 44	O 45
12.	The field production that almost always requires careful postproduction is (46) ENG (47) a big remote (48) EFP.	12	O 46	O 47	O 48
13.	To ensure access to the event location, you need (49) a contact person (50) a written statement from the producer (51) an OK from the chief of police.	13	O 49	50	51
14	The normal transmission equipment in ENG vans is (52) a microwave transmitter (53) a satellite uplink (54) fiber-optic cable.	14	O 52	53	O 54
		SE	CTION		•

REVIEW OF BIG REMOTES

1. Analyze the following five location sketches for field productions and big remotes. Evaluate the type and the position of each camera by the criteria listed below and fill in the bubbles with the corresponding numbers.

(Multiple answers are possible.)

- (55) camera position OK
- (56) wrong or unnecessary camera position
- (57) inappropriate camera type
- (58) cable hazard
- (59) lighting problems (shooting into the sun or against another strong light source)

Key for camera type:

ENG/EFP camera or camcorder

Studio/field camera

- (55) camera position OK
- (56) wrong or unnecessary camera position
- (57) inappropriate camera type
- (58) cable hazard
- (59) lighting problems (shooting into the sun or against another strong light source)

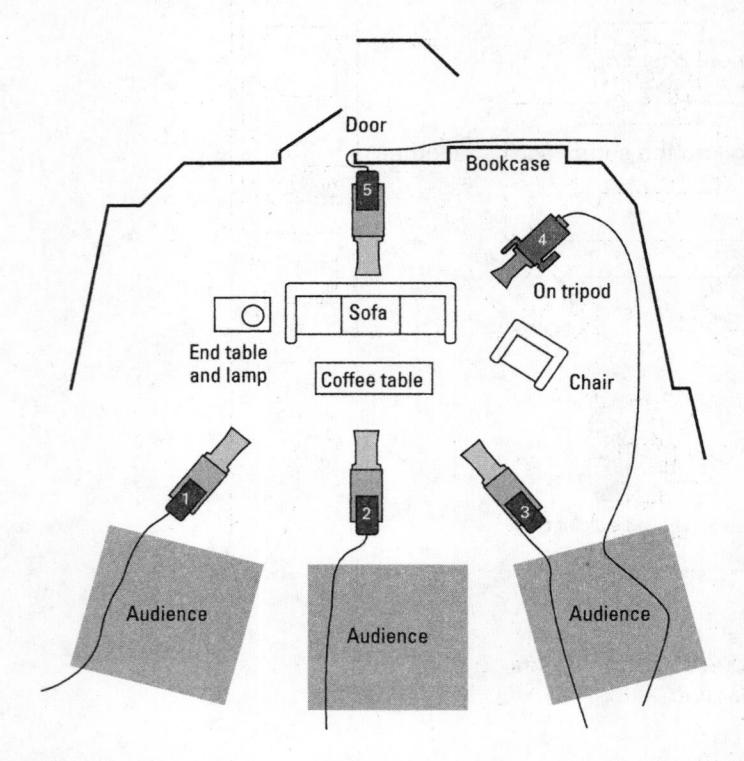

Play

Video recording of two performances of a high-school play (situation comedy) with a live audience, minimal postproduction, and the use of a large remote truck

- a. comments on C1
- b. comments on C2
- c. comments on C3
- d. comments on C4
- e. comments on C5

		0	56	57	
1b (C2	○ 55 ○ 58	56	57	
1c (C3	○ 55 ○ 58	56	57	
1d (C4	5558	56	57	
1e (C 5	55 58	56	57	
PATOT	G A	E [

1a C1 0 0 0

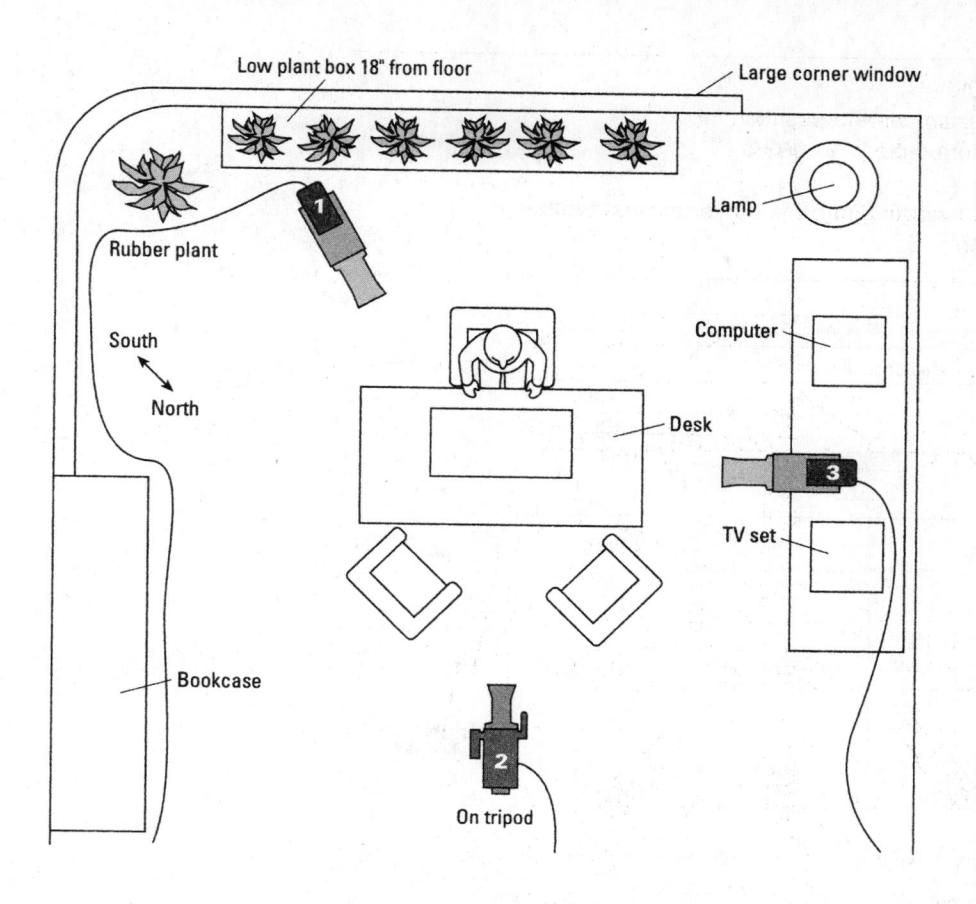

EFP of Company President's Address to Employees

Live-recorded or minimal postproduction

Recording date: July 15

Recording time: 2:30 p.m. to 4:30 p.m.

Place: President's office, Tower Building, 34th floor

- f. comments on C1
- g. comments on C2
- h. comments on C3

1f	C1	55	○ 56 ○ 59		
1g	C2	55	○ 56 ○ 59	57	
1h	C3	55	○ 56 ○ 59		
P A	G T A	EL			

- (55) camera position OK
- (56) wrong or unnecessary camera position
- (57) inappropriate camera type
- (58) cable hazard
- (59) lighting problems (shooting into the sun or against another strong light source)

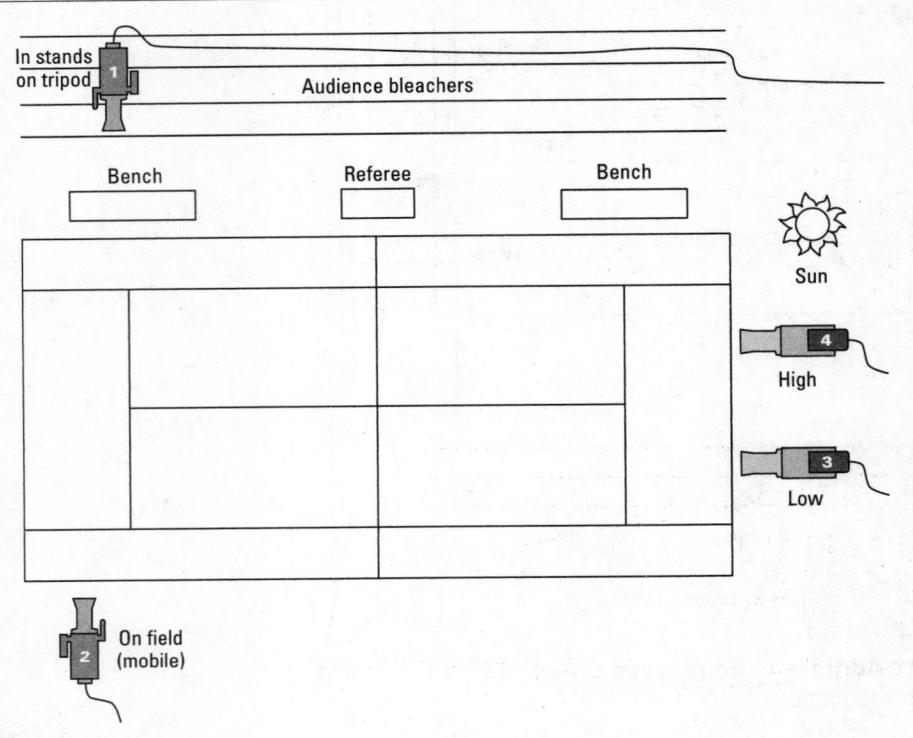

Tennis Match

Live coverage of tennis match

- i. comments on C1
- j. comments on C2
- k. comments on C3
- I. comments on C4

1i	C1	55 58	56	57	
1j	C2	55	56	57	
1k	СЗ	55	○ 56 ○ 59	57	
11	C4	55	○ 56 ○ 59		
PA	G	E			

© 2009 Wadsworth Cengage Learning

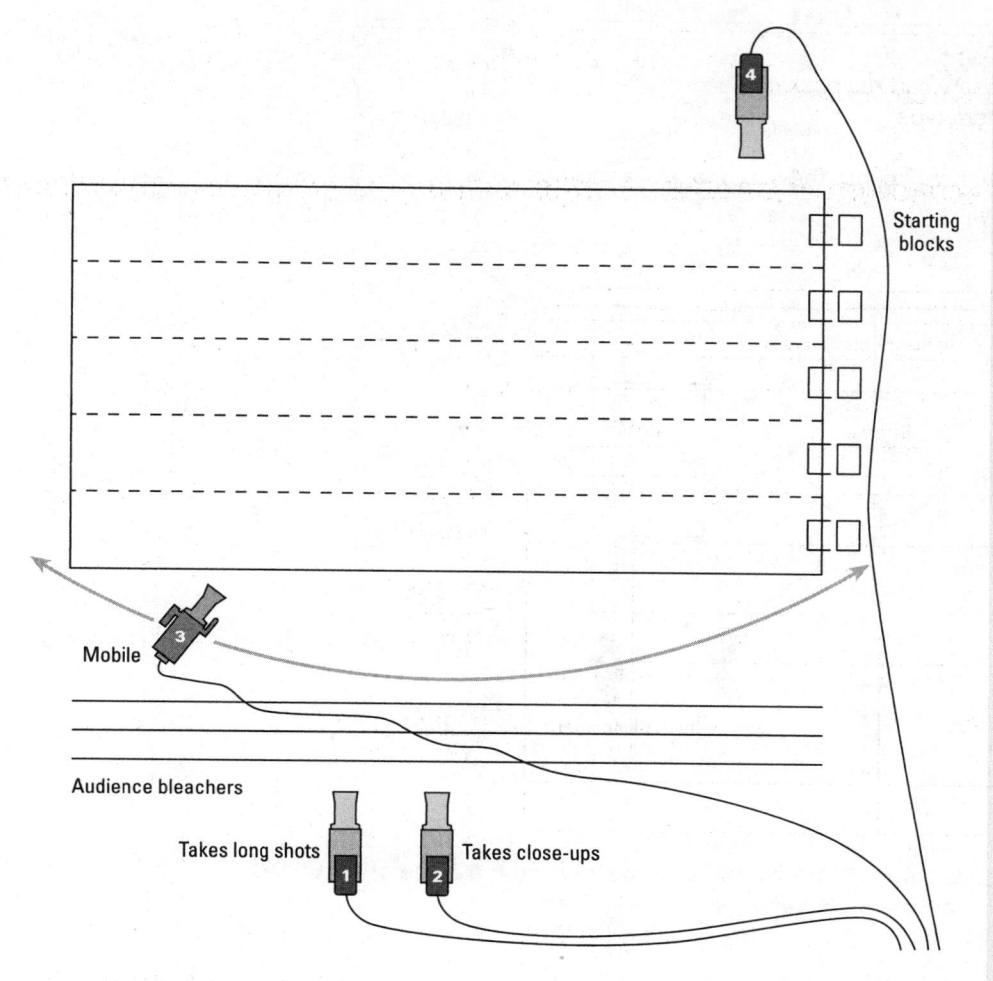

Swim Meet

Live telecast of state swim meet; large indoor pool

- m.comments on C1
- n. comments on C2
- o. comments on C3
- p. comments on C4

1m C	55	56 0 59		
1n C	55	○ 56 ○ 59		
10 C	55	○ 56 ○ 59		
1р С	55	○ 56 ○ 59		
PACTOT	S E A L]

- (55) camera position OK
- (56) wrong or unnecessary camera position
- (57) inappropriate camera type
- (58) cable hazard
- (59) lighting problems (shooting into the sun or against another strong light source)

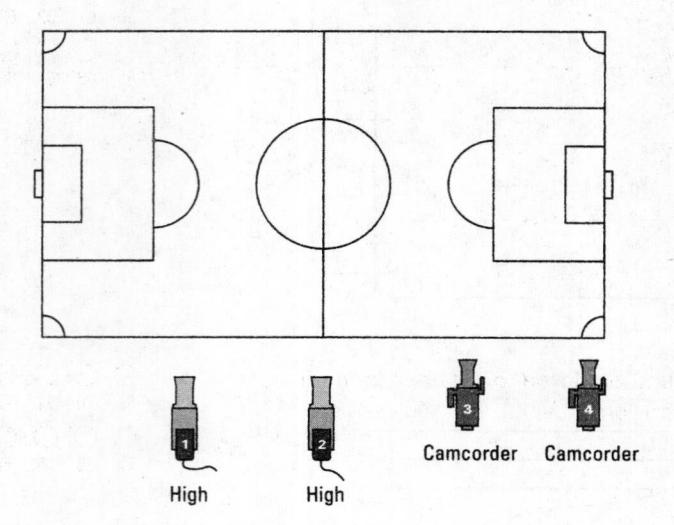

Soccer Practice

EFP of soccer practice for a show that demonstrates the beauty and the grace of a soccer game; heavy postproduction with effects and sound track

- q. comments on C1
- r. comments on C2
- s. comments on C3
- t. comments on C4

- 1q C1 O O O 55 56 57 O S8 59
- 1r C2 O O O 55 56 57 O S8 59
- 1s C3 O O O 55 56 57 O S8 59
- 1t C4 O O O 55 56 57 O S8 59

PAGE TOTAL

REVIEW OF FACILITIES REQUESTS

Evaluate the equipment facilities requests for the three EFPs described below. Identify the wrong equipment and the items not needed and fill in the bubbles with the corresponding numbers. Multiple answers are possible.

1. taped interview of a media scholar in his hotel room for news item

Facilities Request 1

- (60) camcorder
- (61) iso video recorder
- (62) portable lighting kit
- (63) RCU
- (64) 2 lavalier mics
- (65) portable audio mixer
- (66) recording media
- (67) batteries
- (68) preview monitors
- 2. midmorning recording of a brief dance number in front of city hall for a music video using ENG/EFP cameras, not camcorders

Facilities Request 2

- (69) 3 ENG/EFP cameras
- (70) 6 shotgun mics
- (71) ESS
- (72) 3 video recorders
- (73) 3 RCUs, connecting cables, and portable monitors
- (74) large audio mixer
- (75) P.A. audiotape playback system
- (76) portable lighting kit
- (77) C.G.
- 3. live stand-up traffic report from downtown during the afternoon rush hour

Facilities Request 3

- (78) camcorder
- (79) 2 video recorders
- (80) shotgun mic (camera mic)
- (81) hand mic
- (82) 3 portable lighting kits
- (83) audiotape recorder
- (84) microwave transmission equipment
- (85) I.F.B. intercom
- (86) C.G.

1	0	0	0	0	0
	60	61	62	63	64
	0	0	0	0	
			67		

2	0	0	0	0	0
	69	70	71	72	73
		A 10 (10 S 10 S 10 S	0		

3	0	0	0	0	(
	78	79	80	81	
	0	0	0	0	
				96	

ECTION	
ECTION	
OTAL	
O . A .	

REVIEW OF SIGNAL TRANSPORT SYSTEMS Select the correct answers and fill in the bubbles with the corresponding numbers. 1. Small uplink trucks use (87) the Ku-band (88) the C-band (89) their own satellite frequency for signal transmission. 0 2. EFP makes (90) more-frequent use of satellite transmission than (91) less-2 frequent use of satellite transmission than (92) about the same amount of satellite transmission as big remotes. 3 3. A microwave signal (93) can (94) cannot be blocked by big buildings or mountains. 4. A mini-link refers to (95) a small uplink (96) a small downlink (97) several microwave links to transport the signal around an obstacle. 5. The C-band uplink and downlink dishes are (98) the same as (99) smaller 100 than (100) larger than the ones for the Ku-band. 0 6. Assuming proper access, digital ENG content can be transported by 102 103 (101) broadband (102) KKX satellite (103) power lines. 0 7 0 7. The Ku-band operates on a frequency that is (104) higher than (105) lower 104 105 106 than (106) the same as the frequency for the C-band and is (107) more 0 0 0 stable in bad weather (108) less stable in bad weather (109) immune to

weather conditions. (Fill in two bubbles.)

SECTION	
TOTAL	

© 2009 Wadsworth Cengage Learning

REVIEW QUIZ

Mark the following statements as true or false by filling in the bubbles in the T (for true) or F (for false) column.

- 1. Remote surveys are relatively unimportant for ENG.
- 2. A careful audio setup is as important as the camera setup in big remotes.
- **3.** Big-remote trucks usually contain an audio control center, a video control center, a production control center, a video-recording room, a video control center, and a transmission area.
- **4.** When shooting single-camera EFP for postproduction, you do not need extensive intercom systems.
- 5. You need a switcher when using three EFP cameras as multiple isos.
- **6.** So long as you use an I.F.B. system, the floor manager is unnecessary for big remotes.
- 7. The contact person is important only in preproduction.
- **8.** So long as you have a good transmission system, you do not need video recorders in the remote truck.
- **9.** Cameras used for the regular coverage of a remote telecast cannot be used for instant replay.
- **10.** The C.G. operation is especially important during a live broadcast of a football game.
- 11. To make the remote telecast as exciting as possible, you should use as many cameras as are available.
- **12.** If possible, you should do the survey for an outdoor remote during the time the actual production will take place.
- **13.** So long as you have good headsets, you do not need other intercom systems on big remotes.
- 14. Remote surveys are relatively unimportant for EFP.

SECTION	Williams Co.
TOTAL	

12 0

PROBLEM-SOLVING APPLICATIONS

- 1. To get a good overhead shot of a parade, you, the director, would like to place one of the cameras on the balcony of a twentieth-floor window of a nearby hotel. The TD informs you that the hotel manager has nothing against your renting the room for the day and setting up the camera, but she will not allow any cable runs either inside or outside the hotel. What would you suggest?
- 2. The producer learns at the last minute that the president of the European Union will arrive at the international airport and wants you to cover her arrival live. According to the producer, you should have no problem with the transmission because the station's transmitter is in line-of-sight of the airport. What field production method would you recommend? Specifically, what equipment and personnel would you need to accomplish this assignment?
- 3. You are the director for the live coverage of a large computer convention. While you're giving instructions to the talent to wind up her interview with one of the computer experts, her I.F.B. fails. How else can you communicate with her while she is on the air?
- 4. Conduct a detailed remote survey for the live coverage of one of the following: (1) a football game, (2) a track meet, (3) a basketball game, (4) a baseball game, (5) a concert of a symphony orchestra, (6) an outdoor rock concert, or (7) a modern dance performance in a city park. Be sure to include all major production items, such as camera placement, audio and lighting requirements, intercom and transmission systems, power source, and so forth.
- **5.** Prepare location sketches and facilities requests for the remote or EFP selected in the previous question.

19

Postproduction Editing: How It Works

REVIEW OF KEY TERMS

Match each term with its appropriate definition by filling in the corresponding bubble.

- 1. clip
- 2. source media
- 3. insert editing
- 4. on-line editing
- 5. off-line editing
- 6. linear editing
- 7. capture
- 8. assemble editing
- 9. edit master recording
- 10. EDL
- 11. window dub
- 12. VR log
- 13. source VTR
- 14. record VTR
- 15. time code
- 16. edit controller
- 17. NLE
- 18. ADR
- A. Consists of edit-in and edit-out points expressed in time code numbers

B. Editing that uses tape-based systems

16 17 18

	1905040		Distance of	98000000000000
P	A	G	E	
Т	0	ГА	L	

- 13. source VTR 1. clip 7. capture 8. assemble editing 14. record VTR 2. source media 9. edit master recording 15. time code 3. insert editing 16. edit controller 4. on-line editing 10. EDL 5. off-line editing 11. window dub 17. NLE 12. VR log 18. ADR 6. linear editing
- C. Adding shots on videotape without prior recording of a control track
- D. A "bumped-down" copy of all source recordings with the time code keyed over each frame

E. Requires the prior laying of a control track

F. Recapturing the assembled shots at a higher resolution or creating a high-quality edit master tape

P A G E

- **G.** Process that produces the EDL, a videotape not used for broadcast, or low-resolution capture
- H. Transferring of video and audio information to a computer hard drive
- 0 0 0 0 0 1 2 3 4 5 0 0 0 0 0 0 0 0 0 0 0 0 0 0 0 11 12 13 14 15 0 0 0 16 17 18

I. The videotape recorder that supplies the shots to be assembled

- J. Allows instant random access to and easy rearrangement of shots

K. A shot or brief sequence of shots captured on the hard drive

P A G E T O T A L

- 1. clip
- 2. source media
- 3. insert editing
- 4. on-line editing
- 5. off-line editing
- 6. linear editing
- 7. capture
- 8. assemble editing
- 9. edit master recording
- 10. EDL
- 11. window dub
- 12. VR log

- 13. source VTR
- 14. record VTR
- 15. time code
- 16. edit controller
- 17. NLE
- 18. ADR
- L. The videotape recorder that produces the edit master tape

M. The media that contains the final on-line edit

N. The recording devices (videotape, hard disk, optical disc, or flash memory device) that hold the recorded material

O. A list of all consecutive shots recorded during a production with in and out time code numbers and other information

PAGE

- P. Device that triggers certain play and editing functions in the source and record VTR
- O O O O O O 6 7 8 9 10 00000 11 12 13 14 15 000 16 17 18
- Q. The synchronization of speech with the lip movements of the speaker in postproduction
- 00000 1 2 3 4 5 O O O O O 6 7 8 9 10 00000 11 12 13 14 15 000 16 17 18

R. Gives each television frame a specific address

R 00000 1 2 3 4 5 O O O O O O 6 7 8 9 10 00000 11 12 13 14 15 000 16 17 18

- :
•
-
•
٠
ζ
•
ē
_
Ŧ
- 5
-
-
-
.0
-
_
-
7
7
=
٠.
6

P A G E T O T A L	
SECTION TOTAL	

	REVIEW OF NONLINEAR EDITING				
Sele	ct the correct answers and fill in the bubbles with the corresponding numbers.				
	Nonlinear systems (19) allow (20) do not allow random access to the source material and use (21) videotape (22) disk-based storage systems. (Fill in two bubbles.)	1	O 19 O 21	O 20 O 22	
2.	The operational principle of nonlinear editing is (23) copying images from a source to a record device (24) rearranging audio and video data files (25) transferring digital data from a VTR to a hard drive.	2	23	O 24	O 25
3.	Audio/video capture from a camcorder to a hard drive is normally done via (26) FireWire or HDMI cable (27) S-video cable (28) coaxial cable.	3	O 26	O 27	28
4.	The three major components of a nonlinear editing system are (29) source media, editing software, digitizer (30) source VTR, software, edit master VTR (31) source media, computer, editing software.	4	29	30	O 31
5.	Compared with linear editing, nonlinear editing systems require that you pay (32) <i>less</i> (33) <i>more</i> (34) <i>the same</i> attention to shot continuity in the shooting phase.	5	32	33	34
6.	Compared with linear editing, an accurate EDL is (35) more (36) less (37) equally important in nonlinear editing.	6	35	36	37
7.	The time code frames and seconds roll over at (38) 59 frames, 59 seconds (39) 29 frames, 59 seconds (40) 29 frames, 29 seconds.	7	38	39	40
8.	When you want the time code to indicate the correct elapsed clock time even for a long running time, you should record the shots in (41) drop frame mode (42) non-drop frame mode (43) PAL time code.	8	41	O 42	43
9.	The VR log helps (44) organize the source material (45) eliminate unimportant cutaways (46) locate specific shots during the editing process.	9	O 44	45	46
10.	Audio transcriptions are important especially when editing (47) a fully scripted drama (48) an interview (49) a fully scripted 30-second commercial.	10	O 47	48	O 49
11.	When editing video to audio, you use (50) video as the A-roll and audio as the B-roll (51) audio as the A-roll and video as the B-roll (52) no A and B rolls.	11	50	51	52
		.	CTIOI	, [1

Name

REVIEW OF LINEAR EDITING

Select the correct answers and fill in the bubbles with the corresponding numbers. Fill in two bubbles for problems 1 through 6.

- 1. The control track editing system is (53) more accurate (54) less accurate in locating a specific frame than the time code system because it (55) marks (56) does not mark each individual frame with a unique address.
- 2. When using SMPTE time code, you (57) can (58) cannot add it later over existing source tapes; it (59) does (60) does not necessarily show the actual time during which the production took place.
- 3. Insert edits are (61) more (62) less stable than assemble edits and are (63) more (64) less likely to cause sync rolls.
- 4. In the insert editing mode, the record VTR (65) will (66) will not re-create the control track from the source tape, so you (67) need (68) do not need to prerecord a continuous control track on the edit master tape.
- 5. In the assemble editing mode, the record VTR (69) will (70) will not copy the control track of the source tape, so you (71) need (72) do not need to prerecord a continuous control track on the edit master tape.
- 6. Identify mistakes in the pulse-count display in this figure and fill in the bubbles with the corresponding numbers.

7. Select the correct pulse-count display that exhibits the actual edit-in point of the edit master tape shown in the following figure and fill in the bubble with the corresponding number.

- 1 0000 53 54 55 56
- 0000 57 58 59 60
- 0000 61 62 63 64
- 0000 65 66 67 68
- 0000 69 70 71 72
- 0000 73 74 75 76
- 0000 77 78 79 80

Tape is 15:25 minutes in from start

PA	GE	
TO	TAL	

- 8. To perform split edits (editing video and audio separately), you need to be in the (81) digital (82) insert (83) assemble mode.
- 8 O O O S
- **9.** Fill in the bubbles whose numbers correspond with the numbers identifying the correct insert and assemble edits shown in the following figures.

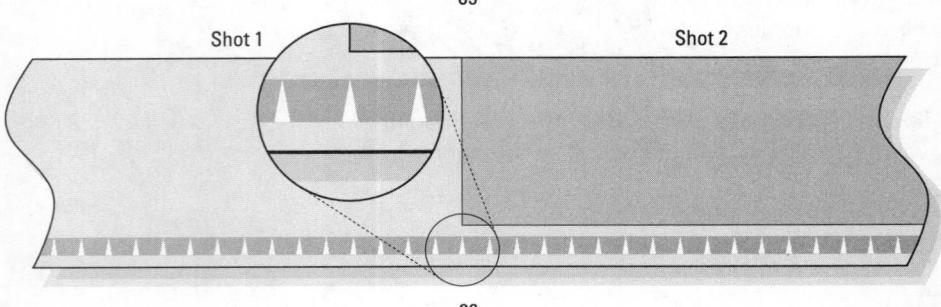

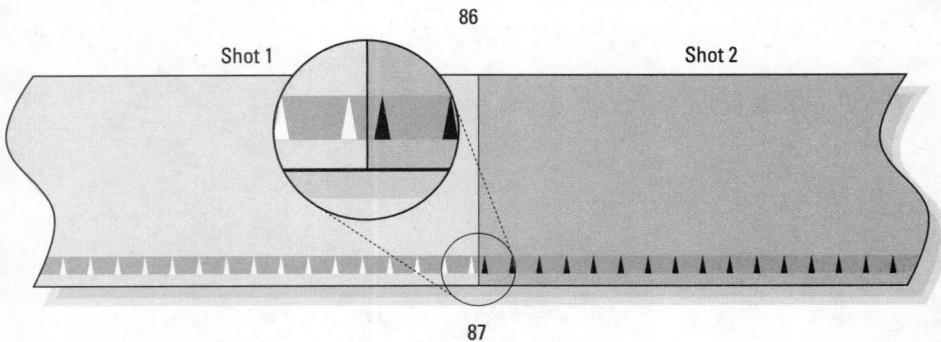

- a. correct insert edit
- **b.** correct assemble edit

9a	0	0	0	0
	84	85	86	87

9b	0	0	0	0
	84	85	86	87

P	A	G	E	
Т	0	TA	L	

Name

- 10. To prepare properly for assemble editing, you must (88) lay a continuous control track for the edit master tape (89) lay a control track on all source tapes to be used (90) do nothing to the record or edit tapes you are using.
- 11. To prepare properly for insert editing, you must (91) prerecord black before using the source tapes (92) lay a control track for the edit master tape (93) simply record time code during the videotaping of the source material.
- 12. A videotape recorder instead of a hard drive (94) can be used for nonlinear editing only if the videotape contains digital video and audio data (95) can be used for nonlinear editing only if the video and audio information is highly compressed (96) cannot be used for nonlinear editing.
- 13. The operational principle of linear editing is (97) file management (98) transferring data from a VTR to a hard drive (99) copying selected portions of the source tapes.

10	88	89	90
11	91	92	93
12	94	O 95	0

13	0	0	0
	97	98	99

-
a
a
-
a
~
C
-
- >
-
_a
_
_
÷
τ
-
- 5
->
U
~
cc
-
5
-
9
\succeq
\approx
63
6

REVIEW QUIZ Mark the following statements as true or false by filling in the bubbles in the T (for true) or F (for false) column. 1. All nonlinear editing systems display a window for the source material and one for the recorded sections. 2. You should use insert editing only when replacing a shot in an edit master 3. Time code must be recorded during the actual production to achieve a continuous frame address. 4. Contrary to linear editing, an EDL is not practical in nonlinear editing. 5. Nonlinear editing can be done with high-end VTRs. 6. EFP and more-elaborate postproduction editing require the careful logging of all source tapes. 7. The concept of AB-roll editing does not apply to nonlinear editing. 8. A VR log is equally helpful in both linear and nonlinear editing. 9. A window dub shows the time code keyed over each recorded frame. 10. Off-line editing calls for identical procedures in linear or nonlinear editing.

SECTION	
SECTION	
TOTAL	

PROBLEM-SOLVING APPLICATIONS

- 1. The news producer tells you, the editor, not to bother with an audio transcription of the recent two-hour interview with the mayor because he needs only about 20 seconds of a few memorable sound bites. What is your reaction? Why?
- 2. When editing your EFP material in the assemble mode for a rough-cut, you experience several sync rolls. When you show the rough-cut to the director, he wants to make sure that all transitions are clean. What editing mode would you have to use to ensure "clean transitions"? Explain the features of the selected mode that prevent editing breakups.
- 3. The novice director warns you, the editor, that the new client is known to change her mind frequently and may require substantive editing changes right in the middle of the show. The director is worried that such major changes may cause serious time delays. Assuming that you are working with a nonlinear editing system, what would you tell the director? Be specific.
- **4.** The same director tells you to be sure to capture all source tapes at the highest resolution even for an off-line rough-cut because "once in the computer, you are stuck with what you imported." What is your reaction? Why?
- **5.** Even with your new nonlinear editing system, it is cumbersome to find shots that show the new car model traveling in specific screen directions. The producer suggests that you note the various vectors when logging the source footage. What does she mean? How can doing this help you locate the desired shots?
- **6.** The director is a big fan of nonlinear editing because fixing mistakes in postproduction is "now a snap." What is your reaction? Give specific examples.

enter de la company de la comp

20

Editing Functions and Principles

REVIEW OF KEY TERMS

Match each term with its appropriate definition by filling in the corresponding bubble.

- 1. complexity editing
- 2. index vector
- 3. mental map
- 4. jump cut
- 5. graphic vector
- 6. montage
- 7. continuity editing
- 8. vector line
- 9. cutaway
- 10. motion vector
- 11. vector
- A. A shot that is inserted to facilitate continuity
- **B.** A vector created by someone looking or something pointing unquestionably in a specific direction
- C. The preservation of visual continuity from shot to shot

- B O O O O O 1 2 3 4 O O O O O 5 6 7 8

P A G E T O T A L

1. complexity editing 5. graphic vector 9. cutaway 2. index vector 6. montage 10. motion vector 7. continuity editing 11. vector 3. mental map 8. vector line 4. jump cut D 0 0 0 0 1 2 3 4 **D.** The juxtaposition of two or more shots to generate a third overall idea, which may not be contained in any one 0000 5 6 7 8 000 9 10 11 E 0000 E. A perceivable force with a direction and a magnitude 1 2 3 4 0000 5 6 7 8 000 9 10 11 0000 F. The juxtaposition of shots that helps intensify the screen event 1 2 3 4 0000 5 6 7 8 000 9 10 11 0000 G. Juxtaposing shots that violate the established continuity 1 2 3 4 0000 5 6 7 8 000 9 10 11 0000 H. Established by two people facing each other or through a prominent 1 2 3 4 movement in a specific direction 0000 5 6 7 8 000

9 10 11

- I. Virtual image of where things are or are supposed to be in on- and off-screen space
- 0000 5 6 7 8 000 9 10 11
- J. Created by an object actually moving or perceived as moving on-screen
- 0000 0000 5 6 7 8 O O O 9 10 11
- K. Created by lines or by stationary elements in such a way as to suggest a line
- $\bigcirc \bigcirc \bigcirc \bigcirc \bigcirc \bigcirc \bigcirc$ $1 \quad 2 \quad 3 \quad 4$ 0000 5 6 7 8 000 9 10 11

© 2009 Wadsworth Cengage Learning

P A G E	
SECTION	

REVIEW OF CONTINUITY EDITING PRINCIPLES

Select the correct answers and fill in the bubbles with the corresponding numbers.

1. You are given a storyboard to assist you in your single-camera EFP of a conversation between a man and a woman (see the following figure). For each storyboard pair, indicate whether the shots (12) can (13) cannot be edited together, assuming normal continuity-editing principles.

a.

b.

C

d.

e.

1a	0	(
	12	1;

1b	0	C
	12	13

10	0	
10		
	12	1

1d	0	C
	12	13

0	0
12	13

P	AG	Е
Г	OTA	L

2. From the screen images below (repeated on the following page), select the sequence pair you would get when cutting from camera 1 to camera 2 as shown in the diagrams of the camera positions.

14

15

16

17

Also indicate whether continuity is (18) good or (19) bad.

a. camera setup A

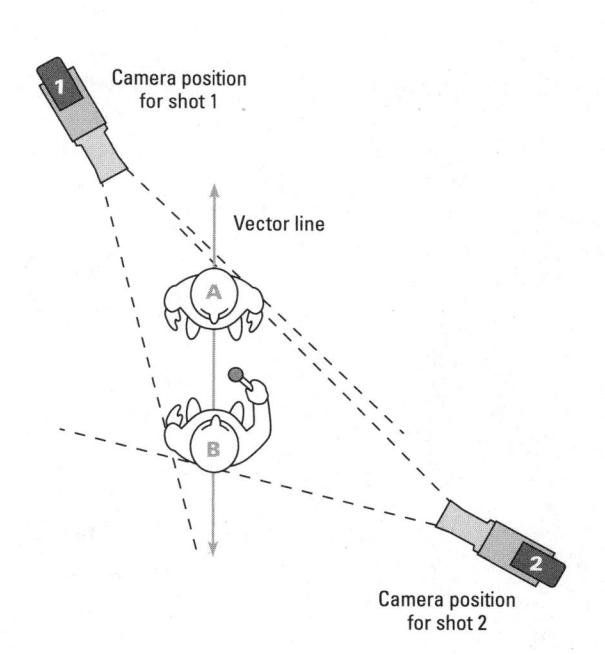

			defendances:	STORES	
P	Α	G	E		
Т	0	TA	ī.		

15

14

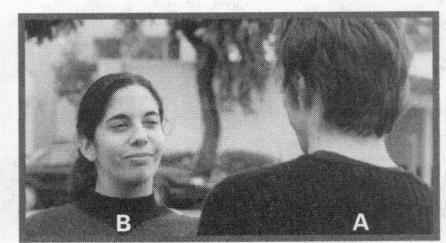

17

Indicate whether continuity is (18) good or (19) bad.

b. camera setup B

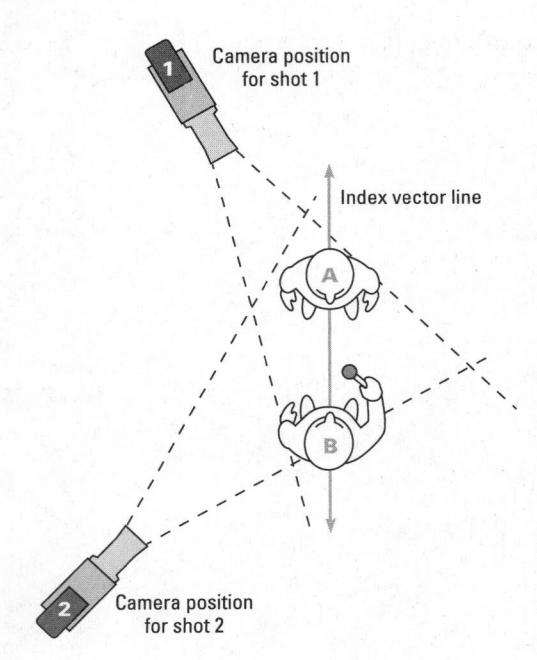

P A G E T O T A L
- 3. In the following four diagrams, select the camera that is in the wrong place for proper continuity editing and fill in the corresponding bubble.
 - a. cutting from two-shots of piano player and singer to CUs

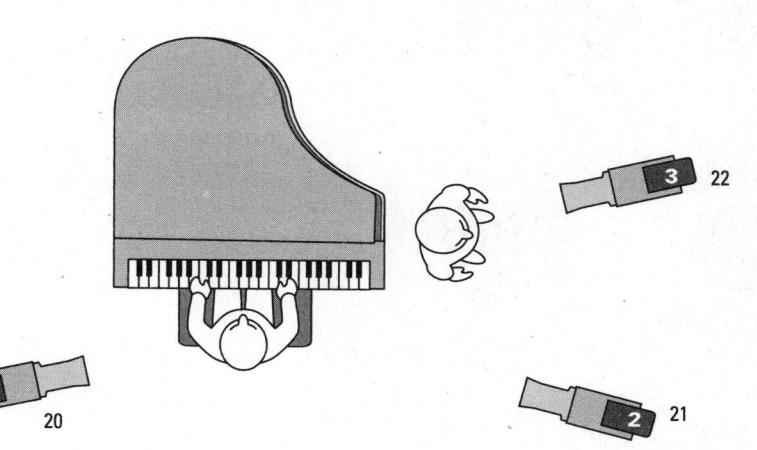

b. cutting from camera 2 to a different point of view of the university president and her husband during a reception

3b	0	0	0	0
	23			

PAGE	
TOTAL	

d. cutting between person A and person B during a conversation

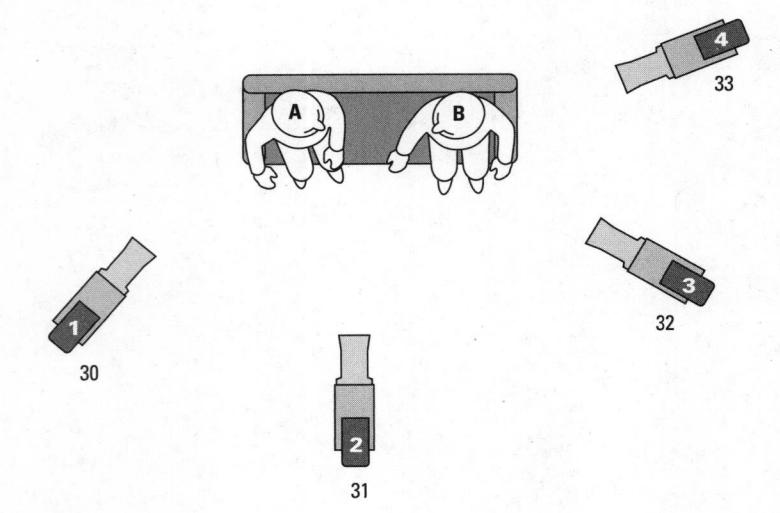

3c O O O O 27 28 29

3d	0	0	0	0
	30	31	32	33

P A G E T O T A L

4. In the following diagram of a simple interview, select the two cameras that will facilitate optimal cross-shooting and fill in the bubbles with the corresponding numbers.

č
•
- 8
-
č
_
ř
6
ř
6
ā
c
_
÷
-
9
5
O
τ
2
<
=
2
≥
5
0
E

P A G E T O T A L

5. From the nine frame grabs of source clips below, select four shots to tell the story of a woman getting into her car and driving off. Fill in the bubbles with the numbers of the shots you selected in the order you would edit them together.

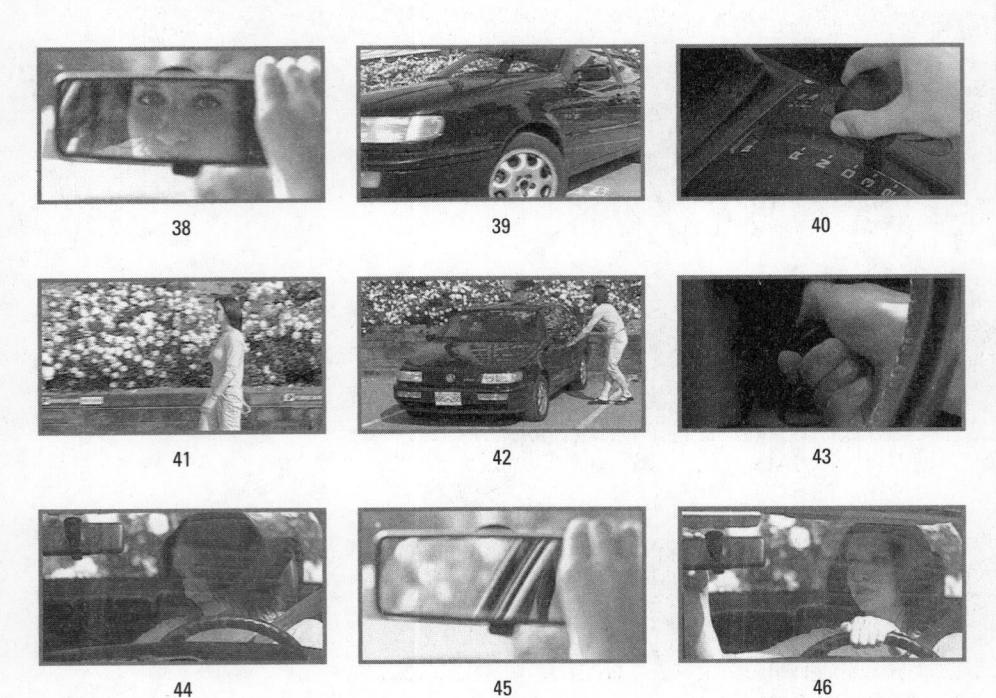

- a. shot 1
- b. shot 2
- c. shot 3
- d. shot 4

5a	0	O 39 O 44	40	41	42	
ōb	0	39	40	41	O 42	
5c	0	39 0 44	40	41	O 42	
5 d	0	O 39 O 44	40	41	O 42	

6. For each of the following shot sequences, fill in the appropriate bubbles to indicate whether the sequence (47) maintains or (48) disturbs the mental map. If the mental map is disturbed, also indicate whether the reason is a (49) position switch or a (50) vector problem. (Multiple answers are possible.)

a.

Shot 1

Shot 2

Shot 3

0 47 48 0 50

b.

Shot 1

Shot 2

Shot 3

0 6b 48 0

C.

Shot 1

Shot 2

Shot 3

O 47 48 O 50 0

d.

Shot 1

Shot 2

Shot 3

6d 0 0 47 48 0 0

© 2009 Wadsworth Cengage Learning

SECTION

REVIEW OF COMPLEXITY EDITING

Select the correct answers and fill in the bubbles with the corresponding numbers.

- 1. Complexity editing (51) can occasionally break with continuity principles (52) must adhere to continuity principles (53) does not consider continuity principles.
- 2. A filmic shorthand in which a rhythmic series of seemingly unrelated shots generates new meaning is called a (54) montage (55) clip (56) sequence.
- **3.** In complexity editing, DVE (57) should be avoided (58) can be used to intensify a scene (59) can be used to clarify a scene.
- **4.** In complexity editing, a jump cut (60) clearly signals an editing mistake (61) should never be used (62) can be used as an intensifier.
- **5.** The simultaneity of several separate events can best be shown with (63) *multiple screens* (64) *flashbacks* (65) *flashforwards*.
- **6.** Assuming that the montage below is properly motivated, the series of shots would be appropriate in (66) *continuity editing* (67) *complexity editing* (68) *instantaneous editing*.

Shot 1

Shot 2

Shot 3

Shot 4

P	A	G	E
T	0	TA	L

0

0

0

0

Name

- 7. A series of quick cuts between camera 1 and camera 2 would be appropriate in (69) continuity editing (70) complexity editing (71) instantaneous editing.
- 7 0
 - O (

PATOT	G E A L	

SECTION	щ					
SECTION	П			T10		-
	п		1.4	110	= 6	9
TOTALL				T A	0	-

	REVIEW QUIZ			
	rk the following statements as true or false by filling in the bubbles in the or true) or F (for false) column.			
1.	Ethical considerations are the purview of the director and have no place in the busy editing room.	1	T O 72	F O 73
2.	A jump cut may be used effectively in complexity editing.	2	O 74	O 75
3.	A blurred still shot of a car represents a motion vector.	3	O 76	O 77
4.	A cutaway can be any shot so long as it does not project a vector.	4	O 78	O 79
5.	A mental map helps viewers to organize on- and off-screen space.	5	80	81
6.	If the move is properly motivated, the vector line can be crossed in continuity editing.	6	82	83
7.	Two of the major editing functions are to shorten and to combine.	7	O 84	85
8.	Subject continuity means that we can recognize a person from one shot to the next.	8	86	87
9.	Somebody pointing at an object constitutes an index vector.	9	O 88	89
10.	Index and motion vectors play an important role in continuity editing.	10	90	91
11.	So long as we can recognize a person, it does not matter even in continuity editing that she appears on screen-left in one shot and on screen-right in the next.	11	92	93
12.	The vector line extends from the camera to the horizon.	12	94	95
13.	A shrinking circle wipe is an especially effective way to close a documentary on a flood disaster.	13	96	97
14.	A jump cut occurs when the subject has moved his head even slightly from one shot to the next.	14	98	99
15.	When cutting from an MS to a CU of somebody sitting down, continuity is best preserved by cutting after the person is seated.	15	100	0
16.	Sound is an important factor in maintaining continuity.	16	0	0
17.	The more DVE you use in complexity editing, the more professional your edit will look.	17	104	0 105
18.	Editing must always be done in the context of ethics—the principles of right conduct.	18	106	O 107
		SEC	TION	

PROBLEM-SOLVING APPLICATIONS

- 1. Select a scene from any type of television show that demonstrates complexity editing. Be specific.
- 2. Use a camcorder and ad-lib a scene in which your crossing the line contributes to an intensified experience.
- **3.** The news director encourages you to use a peel effect for transitions in a headline news teaser. What is your reaction? Be specific.
- 4. The staging for a presidential debate shows two candidates side by side, facing the audience; a moderator is in the middle, facing the candidates, with his back to the audience. The primary cameras are located in the audience, pointing at the stage. One camera is backstage, exactly opposite the moderator. It is to get three-shots in which we see the backs of the candidates and the moderator as he addresses the candidates. Assuming that the objective is seamless continuity, do you have any concerns about this setup? Be specific.
- **5.** The producer tells you not to worry about using a stock shot of videographers for a necessary cutaway in the editing of a news conference. What is your reaction? Be specific.

	1			
	, e			

Scale: 1/4" = 1'

Property List

	The second second						
						9-1-3	
					<u> </u>		
				10 10 10 10 10 10 10 10 10 10 10 10 10 1			
		2					
			,				

Scale: 1/4" = 1'

Property List

	15.0				1				-1
									5.0
								9.33	
		12.							
					The same of the sa				
	,			*	1				
			in the second se						
				***************************************					***************************************
								The second secon	
			Antonio						
								and the same of th	
								The second secon	
-									
								- Company of the Comp	
	-							***************************************	
		2		h				7	
	8								
							Name of the last o		
				10 10 10			***************************************		
					The second secon				
					A 1 1 2 1				
					To a contract of the contract			The second secon	
					The state of the s				
,					and a second and a				1 7 5
	,								
								on and the second secon	
								n)	
	T								
	- Contract of the Contract of							acres	
		N = 1	- 1					принципальный пр	
*		71 1			1 mg 1 1 2 2 2 2 2 2 2 2 2 2 2 2 2 2 2 2 2			one-o-consumation	
	*								
	Province delega		v e texte			-		demonstration	
The state of the s									
							Water and the same		
			27 1 1 1						The state of the state of

Scale: 1/4" = 1'

Property List

© 2009 Wadsworth Cengage Learning

© 2009 Wadsworth Cengage Learning